ART LESSONS
THAT MIRROR THE
CHILD'S WORLD

ART LESSONS
THAT MIRROR THE
CHILD'S WORLD

Ruth L. Klonsky

PARKER PUBLISHING COMPANY, INC.

WEST NYACK, NEW YORK

Library of Congress Cataloging in Publication Data

Klonsky, Ruth L
 Art lessons that mirror the child's world.

 Bibliography: p.
 Includes index.
 1. Art—Study and teaching (Elementary)
I. Title.
N350.K565 372.5'044 75-1477
ISBN 0-13-047423-1

Printed in the United States of America

For

Bob, Karen and Ed

ACKNOWLEDGMENTS

I would like to extend my gratitude and appreciation to my colleagues and friends on the faculty and administration of the Rockville Centre Union Free School District, and in particular to the members of the staff and administration at the Covert School, for their support and cooperation during the preparation of this book. Special thanks must be given to Edward Siergiej, audio visual director, for his advice and assistance, particularly with photographic materials. My thanks, also, to Patricia Arcieri for her expert typing, to my husband, Robert, for his splendid proofreading of the original manuscript, and to Joyce Laskin for her generous sharing of ideas.

Above all, I must acknowledge my students: all the boys and girls who, throughout the years, have always been my teachers, as well as my pupils. Without them, this book would never have been possible.

Ruth L. Klonsky

INTRODUCTION

You are aware of how important visual and tactile experiences are to today's children, and you realize the vital role that art must present in your curriculum. You want to incorporate an art program into your classroom, but it has to be an *effective* one.

How do you go about it? Where do you start? What are activities that will motivate children and nurture their ability to *observe, think imaginatively,* and *work freely*? How can you encourage children so that they will develop into creative, imaginative adults?

To help you organize an *effective*, purposeful art program that will help you to achieve your goals, is the purpose of this book. It will act as a practical and clear guide to help you meet the challenge of today's changing education. Whether you are a proponent of the open classroom, or prefer to work in a more structured arrangement, you will find provocative ideas that can be *adapted* to your needs, and the needs of your students.

The activities in this book are practical and have been planned so that they will provide the child with an opportunity to work as an individual, with a partner, or within a group. Above all, they provide boys and girls with creative experiences that will be rewarding to *them*.

To stress further the importance of meeting the needs of the individual, and to help you develop your art program, the underlying theme: The Child and His World. . . . leading the child to a greater acquaintance of his world through art activities, has been stressed. Each lesson lists materials, procedures and a helpful introduction of the lesson to students, as well as providing explanatory illustrations. New media, as well as new possibilities for materials already on hand, or easily obtained, have also been explored.

So that each activity will be enriched and made more meaningful, an unusual feature of each lesson is a segment entitled "Through the Eye of the Artist." Here, artists, their works, art styles, and art terms will be explained and *related* to the art project.

9

Another unique feature is the portion of each lesson that is entitled "Look Around You." Here, the child's surroundings and his awareness of them will be interwoven with the art experience.

Qualities inherent in materials will also be discussed. In addition, games, visual aids, extra bonus lessons, ways in which to adapt lessons. . . . all kinds of motivating forms will help you along.

We have often told youngsters, when they are in the early stages of developing art skills, that two and two must add up to four, and CAT can be spelled only one way, but art is very personal. Therefore, colors, arrangements, designs, *anything* can be changed to the way you would like it to be. Indeed, an art activity can be expanded in an infinite number of ways. *Your* adult imagination, once stimulated, can lead to all sorts of creative adventures. The aim of this book is to act as a catalyst that will start you on a truly effective art program of your own.

And so, take up the challenge! Adapt and change the projects in this book to meet your special needs, or use them as they are presented. Above all, use this book as your guide, as you establish and explore new paths to an effective and stimulating approach to elementary art. Where these paths will eventually lead you and your students is the very essence of artistic adventure.

Bon Voyage!

Ruth L. Klonsky

CONTENTS

Chapter 3—Art Activities Related to Writing *(Cont.)*

WE ARE AWARE OF OUR ECOLOGY

Chapter 4—Re-cycling

Lessons:

WE ARE PART OF ALL THAT IS NATURAL

Chapter 5—Art Activities Related to Nature

Lessons:

WE ARE AFFECTED BY WEATHER

Chapter 6—Art Activities Related to Weather and Seasons

Lessons:

Chapter 10—The Future *(Cont.)*

ART LESSONS
THAT MIRROR THE
CHILD'S WORLD

OUR EMOTIONS

We Have Feelings and Moods

We all have our private worlds of emotions and moods. From the young child whose wants and frustrations are sometimes expressed physically, to the older child who keeps a secret diary, children, like adults, have the need to express their inner thoughts and feelings. On the next several pages, we will be exploring some of these emotions and expressing them through art.

Although complex feelings such as sadness, loneliness, happiness, and fear are related to the activities, the projects themselves are not difficult and incorporate readily available materials. Moreover, they can be inter-related and adapted by the teacher to meet specific class needs.

Because the lessons are to be interpreted in highly personal ways, they are extremely self-motivating. As a result, the works are satisfying and are most unique and attractive to display. An added dividend will be the broadening of the student's ability to enjoy and understand fine arts, as his own artistic efforts become knowledgeably intertwined with those of well known artists.

As the child explores his world of emotions through art, he is bound to gain a better understanding of himself as well as others so that his social world will also benefit. Ultimately, he will be able to express himself more articulately in his writing and speaking as well. Hopefully, the teacher, too, will have the added benefit of gaining new insights into her pupils.

LESSON 1-1

Jittery, Jumpy!

(line drawings)

Materials

white paper—12″ x 18″
crayons or felt markers
scissors
paste and paste sticks
construction paper—assorted
 colors
scrap paper and pencils

Figure 1-1

Be Prepared

1. At the start of the lesson, have art helpers distribute the necessary supplies. Each child will need one sheet of 12″ x 18″ white paper, a pencil, and some scrap paper. Paste and scissors can be shared.

2. Construction paper slightly larger than 12″ x 18″, should be available in a central supply area. Each student will require one sheet for the completion of his project.

3. Several line drawings should be made in advance of the lesson. This will acquaint the teacher with the creative procedures, and will provide the class with the visual examples of the finished project. Remember to explain that these are samples and are not meant to be copied. Each line expression should be very individual in concept.

4. Designate an area where the children can place their finished projects until ready for display.

Introduction of Lesson to Students

Is a line always straight? A line does not have to be horizontal (across) or vertical (up and down). Indeed, it can appear in many ways. A line can have a mood, just like you. It can be jittery, jumpy, calm or nervous. It can seem droopy, angry, happy, or sad. Let's see how!

Procedure

1. Hold the white paper vertically and fold it in half. Then fold it down to form another half. Repeat this procedure once more. Open it up and eight sections will unfold (Figure 1a).

2. Now let's put the paper aside while we explore "moody lines." First think of some descriptive words, pertaining to moods and feelings. We will list them on the board as we go along. Jittery, jumpy, nervous, angry, silly, frantic, bewildered, happy, excited, calm, quiet, sad, tired, lonely, droopy. Very good! After you begin to work, you are bound to think of even more.

3. How are we going to show these feelings in our drawings? Think of one mood; nervous, for example. What shape and direction would this line take? Would the line appear swirling and jagged at times? Could it go in several directions? What color or combination of colors would seem most appropriate? Would a calm line appear differently? Might it be longer in length, without as many twists and turns as the nervous line? What color could it be? Should it be fatter than the nervous line?

4. By now you are beginning to realize that lines can indeed take on many different appearances and moods, depending on the shapes, widths, directions, and colors used to depict them. You can also see that your choices of lines are very personal: they are your very own. A color choice for one person is not necessarily the same for another.

5. Choose several of the listed variations of moods, or think about new ideas. Experiment on scrap paper with pencils to try to interpret the mood visually, using one line, or several lines. Experiment also with colors.

6. Choose eight of the lines that you feel most successfully show the idea of moods, and make similar drawings on the white paper, using pencil first, and then adding color with crayons or felt markers (Figure a).

7. When the eight line drawings are complete, cut them out into a *shape* that also suits the mood drawing. For instance, a calm line drawing might be within a smoother shape than a jumpy one (Figure 1b).

8. Label each cut out line drawing with the mood it is meant to portray in small, neat letters in a corner of the shape (Figure 1c). Use a pencil or marker for this.

9. Choose a background color from one of the assorted construction papers and arrange the cut-out drawings into an interesting composition (Figure

1d). Perhaps you would like to alternate happy moods with sad ones, or you may have chosen to illustrate similar moods.

10. Once the arrangement appears satisfactory, paste all cut-out shapes onto the construction paper. Keep in mind that the negative spaces that will be created between the pasted shapes are as important as the positive space created by the main shapes of the design.

11. Place all completed projects in the designated area.

12. Most scraps left over are not particularly re-usable and should be thrown out.

Look Around You

Have you ever before thought how lines could be used to express moods? Look around the room. How many kinds of lines do you see? The straight lines on the venetian blinds, the swirling lines on the wooden desks, the jagged lines on the cover of that science book. We are constantly exposed to linear patterns, from designs in clothing, wallpaper, and flooring, to natural objects such as wooden bark and spiderwebs. Can too many lines make you dizzy? Can bright, bold lines appear overpowering? Can soft, flowing lines make you feel rested? Just as we drew many lines for moods, can *we* have many moods and feelings? We share many common emotions, and yet each of us has feelings that are our very own. Our world has many people, all with many moods. We should learn to be more understanding of one another.

Adaptations

1. These linear mood drawings make interesting and original displays.

2. Bits of cut or torn colored tissues can add further visual highlights to each cut-out shape. White glue is more suitable if these papers are used.

3. Use the same basic approach with wet paper and inks.

4. Make descriptive linear drawings using adjectives such as jagged, curly, broken, fragmented, crooked, etc.

5. Do realistic drawings, using lines only.

6. Add collage materials for further embellishments.

7. Make booklets of magazine and newspaper advertisements and pictures that stress the use of line.

Through the Eye of the Artist

The use of lines to emphasize or create moods and effects is extremely important to artists and sculptors. Discuss lines in various reproductions, especially stressing the mood they evoke.

Suggestions

 Paintings:

 Pollock—"Full Fathom Five"

 Miro—"Painting"

 Tchelitchew—"Hide and Seek"

 Arp—"Automatic Drawing"

 Gorky—"Agony"

 Copley—"Watson and the Shark"

 Sculpture:

 Mobiles by Calder

 Lippold—"Variation Number 7, Full Moon"

 Smith—"Hudson River Landscape"

Glossary

Negative space: the areas of space created between the dominant shapes within a design

Positive space: the dominant areas of shape within a design

Horizontal: across, or parallel to the horizon

Vertical: up and down, or perpendicular to the horizon

LESSON 1-2

Scaredy Cats

(torn paper)

Materials

construction paper for backgrounds

contrasting construction paper for cats

paste and paste sticks

metallic paper

toothpicks

scissors

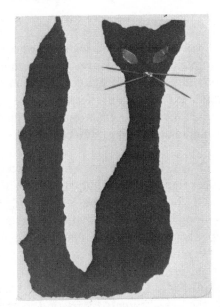

Figure 1-2

Be Prepared

1. Pre-cut assorted papers to approximately 6″ x 9″. Larger construction sheets may be used, but are harder to handle when tearing shapes. Colors may or may not be realistic.

2. Background papers should be in contrasting colors. If each child is to make only one "scaredy cat," the background paper should be cut to the same size as that which is to be torn into shape.

3. Pre-cut small pieces of metallic paper, to be used as eyes.

4. Art helpers should distribute the necessary supplies at the start of the lesson. Each child will need two sheets of construction paper and a piece of metallic paper. Scissors, toothpicks, paste and paste sticks can be shared.

5. Designate an area for the children to place their finished projects until ready for display.

6. Have a box in which students can place leftover scraps of paper, so they may be used in future projects.

Introduction of Lesson to Students

When you are frightened, really scared, how do you feel? Shivery and shaky? Have you ever heard the expression "scaredy cat"? If we were to try and create paper "scaredy cats," how could we make the paper appear "frightened"? How could we create a scared feeling in our art? Let's see!

Procedure

1. Choose the color paper from which you want to form your cat. Tear a very small piece from a corner. Now examine it carefully and notice what has happened to the torn edge. Is it still straight? The uneven effect resembles fur, especially if we think of "shivering" cats.

2. Lightly sketch a cat with chalk onto the construction paper. The cat might be sitting, running or standing. Remember that cats have long necks and tails.

3. Place thumb and forefinger of your left hand on a part of the chalk outline, and with your right hand carefully tear the paper, following the outline of your drawing. (Of course, if you are left-handed, reverse the procedure). Move your hands along the paper, so that a firm grip is maintained.

4. As the paper is torn, the outline may not be precisely followed. This is perfectly all right, because the small differences that will result tend to add to a feeling of "shivering."

5. Paste the finished "scaredy cat" onto the background paper.

6. Embellish the cat's features by pasting toothpicks for whiskers, and cutting and pasting metallic paper eyes (see Figure 1-2).

7. Place the finished work in the designated area and return all paper to the scrap box.

Look Around You

What caused our cats to be scared? Do any of these causes frighten you? When have you felt afraid? When you have been alone, at night? What do you see that makes you frightened? Movies, cartoons, television shows? Perhaps we should be more careful in what we choose to watch.

Often we realize that we should not have been afraid of something, such as a strange place or a sudden loud noise, which might be nothing more than a door moved by the wind. Sometimes fear can serve a useful purpose by warning us of approaching danger, such as a fire. However, fear is never a pleasant feeling. We should certainly not be the cause of it to others, including animals as well as people. Understanding and discussing our fears help to get rid of them, and to make our world a much more pleasant place.

Adaptations

1. Display the "scaredy cats" for a particularly effective Halloween exhibit.

2. Combine many torn paper felines on larger paper for an unusual mural.

3. Paint or crayon in backgrounds that convey a frightening experience you had.

4. Try other torn paper objects that do not necessarily convey fear, e.g., torn paper birds, chicks, rabbits, etc. Discuss how the same technique can be used to create differing effects.

5. Experiment with realistic and abstract torn paper collages.

6. Use different media, such as water colors to express emotions.

7. Tear a shape from paper and by adding paint or collage materials create something or someone frightening.

8. Draw chalk "monsters." More than likely it will turn into an hilarious project. Discuss the change from fear to humor, and their close relationship.

Through the Eye of the Artist

Fear is often conveyed in an artist's work. A selection of reproductions of such paintings and sculpture should be followed by a discussion of how the artist achieved his effects, through colors, subject matter, etc. In addition, an individual student's reactions to the art may vary and prove enlightening.

Suggestions

> Homer—"The Gulf Stream"
> Blake—"Painting"
> de Kooning—"Woman, I"
> Tamayo—"Animals"

> *Sculpture:*

>> African, Oceanic, and American Indian ceremonial masks and figures
>> Butler—"The Unknown Political Prisoner"

Glossary

> Form: solid shapes and masses
> Background: the part of a composition that is in back of the dominant subject

LESSON 1-3

Oh, Happy Day

(painting on tissue)

Materials

12″ x 18″ tissues—warm, bright
 colors
12″ x 18″ white drawing paper
tempera paints and brushes
crayons
scrap paper for sketching pre-
 liminary ideas
paste and paste sticks

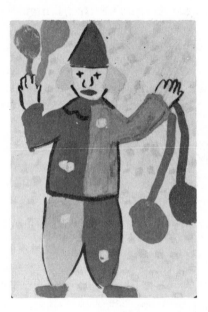

Figure 1-3

Be Prepared

1. Cover all work areas with newspapers for easy clean up. Individual desks or several pushed together will suffice if tables are not available.

2. Pre-cut tissues to 12″ x 18″ size. White paper is readily available in that same size. Larger papers can be used, but the white should be the same dimensions as the tissue.

3. Paints can be distributed in egg cartons, juice cans, or a central paint area can be set up in a corner of the room. Coffee cans, partially filled with water, will aid in quick rinsing of brushes.

4. Children should wear smocks.

5. At the start of the lesson, have art helpers distribute the necessary supplies. Each student will need a sheet of tissue paper and a sheet of white paper. Crayons and paste can be shared. Scrap paper should be available for those children who wish to make preliminary sketches.

6. All art projects are more attractive when mounted. If possible, have a supply of 18″ x 24″ white paper, plus staplers, available as backing for the finished works of art. Older children can mount their own project. The teacher, or group of upper grade art helpers can mount younger children's paintings.

7. Designate an area for children to put their paintings to dry.

Introduction of Lesson to Students

Everyone prefers happiness to sadness. When we are in a happy frame of mind, everything seems to be right with the world. Let's concentrate on happy thoughts today as ideas for our paintings. The very paper that we will be painting upon will be special. Tissues are enjoyably easy to paint upon, as you will soon discover, and their colors are especially bright and gay. So relax, smile, and let's have a happy day!

Procedure

1. You will find that when you are painting, the brush seems to glide very smoothly over the tissue paper. However, tissue is extremely thin and can tear easily. To prevent this from happening, we will back ours with the white paper. Carefully paste each *corner* of the tissue, and place it onto the white paper so that the two sheets are evenly aligned.

2. Think about what you wish to portray. What are things, events or times that have made you especially happy? Birthday parties, clowns at a circus, puppies, a beautiful garden, a family outing, a day at the beach? When you have decided upon an idea, you may wish to start painting directly onto the tissue, or you may want to make a preliminary sketch on scrap paper.

3. Choose bright, warm colors to convey a feeling of happiness. You will notice as you paint that the tissue has a tendency to wrinkle slightly. This actually lends a pleasant texture and appearance to the finished paintings, and makes them special.

4. Allow some of the tissue paper to remain unpainted, as part of the background. The colors are so vibrant, that you will not want to cover them completely with paint.

5. When you are satisfied that your project is complete, carefully carry it to the designated area to dry.

Look Around You

Just looking at our paintings gives a happy feeling! Do you think the colors of the tissues help to create a lively and gay mood? By not painting completely over the tissues we have achieved some unusual color effects for backgrounds. Notice the pink sky, for example. Is the sky really always blue? What about sunsets or stormy days? The ground in that painting is sunny yellow. If it had been painted dark green, do you think the effect would have been as bright? Have you ever seen ground that was somewhat yellow? What about hay-covered fields or golden-colored sand? Do you think that warm colors (reds, yellows and oranges) are happier in feeling than cool colors (blues, greens and purples)? Why?

Adaptations

1. Exhibit these paintings for a very decorative and happy display.

2. Use cool-colored tissues to paint other mood pictures, such as sad, lonely, moody, etc.

3. Painting on black tissue makes for especially striking Halloween pictures.

4. Make booklets of paintings that are happy or sad, along with original stories and poems.

5. Paint pictures of dreams on subtly hued tissues.

6. Make crayon drawings using *only* warm colors or cool colors.

Through the Eye of the Artist

Discuss the use of warm and cool colors in various reproductions of paintings, and how the use of color heightens the mood an artist wishes to convey. A class discussion on individual emotional reactions to the paintings will also be stimulating.

Suggestions

Homer—"Eight Bells," "The Gulf Stream"

Ryder—"Toilers of the Sea"

O'Keeffe—"From the Plains No. I"

Pippin—"John Brown Going to His Hanging"

Matisse—"The Red Studio"

Shahn—"The Red Stairway"

Kuhn—"Trio"

Matta—"Listen to Living"

Glossary

Warm colors: reds, oranges, yellows and other colors with admixtures of these hues

Cool colors: greens, blues, violets

LESSON 1-4

Lonely and Sad

(mood drawings: oil crayons)

Materials

oil crayons
drawing paper or dark construction paper

<div align="right">Figure 1-4</div>

Be Prepared

1. Cover work areas with newspapers for easy cleanup.

2. Have art helpers distribute the necessary supplies at the start of the lesson. Each child will need one sheet of drawing paper or construction paper. Crayons can be distributed in empty T.V. dinner trays and can be shared.

3. White drawing paper may be used for this lesson. However, the colors of the oil crayons appear more effective on dark backgrounds. Moreover, children enjoy the novelty of drawing on paper that is unusually colored.

4. Designate an area for students to place their finished drawings until ready for display.

Introduction of Lesson to Students

Our moods change and often do not last long. Sometimes, especially when we are sad, we also feel lonely. It may be difficult for us to describe in words what our emotions are, but perhaps we can attempt to describe them visually through our art. Our drawings need not be realistic, but abstract, or unrealistic. In fact, colors, shapes, lines and forms are likely to seem easier to help us portray our world of many moods.

Procedure

1. Think about a time or place that had made you sad or unhappy. Try to remember how you felt. Think about colors and shapes that seem to suit those feelings. Perhaps blues, greys, blacks and purples will seem more appropriate than brighter colors. Soft, intertwined shapes will probably be more suitable than lively, round ones. You may wish to incorporate some realism into your mood drawing: teardrop forms, for example.

2. Try to work freely and directly on the paper, remembering all the while those events that have made you feel sad. Use lines to accent the forms you draw, and remember to choose your colors carefully. Create abstract designs.

3. Experiment with blending colors together to create new ones. White over other hues creates beautiful tints.

4. Use the oil crayons imaginatively. Don't be afraid to apply unusual colors if you think that they will create a special effect. Try peeling the paper, and using the sides of the crayons, especially when you wish to cover a large area.

5. When finished, place your drawing in the designated area for finished work.

6. Return all oil crayons.

Look Around You

What are some of the things that make us feel lonely and sad? Can you feel lonely, even if surrounded by people? Do our surroundings have an effect upon our moods? Can we feel sad when listening to music? Do you think that a painting can bring about sad, as well as happy feelings? Do you think that animals feel lonely or sad? Sometimes if we understand what causes these feelings, we can learn not only to help ourselves, but to be more thoughtful of others as well. We are all different, and yet we all share many emotions that are the same. Our world can be a happier place if we all try to understand each other's feelings.

Adaptations

1. Try more realistic interpretations of sad emotions.

2. Make an exhibit of the various drawings depicting loneliness and sadness, and combine them with pictures and articles from magazines and newspapers that reflect these emotions.

3. Create collages with the same theme.

4. Work in groups to create a "Mural of Moods."

5. Paint to music that relates to a thematic mood.

6. Experiment with different media and compare the visual results.

Through the Eye of the Artist

Many artists have used the theme of loneliness and sadness as subject matter for their paintings. Reproductions should be shown to the class, followed by a discussion of what feelings the paintings evoked from the students, and how the artist used colors, subject matter, technique, etc. to achieve his results. In addition, the Expressionist movement in art could well be part of the lesson. (See Glossary)

Suggestions

Expressionists—Kandinsky, Weber, Klee, Rouault, etc.

Wyeth—"Christmas World," "Day of the Fair"

Hopper—"New York Movie"

Graves—"Blind Bird"

Siqueiros—"Echo of a Scream"

La Tour—"La Madeleine a la Veilleuse"

Sculpture

Giacometti—"Dog"

Butler—"The Unknown Political Prisoner"

Glossary

Expressionism: art which predominately conveys personal emotions of the artist, often through distortions of color and form

Tint: produced by adding white to a basic color

Abstract: art that creates new forms and shapes which may be derived from natural forms

LESSON 1-5

Do Clowns Always Smile?

(tempera paintings: facial expressions)

Materials

tempera paints
brushes
dark construction paper—12″ x
 18″ or 18″ x 24″
chalk
scrap paper

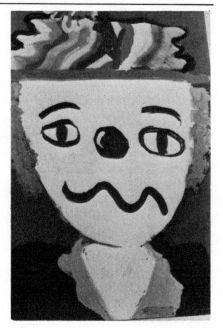

Figure 1-5a

Be Prepared

1. Cover all work areas with newspapers for easy clean up. Individual desks, or several pushed together, will suffice if tables are not available.

2. At the start of the lesson, have art helpers distribute the necessary supplies. Each child will need one sheet of construction paper and a piece of chalk. Scrap paper should be available for students who wish to make preliminary sketches. Paints can be distributed in egg cartons or juice cans, or a central paint area can be set up in a corner of the room. Coffee cans, partially filled with water, will aid in quick rinsing of brushes.

3. All art projects are more attractive when mounted. If possible, have a supply of large white, or other contrasting paper, as well as staplers, available for backing the finished art work. The teacher or a group of upper grade helpers can mount younger children's work. Older students can mount their own paintings.

4. All students should wear smocks.

5. Designate an area, even if it is the hall floor. where children can place

their finished paintings to dry. Caution children to carry their work "tray-like" to avoid dripping of paints.

Introduction of Lesson to Students

No one is always happy. It is nice to see a smiling face, but sometimes we frown, or cry, or look angry. Everyone has different moods and often we show our feelings through facial expressions. Even clowns. A circus is a very happy place, but do the clowns always smile?

Procedure

1. Pictures of faces are called "portraits." Before making preliminary sketches of our clown portraits, it is important for us to have a discussion on facial expressions. Smile. Feel your lips. Does your mouth curve upwards or downwards? Now frown. In what direction does your mouth go now? When we are angry, what happens to our eyebrows? If we are sad, do they move into a different position? (See Figure 1-5b.)

2. Decide on what kind of expression your clown is to have. Perhaps he will be very happy, or sleepy, or droopy. What kind of make-up should he wear? A tramp's hat and old tie, a cap with a flower, a ruffled collar? Remember that clowns often paint their eyes with make-up so they look almost like plus signs (see Figure 1-5b.)

3. After you have decided on what feeling you wish to portray in your paintings, sketch the clown's portrait onto the construction paper.

4. Paint in the entire face first, so that the area can dry before painting in detailed features. Clowns often use white makeup for their faces. While waiting for the facial area to dry, proceed to paint the hats, collars, backgrounds, etc.

5. Colors are very important. Bright, warm colors might well be used for smiling faces, and darker, cooler colors may seem more appropriate for sadder ones. (Note: Older children may wish to take two sessions for these paintings.)

6. When the painting is complete, place it in the designated area to dry.

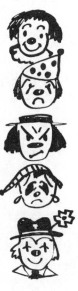

Figure 1-5b

Look Around You

Some of our clowns actually have tear drops painted onto their portraits. Others seem to have an almost crooked smile. As in real circuses, no two are the same! Can you always tell how a person is feeling by his facial expression? Sometimes, do people try to smile when they are really sad? Is it more pleasant to be with someone who has a cheerful face than with a person who always seems grouchy? Is it possible for all adults always to feel rested and happy? Do you think that we should all try to understand and be more tolerant of each

other's moods and feelings? Our world will be a happier and better place, if we do!

Adaptations

1. Arrange these portraits along a large sheet of bright mural paper. Add some balloons for a festive display.
2. Title the portraits with descriptive words connoting moods.
3. Make complete figure drawings of clowns, cut them out, and paste them onto a striped wallpaper length for an unusual circus mural.
4. Paint self-portraits, stressing emotions.
5. Add collage materials, such as yarns, sequins, buttons, etc. for striking clown portraits.

Special Bonus Lesson

Use a paper plate for the clown's face, and add construction paper hats, and tissue paper hair. Paint or crayon the features.

Through the Eye of the Artist

Show the class reproductions of portraits, particularly of circus performers. Discuss the moods and emotions the artist has conveyed, and how colors, facial expressions and background were used to achieve the artistic results.

Suggestions

Kuhn—"Clown with Black Wig," "Trio," "Dressing Room,"—and other paintings of circus performers

Picasso—"Pierrot," "Paul in a Clown Suit"

Wyeth—"A Crow Flew By"

Rembrandt—"Two Young Negroes"

Kuniyoshi—"Amazing Juggler"

Lawrence—"Vaudeville"

Glossary

Portrait: picture of a person, most often of the face

Warm colors: reds, oranges, yellows, and other colors with admixtures of these hues

Cool colors: greens, blues, violets

LESSON 1-6

The Eyes Have It

(cut paper)

Materials

construction paper—white, blue, black, brown, violet, green, grey and skin tones

black crayons or black felt markers

scissors

paste and paste sticks

chalk

scrap paper

Figure 1-6

Be Prepared

1. Pre-cut various skin-toned paper into rectangles approximately 12″ x 5″. All other colors can be pre-cut, approximately 3″ x 2″.

2. Art helpers should distribute the necessary supplies at the start of the lesson. Each student will require one piece of white paper, a piece of scrap paper, scissors, chalk, and a black felt marker or crayon. Each work area should have an assortment of skin-toned construction papers and colors suitable for eyes (see Materials). Paste can be shared.

3. A box should be ready for children to place all re-usable scraps.

4. For demonstration purposes, have several samples of expressive eyes to show the class. This will acquaint the teacher with the creative procedures of the lesson, and will provide students with visual examples of the finished project.

Introduction of Lesson to Students

Many times words describing a person's eyes are used to explain his

mood. He had "angry eyes," "droopy eyes," "shifty eyes," "friendly eyes," are phrases that we have all heard or read. How many of you think it would be possible for us to show emotions by drawing only eyes? Since the "eyes have it," let's go to work!

Procedure

1. It is important to remember that there is the white of the eyeball, the iris, and the pupil (see Figure 1-6), and that eyes are almost symmetrical or exactly even. We have already mentioned some descriptive words for eye expressions. What are some others? Surprised, frightened, happy, disgusted. For a moment let's turn from art to acting, and ask each other to portray some of these emotions, using facial expressions only. Remember, no words or sound; stress feelings through your eyes.

2. Have you noticed how automatically, eyes have changed direction or position according to the emotion someone was attempting to portray? Eyes go upwards in dismay, narrow in anger, open wide in fear. Eyebrows and lids also changed positions. Try sketching some of these eye expressions on scrap paper, until you are satisfied with several.

3. Decide on the expression you wish to convey in the final project. Draw an oval shape onto a piece of white paper. Bear in mind whether or not you are going to emphasize a more open eye, a narrowed eye, etc.

4. Cut one eye shape from the white paper, and trace it on to another white paper so that you will have two whites of the eyes, the same size.

5. Select one of the various tones of skin colors and place the two "whites of the eyes" in position onto the construction paper.

6. Use the size of the whites to help you draw each iris in a color you wish.

7. Superimpose (or place on top) these ovals (iris) onto the white eye shapes and move them into the desired expressive position (Figure 1-6). It may be necessary to cut them smaller, particularly if they are to be looking up or down. Remember, however, that both eyes will be looking in the same direction.

8. When the desired effect has been achieved, paste all parts onto the skin-toned paper of your choice.

9. Add eyebrows to accent the expression. Use chalk first, and then go over the chalk lines with black markers or crayons. Eyelids may be added, in like manner. (*Note:* eyelashes should not be overly stressed, as this tends to a cartoon look.)

Look Around You

Do you have the strange feeling that we are being stared at by all these

eyes? We truly have shown many expressions simply by changing positions and contours (shapes) of both eyes and eyebrows. We should also realize that just as we all have differences in eye shapes and colors, we all have differing emotions from time to time. When you watch a cartoon, movie or television show, from now on particularly watch for the way in which emotions are shown, especially by drawing attention to eyes. Often an actress uses eye makeup dramatically, or a camera will focus closely on an actor's eyes. Look for drawings, comics, cartoons, advertisements and illustrations that show emotions and feelings, with particular stress on eyes. Look for drawings and photographs of animals as well. Ask your family to join in, and before long we are sure to have quite a collection of eye expressions. The experience is sure to be an "eye opener" to you all!

Adaptations

1. Paste these eyes onto dark mural paper for a startling display.
2. Paint pictures of "People From Other Nations," stressing countries such as India, Algeria, Tunisia, etc. where veiled faces emphasize eyes.
3. Draw animal pictures in varying media, stressing eyes.
4. Paint family portraits, emphasizing eyes.
5. Play games of pantomine or charades, stressing eye expression.

Special Bonus Project: Eyeglass Cases

To make attractive eyeglass cases as gifts, fold a pre-cut rectangular 6″ x 7″ piece of colorful felt in half. Paste two sides with white glue or overstitch with thin wool. Cut two eye whites, iris, and brows from appropriately colored felt, and paste them to the front of the case. Once again, emphasize eye expression.

Through the Eye of the Artist

From ancient times, artists have given particular attention to portraying eyes. Varying styles, periods, colors and techniques should be discussed after viewing a variety of reproductions of art that stress the eyes of humans, as well as animals.

Suggestions

Egyptian, Roman, Etruscan wall paintings and carvings of people and
 animals
Da Vinci—"Mona Lisa"
Hals—"The Merry Lute Player," "The Laughing Cavalier"
Watteau—"Mezzetin"

Picasso—"Mother and Child"
Modigliani—"Girl with Braids"
Goya—"The Third of May"
Portraits by Rembrandt, Durer, El Greco, Titian
Rousseau—"The Sleeping Gypsy," "The Repast of the Lions"
Tamayo—"Animals"
Chagall—"I and the Village"
Sculptures by Rodin and Michelangelo

Glossary

Superimpose: to place or paint or draw on top of something

Symmetrical: equal shapes on both sides of a dividing line, which may or
may not be visible

LESSON 1-7

Private Worlds: Inner Thoughts

(free form tissue abstractions)

Materials

tissue papers—assorted colors
white bristol board, or similar
 firm paper
white glue or special collage
 glue
stencil brushes or other firm-
 bristled brushes

Figure 1-7

Be Prepared

1. Cover all work areas with newspapers for easy cleanup.

2. Pre-cut assorted tissues to about 6″ x 9″, or use smaller squares and scraps.

3. Bristol boards should be approximately 9″ x 12″. If time allotted for the lesson permits, the size can be larger.

4. Art helpers should distribute the necessary supplies at the start of the lesson. Each child will need one sheet of bristol board and a stencil brush or other firm brush. Glue may be shared. Note, however, that if white glue is used, it should be diluted in advance with water. If special collage glue is used, it may have to be diluted with *warm* water. Follow the manufacturer's instruction on the labels. Place assorted tissues at each work area. Have an extra supply available if needed.

5. It will facilitate the lesson if several tissue abstracts are made prior to the class lesson. This will acquaint the teacher with the creative procedures, and will provide the class with visual examples of the finished project.

6. All art projects are more attractive when mounted. These tissues will need a backing to prevent curling after they have dried. Have a supply of contrasting construction papers, pre-cut to the desired size, as well as a supply of staplers and staples.

7. Designate an area where the tissues can be placed to dry.

Introduction of Lesson to Students

No one ever knows fully what is in another person's mind. We all have our private world of inner thoughts. Today we are going to attempt to show some personal moods and feelings in a very visual way. You may find that as you work, your project will begin to set the mood, or you may want to pre-determine the emotion you wish to create. Whichever approach you choose, we will obtain some highly individual results.

Procedure

1. Tissue papers come in particularly brilliant colors. Even the darker blues and purples have a unique quality. Choose the tissues that you wish to use and tear them into various sizes and shapes.

2. Spread a small amount of glue on an area of the bristol board, and begin to overlap tissues therein. Choose related or contrasting hues, depending on the mood you wish to convey. Darker colors may give the effect of a stronger feeling than more muted tones. Perhaps you have not decided upon a theme, and wish to create a random design that will eventually create a mood within you.

3. Continue to paste varying shapes of tissues into place until the entire

board has been filled. Note that some of the colors will "bleed" or run into one another, creating new shapes. Different hues will also be created when one area of tissue overlaps another. Always smooth over the tissues with additional glue on top.

4. When the project is complete, place it in the designated area to dry.

5. After the tissues have dried, mount them onto construction paper.

6. Think about unusual titles for your work. Perhaps those reds and pinks make you feel as though you were "Floating on a Sunrise." "Secret Thoughts" is an excellent title for that blue and purple composition. "Colliding Colors"; "Restful Reds"; "Free Forms" are other suggestions. Be as original with your titles as you were in planning your compositions. Remember, these abstracts portray *your* inner thoughts.

Look Around You

The titles of these tissue compositions have been as different as the designs. Do you think that some people might have given the compositions different headings? Each of us can sometimes react differently to the same things. What is very serious to one person may be taken more lightly by another. How can our *outer* surroundings affect our *inner* thoughts? The colors of rooms, the choice of paintings on the walls, the music that is being played, the amount of noise in a room, are all things that can affect our moods. Discuss this with your family and listen to *their* thoughts on this subject. Our worlds of feelings and moods are private, but often it helps us to talk about them.

Adaptations

1. Display these tissue abstractions without the titles showing, and invite another class to list titles that they would suggest. Discuss the similarities and differences that are submitted.

2. When the tissues have completely dried, tempera paints or inks may be used to paint over them. Be sure to allow most of the tissue background to remain visible.

3. Play music while the tissue compositions are being made.

4. Paint or draw pictures of scenes or events that evoke pleasant or unpleasant memories.

5. Place the tissue compositions in an opaque projector for amazing effects. Show these to parents at a "Back to School Night" and ask them to suggest some titles.

Extra Bonus Project: Boutique Tissues

Tear colorful tissues, or use the leftovers from this project, and paste them over the entire outsides of small jars, such as baby food jars. Overlap the

shapes, using either special collage glue or diluted white glue. The former leaves a sheen. The latter may be spray shellacked to obtain a shine. These tissue covered jars make very attractive boutique type gifts.

Through the Eye of the Artist

Art can be a highly personal statement. Choose reproductions, particularly of abstract paintings with unusual titles, and discuss the students' reactions to the artists' themes.

Suggestions

Ernst—''The Little Tear Gland That Says Tic Tac''
Klee—''Equals Infinity''
Gorky—''Agony''
Stella—''Battle of Lights''
Gottlieb—''Frozen Sounds 2''
Marc—''The Fate of Animals''

Glossary

Free form: generally non-realistic, not representative of natural shapes

Overlapping: one object placed partially over another

Composition: the placement of shapes into a pleasing and balanced arrangement

OUR DREAMS

CHAPTER 2

Our World of Imagination and Fantasy

The threads of magic, fantasy and dreams are virtually indispensable to the tapestry of the child's world. His abilities to make believe and pretend can help him mature into a more creative and imaginative adult. To help the child express in visual forms the many marvels in the world of unreality, is the goal of this chapter.

Not only will the student be encouraged to explore many media (paints, construction paper, straw blowing, pastels, crepe paper, etc.), but he will be encouraged to utilize them in highly individual and imaginative ways. By interpreting his own fantasies through art forms, and interrelating them with the *reality* of the world, he will gain both a greater sense of self-worth and an appreciation of the wonders in nature and man-made objects. The theatrical world is also touched upon, with the inclusion of a lesson on basic costume making.

The freedom of expression, and the challenge of discovery, make these lessons highly motivating to children. Because differences in imaginative concepts are so personal and individual, the child will gain an appreciation of originality in himself as well as in others. Hopefully, by encouraging these qualities which are so much a part of the world of childhood, but today are so often neglected, the child will develop and nurture the remarkable abilities to imagine, wonder, seek, and discover in everyday experiences.

LESSON 2-1

Daydreams

(straw blowing; tempera paints)

Materials

drinking straws
tempera paints
dark paper—12″ x 18″
construction paper—assorted
 colors; 12″ x 18″
scissors
paste
tongue depressors or plastic
 spoons

Figure 2-1

Be Prepared

1. Cover all work areas with newspapers for easy cleanup.

2. Have art helpers distribute the necessary supplies at the start of the lesson. All children will need a straw, a sheet of dark paper, and a sheet of contrasting construction paper. Paints can be distributed in egg cartons or juice cans, or a central paint area can be set up in a corner of the room. Paste and scissors can be shared. Distribute several tongue depressors or spoons for each color of paint.

3. All children should wear smocks.

4. Designate an area where the students can place their finished projects to dry.

Introduction of Lesson to Students

Everyone likes to daydream. Have you ever watched clouds and imagined that they formed all kinds of marvelous things? Today we are going to create forms and shapes in a most unusual way: using straws to blow paint. Prehaps we can think of ourselves as wind, gently pushing "paint clouds" into never-to-be made again "free forms," or shapes that are not necessarily real. So, let us enter into our world of daydreams as we create some make-believe fantasies in art.

Procedure

1. Dip a tongue depressor (or spoon) into a color and dab some paint onto the dark paper. Shape the paint by placing the straw near and gently blowing it in several directions. The paint will fan out in various ways, sometimes quite unexpectedly. Do not blow too hard, as the paint may spread too far. Keep the straw from touching the paint.

2. Repeat the procedure, using varying amounts of paint, and different colors. Experiment with paints overlapping, by blowing the paints into one another (see Figure 2-1).

3. No need to worry about accidents of dripping of paints, because this will simply add to the interest of the overall design.

4. When satisfied that the composition is complete, cut it out carefully into an uneven shape, perhaps that of a cloud (see Figure 2-1).

5. Paste the shape carefully onto the construction paper, using the paste sparingly.

6. Place the straw blowings in the designated area to dry.

Look Around You

Let's look at our straw blowings. Each of us can imagine and fantasize different thoughts about each one. Do you think that the cut-out shape of the finished paintings adds interest? Some of our shapes are irregular, and often were made by accident. That is, we did not fully control the finished shape. Are irregular patterns sometimes more interesting than even and repeated designs? Would bark be as beautiful if the wood grains were perfectly straight? Can you give other examples in nature? What about man-made designs? Look for irregular patterns in wallpapers and fabrics, and compare them to geometric, or repeated, ones. Decide which ones you like better.

Adaptations

1. Display these straw blowings and have the students title them.

2. After they have thoroughly dried, ink details may be added for further embellishments.

3. Combine straw blowing with printing with found objects, such as bottle caps and sticks.

4. Crayon a free-form design, and then do a straw blowing over it. While the paint is wet, add bits of torn colored tissues to the composition.

5. Use a central theme, such as "Outer Space Flight" or "Unusual Insects."

6. These straw blowings make unusual program or notebook covers.

7. Experiment with straw blowing on wet paper, using inks alone or combined with paint.

Through the Eye of the Artist

Artists, particularly in more modern times, have experimented with free forms and colors in their paintings. Reproductions of such works, with emphasis on both the artist's techniques and use of titles, should be explored. Paintings on shaped canvas might also be discussed.

Suggestions

Masson—"Battle of Fishes"

Delaunay—"Disks" (shaped canvas)

Louis—"Aleph Series II"

Pollock—"Portrait and a Dream"

Hofmann—"Fantasia in Blue"

Picasso—"The Dream"

Stella—works on shaped canvas

Glossary

Free forms: non-representational shapes

Shaped canvas: works on non-rectangular shapes; early examples are religious paintings on altarpieces; later examples have ranged from circles to alphabet shapes, to irregular forms

LESSON 2-2

Nightmare Monsters

(egg cartons; collage)

Materials

egg cartons

18″ x 24″ dark construction papers

tempera paints

brushes

chalk

white glue

scraps of materials, wallpapers, construction papers, etc.

scissors

Be Prepared

1. Collect egg cartons well in advance of the lesson. Have art helpers cut them so that there are two cups plus the protruding part in between (see Figure 2-2a). A dozen egg cartons will yield five such shapes. Store them in a box until ready for use.

2. Cover all work areas with newspapers for easy cleanup.

3. Art helpers should distribute all necessary supplies at the start of the lesson. Each student will need at least one sheet of paper and one egg carton section, scissors, and a piece of chalk. Paints can be distributed in egg cartons, small juice cans, or a central paint area can be set up in a corner of the room. Coffee cans, partially filled with water, will aid in the quick rinsing of brushes. A variety of collage materials should be readily available, either at each working area or at a central supply station. Glue can be shared.

4. Designate an area where children can place finished projects to dry. Older children may require two sessions to complete their project.

5. All children should wear smocks.

Introduction of Lesson to Students

Have you ever had a nightmare? Sometimes we have unpleasant dreams in which strange creatures appear. Let's turn the same imagination that creates these frightening strangers into make-believe friendly monsters, that will actually be fun to create. We'll use our egg carton sections to start our imaginary beings, and who knows what will result!

Procedure

1. If you examine your egg carton section carefully, you will see that it resembles two eyes and a funny nose. With this in mind, think about a friendly monster that you would like to create. Perhaps a funny little witch, or a gigantic giant (see Figure 2-2a and b). How about a two-headed lady or a creature from outer space? If you wish to paste two pieces of paper together to form a larger one, by all means do so. Work with a partner if you prefer. Your imagination should be your guide and since we are working in the wonderful world of make-believe, anything goes.

2. Once you are satisfied with an idea, place the egg carton section onto the construction paper, and then chalk an outline of the monster's body. (*Note:* This procedure helps determine the proportionate size of the creature.)

3. Paint or cut the various parts that are needed. How about purple and pink hair for that strange witch, or green skin for that giant? Backgrounds can be painted in as well. Be sure to paint the egg carton nose and eyes *after* they have been pasted in place, as they will be too wet to handle easily. Unusual colors, sizes, and arrangements can all be utilized. It is entirely up to you.

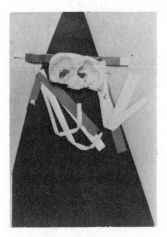

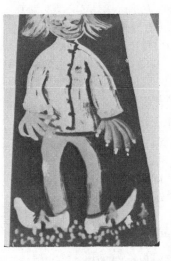

Figure 2-2a Figure 2-2b

4. When the creature is complete, carry it to the designated area to dry. Avoid unnecessary dripping of paint or collage parts dropping off, by carrying the project "tray-like" fashion.

Look Around You

Instead of being frightening, our egg carton monsters have turned out to be wonderful creatures of our imagination. How else could egg cartons be used creatively? Learn to look at real things in an imaginative way, and a whole new world will open to you. Hold a leaf up and feel its texture. Look *inside* a flower and discover colors that you may never have known were there. The next time you see a caterpillar, imagine what it would be like to be so small. How tall would a flower or tree then seem to you? Imaginative thinking and seeing will help you discover the unusual in natural and man-made things.

Adaptations

1. Exhibit the finished egg carton collages for an unusual display.
2. Use the same methods with a central theme, such as Halloween, "The World of Dreams," "Underwater Civilization," etc.
3. Let the children create new subjects, using egg cartons as the starting point. Caterpillars, flowers, etc. will emerge with amazing rapidity.
4. Use egg carton sections on masks, paper bag puppets, etc.
5. Use other media, such as chalks, to create pictures of nightmares.
6. Work in groups to create a "Mural of Monsters."

Through the Eye of the Artist

Surrealistic painters, as well as more traditional artists, have turned to the world of dreams and fantasy for the basis of many paintings. Reproductions of such art, followed by class discussions of the subject matter, techniques and effects, will enrich and expand this lesson.

Suggestions

Bosch—''Ship of Fools''
Dali—''Raphaelesque Head Exploding,'' ''Soft Self-Portrait with Fried Bacon''
Tooker—''The Subway''
Chagall—''I and the Village''

Glossary

Collage: various materials arranged in a pleasing composition and pasted onto a background

Texture: tactile quality, felt or seen

Surrealism: art movement which explores and expresses the artist's subconscious; e.g. fantasies and dreams

LESSON 2-3

Through the Magic Window

(plastic trays; mixed media)

Materials

clear plastic meat trays (from the supermarket)
crayons or oil crayons
clear tape

tempera paint
brushes
12″ x 18″ paper—white or colors

Be Prepared

1. Make a collection of clean, clear plastic food trays well in advance of the lesson. Stack them according to size until ready to use.

Figure 2-3

2. Cover all work areas with newspapers for easy cleanup.

3. Art helpers should distribute the necessary supplies at the start of the lesson. Each child will need one plastic tray and a sheet of white or colored paper. Clear tape and crayons can be shared. Paints can be distributed in juice cans or egg cartons, or a central paint area can be set up in a corner of the room. Coffee cans, partially filled with water, will aid in the quick rinsing of brushes.

4. Designate an area where children can place their finished projects until ready for display.

5. Children should wear smocks.

Introduction of Lesson to Students

Suppose we each had a magic window, and whatever we wished to look at would appear there the moment we said a secret word. What would you wish to see? A king and a queen, a castle, a pink elephant, a princess, an underwater battle? Remember, we could wish for *anything!* Let's make believe that these are not ordinary plastic trays, but very special windows. Our wishes will appear through the magic of our art!

Procedure

1. Place the plastic tray in the center of the white (or colored) paper, and lightly trace around it with a crayon.

2. Remove the tray and the outline just made will serve as the area in which your wish will be made to appear. Decide on what kind of magical scene you are going to draw. Perhaps an Indian Chief, or a magic garden, or a purple dragon? Use your imagination to help you decide.

3. Draw your magic wish inside the outline, using bright colors. Press on your crayons so that the color appears rich and even.

4. Secure the tray carefully over the drawing, by placing a small piece of clear tape over each edge of the tray onto the paper.

5. Paint an outline around the magic window, for extra accents of color. No need to worry about straight lines; allow yourself to work freely (see Figure 2-3).

6. Place your magic window in the designated area to dry.

Look Around You

The world of imagination can turn the most ordinary everyday things into very special objects. Look what has happened to our plastic trays; they have been made into special magic windows! What other things may be put to imaginative uses? Bags, boxes, paper and fabric scraps. Every time we use art materials, we are putting our imaginations to work. What are examples of make-believe things in real life? Plays, motion pictures, puppet shows, stories, television all bring imagination and creativity into our lives. One of our most important human qualities is imagination. We should use it always to the fullest of our ability, and all our world will be made more interesting!

Adaptations

1. Display these magic windows, along with original stories describing them.

2. Use the same methods to illustrate fairy tales, books, etc.

3. Use a central theme, such as holidays or historical events.

4. These plastic trays are excellent to represent aquariums. Use the same method, but limit the drawings to fish and other aquatic life.

5. Use cut paper or paint instead of crayons, to make the underlying pictures.

6. Use the same procedure to illustrate dreams.

Through the Eye of the Artist

Mysticism and magic have long been associated with the art of ancient times, as well as in many countries today. This is an opportune time to discuss such carvings, masks, artifacts and the like.

Suggestions

Egyptian, Oriental, African, American Indian, and Oceanic Art

Glossary

Mixed media: the artist's use of several materials (e.g. paint and crayon) in one creative work

LESSON 2-4

"Thing-a-ma-jiggs"

(imaginary wildlife)

Materials

dark construction paper—18″ x 24″
tempera paints
brushes
chalk
scrap paper

Figure 2-4

Be Prepared

1. Cover all work areas with newspapers for easy cleanup. Several desks pushed together will suffice if tables are not available.

2. Art helpers should distribute the necessary supplies at the start of the lesson. Each student will need one sheet of construction paper and a piece of chalk. Scrap paper should be available for preliminary sketches. Paints can be distributed in egg cartons, juice cans or a central paint area can be set up in a corner of the room. Coffee cans, partially filled with water, will aid in the quick rinsing of brushes.

3. All children should wear smocks. A discarded man's shirt, with the sleeves cut so that the child can work freely, makes an excellent cover up.

4. Designate an area where the children can place their paintings to dry. Caution them to carry their work "tray-like" fashion to avoid dripping paints.

5. If possible, have several photographs of illustrations of real animals and birds, to show the class at the start of the lesson.

Introduction of Lesson to Students

A famous poet once wrote: "a rose, is a rose, is a rose. . ." If we see a certain kind of flower, we often can identify it by a specific name. The same is true for animal species . . . or is it? Because, today our imaginations are going to take us on a journey into a jungle in the world of fantasy, where a giraffe can have a zebra's body and a bird's wings, or an elephant can be given a turtle's

body and a fish's tail. By the time we all have finished, who knows what kinds of marvelous creatures will have been created in our wonderful world of make-believe!

Procedure

1. Make several preliminary sketches of ideas for combining the features of several animals, fish, and/or birds, together. Remember, anything goes, so let your imagination work freely. Try a bird's head on the body of a fish, or perhaps a lion's head on a monkey's torso. Feathers, fins, fur can all be interchanged on these fantasy "thing-a-ma-jiggs."

2. When satisfied with an idea, sketch with chalk onto the construction paper and proceed to paint. Since these are such unrealistic animals, use unusual colors. Pink elephant heads and green lions are all possible in this very special jungle!

3. Experiment with the use of the paint brush. Less paint achieves a rather dry look, excellent for painting fur, feathers, and grass. Paint applied over an area that has not yet dried, produces muddy colors. Keep the colors clear and vivid.

4. When satisfied that the painting is complete, place it in the designated area to dry.

Look Around You

Our "thing-a-ma-jiggs" are marvelous, indeed. Each is a one-of-a-kind creature. How do we recognize real animals? By their colors, sizes, and particularly their *shapes*. If we saw only the shadow of an elephant we would still be able to identify it because we would recognize the shape of its trunk, head, and body. Can you think of examples of animal life illustrations that you have seen that are the results of other people's imaginations? Ancient mythology is filled with combined features of various beings. Would our world be as interesting if people failed to use their imaginations?

Adaptations

1. When displaying these paintings, have the children title their new species.

2. The basic approach in this lesson can be used to create unusual posters.

3. Paint these "thing-a-ma-jiggs" and have the class cut them out and paste them onto large paper for a fantastic "Jungle Jamboree" mural.

4. Play games by dividing the paper into thirds, and having students paint different parts to each animal, while passing the paper to one another.

5. Make up original rhymes and stories to accompany the paintings.

6. Limit the environs for these fantasy creatures, e.g., all underwater or underground.

7. Experiment with mixing parts to machinery (planes plus cars, etc.), people, and plants.

Through the Eye of the Artist

Examples of animals, birds, etc. that have been stylized by artists are to be found in many cultures. Reproductions of such art, along with a class discussion of effects and techniques used, will broaden the lesson. This is also an opportune time to explore mythological figures, such as centaurs, Pegasus, minotaur, etc.

Suggestions

Gargoyles—Greek, Roman, medieval

Statues, carvings—India, Africa, Oceanic, American Indian

Ancient art—Egyptian, Greek, Roman (especially mythology, e.g., centaurs)

Glossary

Gargoyles: grotesque, carved beasts and birds that served as water spouts

Centaurs: in Greek mythology, a being that is half man and half beast

Pegasus: a mythological winged horse

Minotaur: in Greek mythology, a monster having the body of a man and the head of a bull

LESSON 2-5

"If"s

(make believe drawings; pastels)

Materials

pastels
rough paper or construction paper, dark colors
dark crayons

Figure 2-5

Be Prepared

1. Cover all work areas with newspapers for easy cleanup.

2. All children should wear smocks. A discarded man's shirt, with the sleeves cut so that the child can work freely, makes a suitable cover-up.

3. Have art helpers distribute the necessary supplies at the start of the lesson. Each child will need a sheet of paper. Pastels and crayons can be shared.

4. Designate an area for students to place their finished projects until ready for display.

Introduction of Lesson to Students

The world of make-believe is a wonderful one. In it we can pretend to be anything or anybody. It can even change the simple word ''if'' into an introduction to wondrous adventures. Let us enter this exciting, unreal land, and ''if'' will be the password to an unusual art adventure.

Procedure

1. Let us make a list of sentences that begin with ''If.'' How can we complete them so that they can become the starting points of ideas for drawings of make-believe?

 a. If I were the smallest person in the world, I would

 b. If the sun shone all night ..

 c. If I were the tallest person in the world...................................

 d. If insects were larger than people ...

 e. If I lived in a snail's shell(see Figure 2-5)
 f. If I were the richest person on earth.......................................
 g. If I had but one wish ..
 h. If everything were shaped like a square...................................

Can you think of other ideas? Of course you can.

2. Choose an idea or make up one that you would like to illustrate. Fold up the bottom edge of your paper about one inch, and in dark crayon write your sentence, beginning with "If."

3. Use the chalks to make your drawings, but work carefully. Pastels give a soft, dreamlike quality, and produce beautiful colors, but tend to smudge if your hands rub over colored areas. Avoid, too, the mixing of one color upon another, because the effect is muddy in color.

4. When your drawing is complete, place it in the designated area.

Look Around You

When we began, did you think that we could possibly have come up with so many different ideas, all based on sentences beginning with such a tiny word "if"? Our imaginations have taken us into all kinds of marvelous places through our art. Do you think adults have wishes and imaginations, as well as children? Do all wishes come true? Would it be a good thing if they did? Would our lives be as interesting if we never made believe? Can we always make believe in our real world?

Adaptations

1. Various media, paints, crayons, etc. may be utilized in this same lesson. Combine these make-believe drawings with creative writing and display them for everyone to see.

2. Make booklets containing other make-believe ideas, such as original inventions.

3. Use shoe boxes to transform the drawings into three-dimensional dioramas.

4. Relate fantasy to reality, e.g., "How Can We Change Ecology?"

Through the Eye of the Artist

The world of imagination and make-believe is vital to the creativity of the artist. Each uses this ability in varying ways. Compare traditionist works with more modern ones, such as the application of imaginative uses of color, subject matter, interpretation, etc.

Suggestions

Chagall—"I and the Village"

Klee—"Twittering Machine"

Dali—"The Persistence of Memory"

Duchamp—"To be looked at with one eye, close to, for almost an hour"

Bosch—"Ship of Fools"

Glossary

Fantasy: little or no basis in reality

Diorama: small three-dimensional figures and objects against a pictorial background, often in a small box

LESSON 2-6

The Play's the Thing

(quick crepe paper costumes)

Materials

crepe paper folds—desired colors
construction paper
scissors
crayons
white glue

staplers
clear tape
yarns
glitter, metallic papers, etc.
—optional

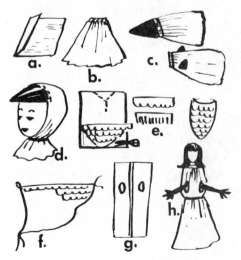

Figure 2-6

Be Prepared

1. If costumes are to be made for a specific play, an assortment of appropriately colored crepe papers and construction papers should be available.

2. Have one or two costumes made in advance of the lesson. This will acquaint the teacher with the creative procedures, and will provide the class with visual examples of the finished project. It will also provide the teacher with a sample costume to fit on to the children so that size adjustments can readily be made.

3. Provide a box in which to store any reusable scraps.

4. Each work crew will need crepe paper, scissors, yarns, glue and staplers. All supplies can be shared.

Introduction of Lesson to Students

For special parties or plays, part of the fun is dressing in a costume. These can be fun to make, and need not be difficult. So, step right this way, folks, for the show is almost ready to begin! (*Note:* The following instructions for basic customes can be adapted to specific plays as needed, or can be used as starting points for original skits.)

A. *Basic Bird, Insect or Animal Cap and Capelette*

Procedure

1. Cut a width of appropriately colored crepe paper, 18″ x 20″.

2. Fold down one edge about one inch (Figure 2-6a).

3. Gather the crepe paper together in folds, and staple them into place (Figure 2-6b).

4. Cut a desired beak, antennas or ears from appropriately colored construction paper (Figure 2-6c).

5. Staple a beak to the folded side of the gathered crepe paper (Figure 2-6c).

6. Ears or antenna can be stapled or pasted to the sides of the gathered crepe paper (Figure 2-6c).

7. Place the cap onto the ''actor's'' head, gather yarn comfortably around the neck, and tie in a bow (Figure 2-6d). Excess crepe paper will fall attractively about the shoulders, to form a capelette.

B. *Vests-Birds, Animals or People*

Procedure

1. Fold a 42″ length of a desired color crepe paper in half and cut an opening for the head (Figure 2-6e).

2. Cut two inch strips of desired colors of crepe paper, fold lengthwise, and with scissors cut scallops or fringes along one edge (Figure 2-6e).

3. Paste the strips to the front and back of the vest (Figure 2-6e). Always start at the bottom and work up, overlapping.

4. If desired, tie a length of yarn around the waist to hold the vest more securely.

C. *Wings*

Procedure

1. Cut desired shapes from large sheets of bristol board or other firm cardboard (Figure 2-6f).

2. Cover the wings with crepe paper, or strips of paper. (Figure 2-6f).

3. Attach to shoulders with safety pins, and to wrists and waist with yarn.

4. Paints, crayons, or glitter, may be added for highlights.

D. *Basic Long Cover-up.*

Procedure

1. Tape or paste two lengths of crepe paper so that it will reach from head to floor (Figure 2-6g).

2. Staple a length of yarn to one end of the crepe paper that has been gathered and stapled in place (Figure 2-6g).

3. Cut holes in the front for arms (Figure 2-6g).

4. Place costume on, and gather together so that the crepe paper comes around to the back; tie yarn around the waist. Tie in back of the neck with yarn (Figure 2-6h).

5. These cover-ups can be embellished further by the addition of cut-out shapes of metallic paper, or glitter.

Look Around You

Our costumes, although simple to make, are most attractive and colorful. Do you think it is more fun to *make* a costume than to buy one? Certainly when we create our own, each is special and cannot be bought in a store. Is the choice of color in a costume important? What makes a good costume? Are costumes worn only in plays or at parties? What about national costumes, parades, and athletic events? Can you think of more? Costumes are used in our world in many ways! Are clothes a kind of costume that is used everyday? Do clothes differ in different parts of the world? Why?

Adaptations

1. Use these costumes for plays or reverse the procedure and write skits for the costumes.

2. Adapt the costumes to specific countries or holidays, such as Thanksgiving.

3. Relate the costumes to other studies, such as mythology or medieval times.

4. Draw original costume designs in crayons or paint.

5. Make the actual costume.

Through the Eye of the Artist

Costumes of various periods of history, as well as those used in the theatre, should be discussed, along with reproductions of a variety of styles. In addition, national costumes should be shown. Tribal peoples, such as American Indian and African nations, developed their costumes into art forms which not only called for skills in weaving, bead work, etc. but also often had significant meanings, such as the central signature feather on Indian war bonnets. Ask the children to bring in any national costumes they might have at home.

Glossary

Overlapping: one object placed partially in front of another

WE ARE WHAT WE SAY

CHAPTER 3

Art Activities Related to Writing

The written word invariably conjures up picture-images in the mind of the reader. This fundamental concept can form the basis for a series of unusual art lessons that incorporate letters and words into art projects. In these lessons, alphabetical forms not only come to be seen as unusual shapes, but also as the very basis for pictorial ideas. The projects are arranged sequentially, starting with simple designs around letters, to more complex word paintings and contour drawings. In addition, there are several special bonus lessons included. The teacher should feel free to interpret the projects and adapt them to her special needs.

Although the materials used in the following activities are minimal, various art skills, such as drawing, lettering and painting will be enhanced. The goals of being able to interpret shapes abstractly as well as realistically, of stimulating design concepts, of encouraging individual thinking and observation, will be realized. Once children become involved with these projects, their verbal awareness will also be heightened, and as a result, reading and writing will take on new dimensions. Above all, boys and girls will find that ideas for their projects will come easily, and hopefully, this will lead to increasing experimentation in art.

It is likely that after utilizing these art lessons related to writing, you and your class will look upon the alphabet in a completely different and creative way. Undoubtedly a greater meaning will be given to the familiar phrase, "one picture is worth a thousand words," as the child's world of words and writing takes on a new and exciting dimension.

LESSON 3-1

Initial It

(designing around initials)

Materials

construction paper—12″ x 18″
chalk
tempera paints
brushes

Figure 3-1

Be Prepared

1. Cover all work areas with newspapers for easy cleanup.
2. Have art helpers distribute the necessary supplies at the start of the lesson. Each child will need a sheet of construction paper (dark colors, preferably) and a small piece of chalk. Paints can be distributed in egg cartons or juice cans, or a central paint area can be set up in a corner of the room. Coffee cans, partially filled with water, will aid in quick rinsing of brushes.
3. Designate an area, even if it is the hall floor, where students can place their finished projects to dry. Always have children carry their paintings in "tray-like" fashion to prevent dripping paints.
4. All children should wear smocks.

Introduction of Lesson to Students

Initials are highly personal; each one of us has his very own. Have you ever thought about the shape of your initials? If we go around the letters with

paints, we not only will create attractive designs, but form some unexpected new shapes in the process. So let's take our paper and initial it, in a different and unusual way.

Procedure

1. Write the initial of your first or last name in chalk on the construction paper. Use the side of the chalk to produce a large, broad letter.
2. Choose a color and carefully paint over the chalk letter.
3. Proceed to follow around the initial with a variety of colors (see Figure 3-1). You may wish to use all warm colors, or all cool colors. Try to keep the paints clear and bright by painting slowly and avoiding one color running into another.
4. Continue painting until the entire paper is filled with paint. (see photo).
5. When the initial design is complete, place it in the designated area to dry.

Look Around You

Our initials have become quite special because of the way in which we have painted around them. Did you discover some new shapes within your initial? How about the triangle that is formed in the upper part of an ''A,'' or the shape within a ''D,'' ''R,'' or ''B.'' Do you think the choice of color was important to the design? Where have you seen letters designed in unusual ways? How about school emblems, pennants, and book plates. Look for advertisements, stationery, book covers, etc. that use decorated letters in their design. Learn to watch for and discover unusual lettering in many of the objects that surround you in your world, every day.

Adaptations

1. Place several letter paintings together to spell out words.
2. Younger children can practice writing their names by incorporating the methods in this lesson while using crayons.
3. Older children can design special book plates or designs for school and team emblems.
4. Paint several initials on one paper.
5. Use numbers instead of letters.
6. Make personalized gift note paper by using this procedure on small sheets of folded paper. Crayons or water colors might be substituted for tempera.
7. Incorporate this lesson when making posters.

Special Bonus Project: Illumination

Older children can design illumination (see glossary) to be used decoratively or as book plates. Have the students paint or use felt markers to decorate an initial that has been crayoned or painted onto a small (about 6″ x 6″) square of bristol board or other firm white paper. Abstract designs or pictures pertaining to the student's hobbies, interests, etc. can be drawn around the initial to embellish it. If possible, gold paint should be used as highlights. Bear in mind that small brushes must be used.

Through the Eye of the Artist

Medieval manuscripts abound with marvels of illumination. Compare reproductions of such works with modern artists, and the incorporation of letters and numbers into their paintings.

Suggestions

> Indiana—"The American Dream No. 5," "I Saw the Figure 5 in Gold"
> Tobey—"Broadway"
> Davis—"Visa," "Owh! in San Pão"

Glossary

> Illumination: developed as an art form in medieval monasteries and churches, illumination consists of the embellishment of letters with colors and intricate designs, usually incorporating gold

> Warm colors: reds, oranges, yellows, and other colors with admixtures of these hues

> Cool colors: greens, blues, violets

LESSON 3-2

From A to Z

(pictures from letters)

Materials

construction paper or drawing paper	crayons
	scrap paper

Figure 3-2

Be Prepared

1. Art helpers should distribute the necessary supplies at the start of the lesson. Each child will need a sheet of paper. Crayons can be distributed in empty T.V. dinner trays, and can be shared. A supply of scrap paper for the sketching of preliminary designs, should be available at each work area.

2. Make several alphabetical drawings in advance of the lesson. This will acquaint the teacher with the creative procedures, and provide the class with visual examples of the finished project.

3. Designate an area where the finished drawings can be placed until ready for display.

Introduction of Lesson to Students

Letters are mostly used to spell words that describe objects or living things. Have you ever thought about the fact that these same alphabetical symbols can also be used as the basis for *drawing* objects as well? In fact, the letter "U" is a great deal like *you*. Let's find out how!

Procedure

1. Choose three or four letters from the alphabet and write them on scrap paper, using crayon. Study them for a while and try to draw an object or living thing using the contour, or shape, of each letter as the basis of the picture.

2. Turn the letters in varying directions, upside down, sideways, backward or combine several together. For example, two capital letter "B's" placed back to back become the wings of a butterfly. An "A" can form the hat

and part of the hair of a fierce witch. A "Y" becomes the trunk of a tree, and a "V" forms the head of a deer. Other ideas are: two "O's" together to make a bird, a "C" to begin a puppy's head and a "T" as the basis for a scarecrow (see Figure 3-2 for all these examples).

3. Experiment with ideas. An upright "U" can become a head, an upside down "U" the torso, and two "L's" legs for a figure drawing. Try a picture of yourself using this method and "U" will almost become YOU (see Figure 3-2).

4. Choose one of your ideas and draw it onto regular paper, stressing details, color and line. Perhaps you would like to embellish your alphabetical drawing by adding backgrounds as well. Above all, feel free to explore and make new shape discoveries within the letters!

Look Around You

It is easier to form pictures from some letters than others. What in the room resembles an "O"? The clock, that ball, the globe, the door knob. What are things that resemble a "U"? How about eyebrows (inverted "U's") or a smiling mouth? What about an open umbrella or a tulip? Can you begin to see other things that are similar to alphabetical letters? Ask your family to help you find and list things that look like various letters. It can become quite a family project, and can open doors to a whole new world of seeing things in a different way!

Adaptations

1. Exhibit the alphabetical drawings and title them "Find the Letters."

2. Distribute sheets of paper with a single large letter pre-inked with felt markers, and ask students to draw or paint a picture around it.

3. Make a highly original "Book of the Alphabet" using the procedures in this lesson.

4. Collect magazine pictures and play games of "Find the Look-Alike Letter." The team or person who can find the most objects or living things within the picture that resemble letters wins the game.

5. Use the letter "U" as explained in this lesson to do a series of figure drawings or portraits.

6. Cut letters from advertisements, paste them onto paper, and draw pictures around them.

Through the Eye of the Artist

Show a series of art reproductions, and along with a discussion of form, line and composition, look for parts of the paintings or sculpture that can indeed be simplified into a letter of the alphabet. It not only will be fun for all, but will stimulate a more astute ability for observation.

Glossary

Composition: the placement of shapes into a pleasing and balanced arrangement

Form: solid shapes and masses

Contour: an outline that forms a pictorial shape

LESSON 3-3

Everyone Loves a Rebus

(crayon puzzle drawings)

Materials

paper—preferably white
crayons
scrap paper
pencils

Figure 3-3

Be Prepared

1. Have art helpers distribute the necessary supplies at the start of the lesson. Crayons can be shared; each child will need one sheet of paper and a pencil. Scrap paper should be available for the sketching of preliminary ideas.

2. These drawings are quite attractive on rectangular shaped paper. If this is to be done, pre-cut papers approximately 6″ x 18″ to facilitate the lesson.

3. Several rebus drawings should be made in advance of the lesson. This will acquaint the teacher with the creative procedures and provide the class with several visual examples of the finished project.

4. Designate an area where students can place their finished projects until ready for display.

5. Note: It is often a good idea to gear these rebus drawings to a central theme, e.g., ecology. Valentines, Mother's Day, etc.

Introduction of Lesson to Students

A rebus is a kind of puzzle-picture. Letters are combined with drawings to form sentences or phrases that are read by adding or subtracting letters to small drawings. Let's have some fun as we combine art with a little spelling and simple math to create rebus drawings.

Procedure

1. Use scrap paper to work out a rebus drawing. It is helpful to write out the phrase that is to be illustrated before starting on the rebus. Titles of songs, idiomatic expressions, or simple sentences can all be used for the basis of the rebus.

2. Proceed to draw the rebus by adding or subtracting letters to pictures. For example, the word "would" can be drawn by illustrating a wooden board. "That" can become T plus the drawing of a hat. (See Figure 3-3 for the full phrase: "Would You Be Mine.")

3. When satisfied that the rebus has been designed completely to your satisfaction, draw it lightly onto the white paper, using a pencil.

4. Outline and color all areas of the rebus.

5. Place the drawings in the designated area, when completed.

Look Around You

Our rebus-illustrations actually replace the usual written word. We have all seen special signs that use shapes of objects instead of words. Bus stops often are recognizable by a sign showing a silhouette or shape of a bus. Shapes are also used for marking school crossings, bicycle paths, horseback riding trails, gasoline stations and camping grounds. Name some others. Can you think of times that you have seen art used as part of writing to illustrate an idea more fully? Think about advertisements, book covers, etc. What would your world be like if there were no writing or words?

Adaptations

1. Use these rebus drawings to write original stories.

2. Holiday cards may be illustrated in this manner.

3. Play games of "Sound Alike Words." The team with the most drawings of words that sound alike, but have different meanings, wins. For example: see-sea; beat-beet; night-knight; too-two, read-red, etc.

4. Unusual posters can be created using rebus illustrations instead of the more usual kinds of printing.

5. Create a giant rebus on mural paper to announce an upcoming school event.

Special Bonus Project: Symbolic Art

Follow up this lesson by creating symbolic art. Cut paper is most effective in creating silhouettes of objects that can be related to Fire Prevention, Seasons, etc. Another idea is to create symbolic signs to designate school areas, such as the cafeteria, auditorium, etc. A contest might be held to choose the most effective symbol for each specified place.

Through the Eye of the Artist

Throughout time, pictorial symbols have been linked with alphabetical symbols. Examples of Egyptian hieroglyphics, Oriental brush lettering, and American Indian writings will enhance this lesson.

Glossary

Silhouette: the contour of a form or object usually filled with black

LESSON 3-4

It's Idiomatic

(pictures from idioms)

Materials

white or manila paper
crayons and/or felt markers
scrap paper

Figure 3-4

Be Prepared

1. Art helpers should distribute the necessary supplies at the start of the lesson. Each child will need one sheet of paper. Crayons and felt markers can be shared. Scrap paper should be available for the preliminary sketching of ideas.

2. Make several drawings of idiomatic expressions in advance of the lesson. This will not only serve to acquaint the teacher with the creative procedures, but will also provide the class with visual examples of the finished project.

3. Designate an area for students to place their finished drawings until ready for display.

Introduction of Lesson to Students

Our language contains many idiomatic expressions. These are expressions that are special to our language, that seem very strange to foreigners—indeed, often we are not conscious of how funny they are when taken literally. Let's transform some idiomatic expressions into drawings, and you will soon see what we mean!

Procedure

1. Let us list on the board some examples of common idiomatic expressions.

> He put his foot in his mouth (see Figure 3-4).
> She has a green thumb.
> Button your lip.
> That's a horse of a different color.
> He has his head in the clouds (see Figure 3-4).
> She has eyes in the back of her head.
> I'm all thumbs.
> They tried to beat the clock.
> Her head is spinning.
> She's green with envy.
> He's purple with rage.

2. The list can go on and on. Choose one of our listed idiomatic expressions or think of one that has not been mentioned. Sketch an idea that will clearly illustrate your choice, without the use of words.

3. When satisfied, make a more detailed drawing on white paper. Colors will be important, so use your crayons or felt markers thoughtfully and carefully. Color in sections fully and smoothly by crayoning or inking in one direction for each area.

4. Write the full expression illustrated in your drawing on the back of it, and place it in the designated area.

Look Around You

There are many, many idiomatic expressions within our own language that are common to us, but not readily understood by people from other nations. All cultures have such expressions. Perhaps your parents or grandparents can tell and explain such sayings to you. Learn to listen carefully for such expressions, and have the fun of visualizing them, in addition to understanding them verbally. Our drawings were not realistic pictures. Can you think of times that you have seen unrealistic illustrations? How about cartoons, motion pictures and advertisements? Where else? Do you think language is a very important part of your world? Have you ever thought about that before?

Adaptations

1. Display these drawings along with a list of the expressions illustrated. Invite other classes to match the idiomatic expressions to the drawings.

2. Gather the drawings together to form a booklet of idiomatic expressions.

3. Enlarge the drawings to create striking paintings.

4. Use the basic ideas of the lesson to create topical cartoons.

Through the Eye of the Artist

Non-representational styles of painting might well be introduced along with this lesson. Fauvism, Surrealism, and Dadaism are several suggestions. Discuss how these unrealistic styles heighten the effect of the paintings.

Suggestions

Fauvism—works by Roualt, Derain, Vlaminck, Dufy and Braque

Surrealism—works by Dali, Klee, Ernst, Blume and Tanguy

Dadaism—works by Duchamp, Ray

Glossary

Idiomatic: a mode of expression special to a particular language or person

Fauvism: art movement in which the artists worked freely, often shunning natural colors for unusual and bold hues

Surrealism: art movement which explored and expressed the artist's subconscious, e.g., fantasies and dreams

Dadaism: an art movement founded in 1916 as a protest against all conventional and traditional art forms, which became the base for much of later twentieth century art

LESSON 3-5

One Picture Is Worth

a Thousand Words

(paintings made from words)

Materials

paper—12″ x 18″ or larger
tempera paints
brushes
chalk
scrap paper

Figure 3-5

Be Prepared

1. Cover all work areas with newspapers for easy cleanup.

2. Art helpers should distribute the necessary supplies at the start of the lesson. Each student will need a sheet of paper and a piece of chalk. Paints can be distributed in egg cartons or juice cans, or a central paint area can be set up in a corner of the room. Coffee cans, partially filled with water, will aid in quick rinsing of brushes. Scrap paper for the sketching of preliminary ideas should be available at each work area.

3. All students should wear smocks.

4. Note: This particular lesson works especially well when a central theme is established, e.g., seasons, holidays, ecology, emotions (fear, happiness, etc.).

Introduction of Lesson to Students

We have all heard the expression "one picture is worth a thousand words." Today, let's have words actually become *part* of the picture. Indeed, nouns, verbs, and adjectives can be the starting point for our drawings. Let's see how it can be done!

Procedure

1. If a central theme is to be used by the entire class, list words that relate to it. For example, Halloween evokes words such as: *fear, boo, scream, witch,* etc. However, almost any word can be used as the basis of a drawing.

2. Choose several words and write them onto scrap paper. Study them for a few minutes and let your imagination work freely to create pictures that relate to the words.

3. Choose a word that particularly appeals to you, and sketch an idea that incorporates the letters into the drawing. "Scream" might be illustrated by using the "s" as part of an ear, "c" to form a mouth, and the remaining letters graduated in size to simulate sound (see Figure 3-5). The "V" in "vanilla" resembles an ice cream cone, and by opening an "e" that swallows "a" and "t", the word "eat" takes on a particular visual meaning. (see illustration) Other ideas for word paintings might be "boo" (the two "o's" forming ghost eyes, or pumpkins); the word "tall" drawn with long thin letters, surrounded by tiny houses and trees; the word "small" done in quite the opposite manner. Above all, experiment and feel free to work as imaginatively as possible.

4. Draw the final idea onto paper with chalk, and proceed to paint the various parts of the composition, placing particular emphasis on clear letters. Backgrounds and small details can be added to embellish the paintings further.

Look Around You

After painting these word pictures, we have a better understanding of how words form pictures in our minds. These images help to emphasize the meaning of the words. Do you think the size and style of the lettering were important to each of our pictures? Was color important as well? Watch for advertisements, signs, posters, etc. Think about whether the particular lettering used relates to the subject matter or helps to make it more meaningful. Observe book illustrations more carefully. Do they fully give the meaning of the story? Letters and words are a constant part of our world. Have you ever thought about how many ways they are used?

Adaptations

1. Display these word pictures along with original titles and short stories.

2. Have the class work in groups on larger word paintings related to specific themes.

3. Use other media, such as felt markers or oil crayons on fabric.

4. Substitute groups of numbers for letters.

5. Create unusual greeting cards (Valentine's, Mother's Day, etc.), using the approach in this lesson.

6. Divide into 12 groups and make an illustrated class calendar, painting word pictures for each month.

Special Bonus Lesson: Haiku

Follow up this lesson on creating pictures from words with an introduction to Haiku, the Japanese poetic form. This poetry usually consists of 17 syllables and is written to convey a poetic bond with nature. Have the children research Haiku and with a little practice they will soon be able to write their own. Paintings or drawings of these nature images will bring a new dimension to understanding the relationship between the written word and visual images.

Examples

"I soon shall go seeking the sun. . . .
Starkly grey clouds have covered my sky."

"So bare.
Gently falls the snow,
Quietly cloaking the limbs of the tree."

Through the Eye of the Artist

Lettering, incorporated into paintings, has been a hallmark of many modern day artists. Introduce reproductions, also, of other periods wherein writing has been an integral part of the overall composition.

Suggestions

Works by Warhol, Davis, Tobey, Indiana, Hopper, Kingman
Illumination (see *Glossary*)
Paintings by American Indians
Egyptian hieroglyphics
Oriental calligraphy

Glossary

Illumination: developed as an art form in medieval monasteries and churches, illumination consists of the embellishment of letters with colors and intricate designs, often incorporating gold

LESSON 3-6

It's in the Outline

(words in contour drawings)

Materials

paper—12″ x 18″ white
felt markers—assorted colors
pencils—with erasers
scrap paper for preliminary
 sketches

Figure 3-6

Be Prepared

1. Art helpers should distribute the necessary art supplies at the start of the lesson. Each child will need a sheet of paper and a pencil. Felt markers can be shared. Scrap paper should be available at each work area.

2. All art work looks more attractive when mounted on contrasting paper. If possible, have a supply of staplers and construction paper somewhat larger than that used for the drawings so that children can mount their finished projects.

3. Designate an area for students to place their finished work until ready for display.

4. Tape a sheet of white paper to the board or bulletin for demonstration of the procedures in the lesson.

Introduction of Lesson to Students

Would you like to try something very different, today? Usually, if we make a contour drawing, we do it by making a linear outline of the shape of an object. These lines can be made more interesting by varying their width and color. But today, we'll be drawing pictures using *words* to form outlines! We'll demonstrate what we mean.

Procedure

A. For demonstration purposes, let's take the simple noun "dog." What are some words that you can use to describe this animal? Friend, furry, bark, collar, love, tail, wag, are some words that come quickly to mind. Now, if we lightly draw the contour, or shape of a dog with pencil, we can then proceed to write the words we have just listed, along the outline. Colors, lettering styles and sizes, can all be used to create interest and variety (see Figure 3-6).

2. What are some other ideas that might be used as the basis for a contour word drawing? Ship, fish, lion, giraffe, clown, bird, flower, castle, elephant . . . the list is almost endless!

3. Jot down on scrap paper several subjects that interest you and make small preliminary sketches of them. Remember, the more unusual your choice of phrases, the more interesting the final results will be.

4. Draw an outline, lightly in pencil, upon the white paper of the subject that you finally choose. Mistakes can be easily erased and corrected.

5. Now for the real fun. Go over the contour drawing with various words that will describe or relate to the picture subject. This can be done in (pencil) first, or work directly with the markers. Remember to make the drawings more interesting by varying the colors and kinds of lettering. Words and colors can, of course, be repeated. Areas also can be filled in with words. For example, a fish might have its entire shape filled with words such as: swim, ocean, water, catch, etc. A lion's mane might be drawn with phrases such as: roar, strong, fierce, and king. A flower would lend itself to outlines of terms such as: green, fragrant, colorful, bouquet, blossoms, etc. As you work, more and more ideas will come to you.

6. Continue to work in this manner until you feel all that you wish to outline has been filled with descriptive words.

7. When the ink is dry (a few minutes), erase all pencil marks.

8. Staple your finished art onto a piece of construction paper.

Look Around You

How often do you see letters and words as part of your daily surroundings? How about bill board signs, store signs, advertisements on public transportation, posters and the like? What about all the times that printed words appear on television? We all see words and letters in books, magazines, and newspapers, both at home and at school. What about the printing on the sides of trucks, or on the covers of record albums? Let's make a collection of reproductions of art, in addition to unusual advertising examples (such as shopping bags) that include lettering as an important part of the design. We can include wallpaper samples, and fabrics too. We're going to be surprised at the many ways in which lettering is used for creative effects in our world!

Adaptations

1. Display all finished projects for a most unusual bulletin exhibit.
2. Have students work in groups to make larger, striking word contour drawings.
3. Try using paints, or combining varied media for more colorful, dramatic effects.
4. Relate all drawings to one subject, such as "ecology" for an unusual class project. (See Chapter 4 for other ideas.)
5. Make booklets of contour word drawings for a unique addition to the school library.
6. Enhance original stories and poems by illustrating them with word contour drawings.
7. Use the project for posters, covers for school programs, etc.

Through the Eye of the Artist

Incorporating letters or words into a work of art has intrigued many artists. Select reproductions that illustrate this and discuss how the lettering enhances and emphasizes the composition of the paintings, as well as the use of letters in a realistic or abstract manner.

Suggestions

Davis—"Visa"
Kingman—"Angel Square"
Gris—"Breakfast"
Lichtenstein—"Good Morning, Darling"
Hartley—"E"
Demuth—"Business"
Hopper—"Nighthawks"

Glossary

Contour: an outline that forms a pictorial shape

LESSON 3-7

What's in a Name

(abstract calligraphy)

Materials

construction paper—12″ x 18″
tempera paints
brushes
chalk
scissors—optional

Figure 3-7

Be Prepared

1. Cover all work areas with newspaper for easy cleanup.

2. Art helpers should distribute the necessary supplies at the start of the lesson. Each student will need a sheet of construction paper and a piece of chalk. Paints can be distributed in egg cartons or juice cans, or a central paint area can be set up in a corner of the room. Coffee cans, partially filled with water, will aid in quick rinsing of brushes.

3. All children should wear smocks. A discarded man's shirt, with the sleeves cut so that the child can work freely, makes a suitable cover-up.

4. Designate an area, even if it is the hall floor, for students to place their finished paintings to dry. Caution children to carry their projects in ''tray-like'' fashion to avoid dripping paints.

Introduction of Lesson to Students

What's in a name? Is it merely a certain grouping of letters? Or can those same alphabetical symbols be used as shapes to create surprisingly unusual designs? Let's find out.

Procedure

1. Use the letters in your first name as the basis for your design. Write the letters in chalk, placing them in upside down or sideways positions, or over-

lapping (see Figure 3-7—"Edward"). Mix lower case letters with capital ones, or write your name in script (see Figure 3-7—"Karen").

2. Start to paint the letters in varying colors, covering the chalk completely.

3. Proceed to paint around the letters, thinking of them as shapes. Use contrasting, bright colors. As the paint dries, embellish the shapes that have been created with lines, dots, etc. (see Figure 3-7).

4. When the painting is complete, carry it to the designated area to dry.

5. Perhaps you would like to cut out your name design into an interesting shape (see Figure 3-7—"Karen").

Look Around You

Using calligraphy, or fancy lettering, as a basis for design, we have created interesting and varied shapes. Even though many of us have similar letters in our names, and a few of us even have the same name, each design has been different! Some letters such as B, or R, have shapes within them. Where else can you find shapes within shapes? Look around you. The openings in the pencil sharpener, the handles of scissors, the spirals on those notebooks. Where else? How about foods, such as pretzels and doughnuts? Look around the room again. How many different kinds of lettering do you see, on posters, books, boxes, etc? Look at home, too, and discuss this with your family. See how many new shapes within shapes, and different kinds of letters you can discover together.

Adaptations

1. Exhibit these highly original name designs for a colorful display.
2. Experiment with other media, e.g., black ink on white paper.
3. Use words related to a theme, such as fire prevention or a holiday.
4. Work with partners to create large word abstractions.
5. Explore the use of various types of lettering.

Through the Eye of the Artist

Lettering and calligraphy have often been incorporated into works of art. Reproductions of such works, along with a discussion of how the letters become parts of the overall design, will greatly enhance this lesson.

Suggestions

Oriental brush paintings, including calligraphy

Tobey—"Broadway"

Davis—"Visa"

Indiana—"The American Dream No. 5," "I Saw the Figure 5 in Gold"

Hartley—"E"

Tomlin—"In Praise of Gertrude Stein"

Holbein—"Portrait of a Member of the Wedigh Family"

Glossary

Calligraphy: elegant lettering or penmanship

Lower case letters: small letters such as a, b, c

Capital letters: large letters, such as A, B, C

LESSON 3-8

Marked Personal

(spool print stationery)

Materials

wooden sewing spools
assorted drawing inks
water color brushes
tissues or toweling
cans of water
paper—approximately 6″ x 9″
felt markers—assorted colors

Figure 3-8

Be Prepared

1. Make a collection of empty wooden sewing spools well in advance of the lesson. Local tailors and dry goods stores often will be pleased to save the spools for school use.

2. At the start of the lesson, art helpers should distribute the necessary supplies. Each child will need one spool, a brush, and several sheets of paper. Each work area should also have several bottles of ink in various colors, and an assortment of felt markers. Coffee cans, partially filled with water, will aid in

quick rinsing of brushes. Tissues or toweling should also be available for wiping excess water from brushes.

3. A supply of scrap paper will facilitate preliminary experimentation with spool printing.

4. Designate an area for children to place their stationery to dry.

Introduction of Lesson to Students

The stationery departments in stores stock a great variety of papers, styled and designed to meet most tastes. Why not create our own writing paper? Not only will it be fun to make, but we will all have personal stationery that is not to be found anywhere else.

Procedure

1. Decide if you would prefer stationery that is folded or on single sheets. If the former is your choice, simply fold several sheets of paper in half, and print your design only on the front flaps. If single sheets are to be used, a design might be placed on the top, along the bottom, or even along the side. Bear in mind that room must be left for writing space.

2. Brush a color of ink over the top of the empty wooden spool, and press the spool onto the paper. A shape similar to a doughnut will be imprinted (see Figure 3-8). Experiment with several combinations of circles and overlapping shapes. Then add features and details to the imprints with felt markers, to form a picture or design (see Figure 3-8). Perhaps flowers in a variety of colors across the top of a sheet of paper, or several birds, will be your final choice of an idea. Remember, however, to rinse off the brush after each color. Both ends of the spool can be used, but it is a good idea to apply only one hue to each end, in order to keep the colors clear and bright. Share the spools, so that one or two spools at each work area can be used for red, another for black, etc.

3. When you have decided upon one or two designs, print them onto the folded (or unfolded) sheets of paper. Place each sheet of stationery in the designated area to dry as it is completed.

Look Around You

Why do you think people enjoy choosing stationery that has a design or picture imprinted upon it? Are business letters ever written on colored or patterned paper? Are such letters as personal as private correspondence? Look around the stationery departments of stores and observe the many kinds of papers that are available. Look, too, for initialed or personalized papers. Ask your parents to show you the stationery that they have chosen to use. Discuss what you like or dislike about the various designs you see. Our world is filled with designs and patterns; we should learn to choose the ones we find most pleasing and attractive.

Adaptations

1. Spool-imprinted stationery makes ideal gifts. They may be wrapped in cellophane or small plastic bags for neat packaging.

2. Add initials or names to the stationery with felt markers for greater personalization.

3. Make pictures using spool printing.

4. Tempera paints may be used in place of inks. The same procedure is used, but the paints should not be too thin.

5. Make covers for programs, scrap books, etc., using the methods in this lesson.

6. Cloth may be imprinted in the same manner to produce wall hangings, handkerchiefs, scarves, etc.

7. Make up a sample book of stationery that the class has made and place orders as a class fund-raising project.

8. Design wrapping paper by printing with spools onto tissues.

Through the Eye of the Artist

Examples of commercial art, particularly stationery, cards, etc., should be brought to class and discussed. This might well be an opportune time to explore the designing of stamps, post cards, and other items used in mailing. If possible, reproductions of letters and cards used in by-gone times, or by historical figures, should also be shown to the class.

Glossary

Printing: the process of stamping a design, picture, or letters upon a surface

WE ARE AWARE
OF OUR ECOLOGY

Re-cycling

Words, like fashion, come in and out of vogue. "Ecology," however, is a term that will have bearing on our world for years to come. Boys and girls are concerned about pollution and know the importance of re-cycling material as a way of lessening it.

This interest in their environment, on the part of even the youngest of school children, can provide the starting point for a series of highly motivating art projects. Youngsters are particularly eager to participate in activities that stimulate their imaginations to find new and creative uses for old and familiar materials.

The lessons in this chapter not only increase the child's awareness of his environment, but will encourage him to discover tactile and visual qualities inherent in ordinary objects and fabrics. In addition, the abilities to cut, shape, paste, and create forms will be developed.

An extra bonus to teacher and student alike is that the materials used in these projects are readily available and are usually of nominal or no cost at all.

Above all, the projects will be exciting, for not only will they be individual in concept, but what is produced will be both decorative and functional, as the result of young artists at work re-cycling objects that were discarded as worthless.

LESSON 4-1

Supermarket Funny Faces

(vegetable trays and cast-offs)

Materials

empty vegetable—fruit trays from the supermarket

collection of materials found in markets—bottle caps, string, egg cartons, corks, scraps of tissue, etc.

strips of newspaper—approximately 1″ wide

white glue

scissors

tempera paints

brushes

water, for cleaning brushes

12″ x 18″ colored construction paper (one sheet per child)

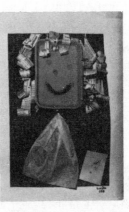

Figure 4-1

Be Prepared

1. Have work tables covered with newspaper for easy cleanup. Individual desks, or several pushed together, will suffice if tables are not available.

2. Have a central supply area with boxes of sorted materials.

3. Have group helpers selected who will distribute the necessary materials at the proper time.

4. Provide each child with a vegetable tray, scissors, and a selection of some materials (e.g., bottle caps) to start. This will prevent everyone crowding the supply center at one time. Glue may be shared.

5. Pre-cut ½″ wide, full length strips of newspaper.

6. Paints can be distributed in egg cartons, juice cans, or a central paint area can be permanently set up in a corner of the room. Clean plastic food containers make excellent paint receptacles. Coffee cans, partially filled with water, will aid in quick rinsing of brushes.

7. All art projects look much more attractive when mounted. If possible, have a supply of 18″ x 24″ white, or contrasting, construction paper, plus

staplers, available as backing for the finished works of art. Older children can mount their own projects. The teacher, or a group of upper grade art helpers can mount younger children's works.

8. Have an area (even if it is the hall floor) to spread finished art projects out to dry. Lifting of pasted collages too soon will cause unnecessary "drop offs."

Introduction of Lesson to Students

Save those trays! Save that string! Save those bottle caps! Save everything and anything that is readily available at the local supermarkets. Make a collection with your class, well in advance of the lesson, and sort the materials in boxes.

Have the class discuss how they could use the materials to create "Supermarket Funny Faces." Could bottle caps be used for eyes? What about a part of an egg carton for the nose? How about hair? Strips of newspapers pulled gently along the edge of an open pair of scissors make wonderfully wild and curly hair. Crumbled tissue or torn strips of brown paper bags will work. What about making eyeglasses from wire bent into shape? Remember, everything we use will be cast-offs from the market.

Excitement is sure to grow as you hold up an empty vegetable tray and demonstrate some techniques for turning discarded materials into inventive collages!

Procedure

1. First, paste the container on to a piece of construction paper. Bright colors are most exciting to children. Allow room for a neck or shoulders, if desired.

2. Start to arrange the features of the funny face: cork eyes, an egg carton part nose, bottle caps for teeth, jar lids for ears, crumbled newspaper for hair, etc. How about a twisted piece of tissue for a tie? Imagination is the keynote and each child should be encouraged to create his own supermarket funny face.

3. Details, such as eyelashes or freckles, can be painted in.

4. Be available! Walk around and encourage children to try unusual combinations of materials. Let them try several ideas before doing their final pasting. Laugh with them, frown with them! Discuss variations in expression. Remember, this is a fun project!

Look Around You

The next time you go to the supermarket, take a piece of paper and pencil along and list all the materials you see that you didn't use in making your funny face today. Let's combine our lists and see what new ideas we can come up

with. Maybe Mother and Dad will join in and you can make a family project at home. Think about all these things we used today that ordinarily would have been thrown away. Do you think we have found a new way of re-cycling?

Adaptations

1. Try the same basic procedure to create animal and bird fantasies.

2. In upper grades, try a mural by pasting the heads on to large mural paper, and adding bodies with paint and pasted materials.

3. Paste two sheets of 18″ x 24″ paper together to form a large rectangle. Using the trays for heads, have students create, individually or with a partner, their own supermarket characters.

4. Create two- and three-headed monsters in the same manner.

5. Explore the use of the trays for other parts of the body (e.g., football shoulder pads).

6. Have a local supermarket display some of the finished projects. Thereby the community will be aware of your ecology-minded students, and the young artists will have the pride of seeing their work on display.

Through the Eye of the Artist

Many artists like to add a touch of humor to their paintings and sculpture. Collect reproductions that will illustrate humor in art, especially those that illustrate the use of found objects as part of the design.

Suggestions

Sculpture:

 Picasso—"Baboon and Young," "Woman with a Pram," "Goat"
 Lipchitz—"Figure"
 Indian Art—especially masks
 African Art—sculpture and masks

Painting:

 Picasso—"Three Musicians"
 Dubuffet—"Snack for Two"
 Klee—"The Crooked Mouth and the Light Green Eyes of Mrs. B."

Glossary

 Collage: various materials made into a picture or design and pasted on a background.

 Found objects—easily found and often cast-off materials that can be incorporated into creative projects

LESSON 4-2

Light-Bulb Ladies and Gentlemen

(cans and light bulbs)

Materials

empty (clean) 6-oz. frozen juice
 cans
bottles of white glue
scissors
scraps of bright felt, burlap and
 other fabrics
yarn
pre-cut felt rectangles 3⅝″ x
 7½″ in a variety of colors
collection of 40-150 watts stand-
 ard light bulbs.

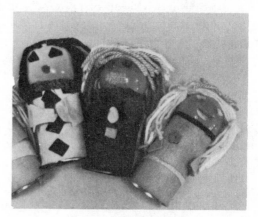

Figure 4-2

Be Prepared

1. Start a collection of clean, washed 6-oz. juice cans, as well as used standard light bulbs, well in advance of your lesson. *Note*: check to make sure that the cans are opened smoothly, with no jagged edges. A good source of used bulbs is the maitnenance departments of local stores.

2. Caution the children to handle light bulbs very carefully, because they are so fragile. Should an accident occur, be prepared with a dust pan and broom. Store all bulbs, until ready for use, in a box between layers of newspapers. Once the children know that they are going to have a "surprise" art lesson using light bulbs, you will be amazed how quickly the collection grows.

3. To facilitate the lesson, have a pre-cut assortment of 3⅝″ x 7½″ pieces of felt. These will fit precisely over the cans. They can be cut easily and quickly, four or five at a time, on a standard paper cutter.

4. Have containers of yarn and scraps of felt at each work area.

5. Have art helpers ready to distribute necessary supplies (a light bulb and juice can to each student; glue, scissors, etc.), at the beginning of the lesson and to collect supplies at the end. Have extra bulbs available.

6. These same helpers can be in charge of properly closing the bottles of liquid glue.

7. Allow time for cleanup!

Introduction of Lesson to Students

We have quite a collection of light bulbs and juice cans! Let's examine them. How do you think they could possibly be used to create people? The light bulb *does* resemble a head and a neck! And it surely does fit into the top of the can, which can be used as the body.

Let us think of a real person. He can be seen from all sides. He can be young or old, happy or sad, hairy or bald. But let's create our own people. They can be seen from all sides too. They will be three-dimensional, in fact, they will be small pieces of sculpture. But we'll be using our imaginations and so our light-bulb ladies and gentlemen can be purple-haired and orange-lipped. They can be full of fantasy, or they can resemble people we know—maybe even ourselves. We can cut strips of felt for hands and have our people holding flowers or newspapers or even a fish!

Anything goes—so let's get started! But remember, our bulbs are fragile, so handle them with care!

Procedure

1. Demonstrate how to make a "frame" of glue by outlining the felt rectangle with white glue straight from the bottle. Start about ¼″ from the edge of the felt to allow for the spread of the glue. Remember to use the glue sparingly.

2. Carefully place the felt over the can and press firmly. It's a good idea to have the children count to ten silently while holding the felt in place.

3. Keep in mind that the seam of the felt will be the back of the light-bulb person.

4. Rim the opening of the can with glue.

5. Gently press the light bulb into place, and again, hold for a silent count of ten.

6. Decorate the head and body with bits of yarn and cloth. Be as imaginative and decorative as you can.

7. Arms and hands may be cut from other scraps and glued into place. Objects such as flowers, books, etc. may also be fashioned from these materials, and glued to the hands.

Look Around You

Have you ever given much thought to the common light bulb? After all, we use them every night, and often during the day. Do they come in only one size and shape? How many different shapes of light bulbs can you think of? What about flashlight bulbs, holiday and ornamental bulbs, not to mention

sewing machine and fish tank bulbs. And let's not forget neon lights. These marvelous tubes probably come in the greatest variety of shapes and sizes of all! Indeed, the list can go on and on.

How many ways can you think of where lights are used for decoration as well as utilitarian purposes? What about chandeliers and lamps? How important is lighting to a puppet show or other theatrical productions? How often do we make use of colored lights? Are all bulbs smooth in texture? Are bulbs always fragile? When broken, bulbs might be harmful. Can you think of things in our world that offer pleasure but also may be dangerous? Fire, deep water. What else?

Perhaps we shouldn't take the simple light bulb so lightly any more.

Adaptations

1. These charming light-bulb people make delightful holiday gifts to decorate desk tops or room shelves.

2. Use this lesson for historical groupings of famous persons.

3. Make characters that illustrate original stories, or fictional characters from books.

4. Create a world of outer-space inhabitants. (See Chapter 10, "The Future," for other ideas.)

5. Try odd-shaped bulbs in different sized cans.

6. Make a drawing for an invention that will use light bulbs in a new or decorative way.

7. Build the invention.

8. Create a menagerie of "can-imals."

Through the Eye of the Artist

Artists have always been fascinated with light and have constantly experimented with ways in which to capture it on canvas. Increasingly, however, they have attempted to create works of art using electricity itself. Be on the lookout for articles and reproductions concerning these "light" works, often referred to as kinetic art. In addition, collect reproductions of whimiscal sculptures, particularly of people, that incorporate found objects.

Suggestions

Kinetic Art:

Lassus—"Light Breaker"

Agam—"Space Rhythmed by Light"

Rossi—"Luminous Box"

Sculpture:

Fullard—''The Patriot''
Nele—''The Couple''
Jensen—''Lure of the Turf''

Glossary

Kinetic Art: Three dimensional art that is always changing, often through the use of light and motion

Three-dimensional: objects that have height, width and depth

LESSON 4-3

Bag It!

(paper bag puppets)

Materials

tan paper bags—sizes 6 and 8 are most suitable
scraps of colored construction paper
paste, paste sticks
scissors
crayons

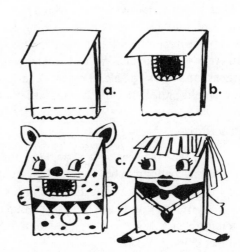

Figure 4-3

Be Prepared

1. Have several paper bag puppets made in advance of the lesson. This will acquaint the teacher with the creative procedures, and will provide the class with visual examples of the finished project. Remember to explain that these are samples and are not meant to be copied. Each puppet will be individual in concept, and the possibilities for making them are as varied as there are students in the class.

2. Cover work areas with newspaper for easy cleanup. Individual desks will suffice if tables are not available.

3. Set up a central supply area with assorted scraps of construction paper.

4. Select group helpers who will distribute the necessary supplies at the proper time: a paper bag and scissors to each student; paste and crayons may be shared.

5. Provide each youngster with several scraps of construction paper to start. This will prevent everyone crowding the supply center at once.

6. Allow time for cleanup. Children should return all usable scraps to the central supply area.

7. Boys and girls will be most eager to use their puppets. Designate a "quiet rehearsal corner" for children to go and play with their puppets as soon as they have finished them and have cleaned up their work area.

Introduction of Lesson to Students

Bags serve a very useful purpose for us when we bring home supplies from the stores, but what about afterwards? Should we simply throw away these rather drab, ordinary bags when, with a little imagination, we can turn them into wonderful "talking" bags?

Each of us has a flat bag, which has a flap at the closed end. When we put our hand into the open end, by closing and opening our hand we can make the flap move very much like a mouth. Our "talking" bags will actually become our very own puppets. We can create puppets that are like pets. Rabbits, dogs, kittens, and birds can all be made. A funny clown or a pretty lady may be what you would prefer. It's up to you, so let's begin!

Procedure

1. Place the bag over your hand and move the flap up and down. If the bag seems too long to be comfortable, cut off several inches from the *open* end. Test the bag again for size. Be careful not to cut off too much (Figure 4-3a).

2. Before you begin to design your puppet, make certain that the flap is facing towards you. That is the side of the bag that will be the front of the puppet (Figure 4-3b).

3. Start to cut out the various features you want your puppet to have. How about a hat for that clown? What about trying a scarecrow or an Indian? Don't be too concerned about having eyes and ears identical. You can make features the same size, however, simply by folding a piece of paper in half and cutting out a shape from both halves at the same time.

4. Arrange the features of the puppet before applying paste. Remember not to paste down the flap of the bag, or the puppet will not be able to move its mouth!

5. You can decorate the inside of your puppet's mouth, simply by raising the flap and adding a construction paper tongue and teeth (Figure 4-3b).

6. Polka dots, hair, collars, necklaces, even arms and legs can be added by cutting and pasting the desired shapes from construction paper. (Figure 4-3c).

7. Remember, the puppet has a back too. So don't forget to turn the bag over to add details such as tails on animals and birds, or hair on people. If a dog has spots on the front, he should have them in back, too. Be very careful during this step because you do not want the items pasted on the front to fall off. If you paste carefully, pressing down on each section, everything should stay in place.

8. Details, such as eyelashes and eyebrows may be added with crayon. Try unusual ideas. How about adding a feather and band to that hat? How about fringing that moustache? This bird could have two beautiful wide-spread wings and a juicy, brown paper worm in his beak!

9. Inspect your bag puppets from front and back. When you are satisfied that you have added everything you would like, return all the usable supplies to the proper containers and clean up your work area. How would you like to play quietly with your puppet? Take it to your "quiet-rehearsal corner", but have them whisper at first, because other people are still working.

Look Around You

Everyone likes puppets! You can be alone with your puppet and have a wonderful conversation with it, or you can make up an entire play with several friends. Best of all, puppets often can be made from simple materials such as these bags. What other materials are available in our room that could be used for making puppets? We might have used scraps of fabric or wallpaper to decorate them. We certainly could have applied yarn for hair and animal tails. Suppose we had used tongue depressors for the body? We could have cut out heads, arms, legs, etc. from paper, and pasted them on to the wood. Then, simply by moving the stick in different directions, we would have created another type of puppet!

Look around your house and see what objects you can find to make a puppet. Perhaps your older brothers and sisters will join you and you will be able to put on a family puppet show. Have fun!

Adaptations

1. At the close of this lesson children are very eager to show off their puppets. Have each child introduce his puppet to the class in a sentence or two.

2. Put on a group puppet show. A large table with fabric or mural paper wrapped around it serves as a most adequate stage.

3. Bring original stories to life by making paper bag puppets of the characters and then acting out the story.

4. Draw pictures of the puppets and add background scenes.

5. Use these puppets for story telling and song sessions.

6. Create puppets that relate to a central theme, such as Halloween, a circus, an historical event, etc.

7. Use paint for features and decorations. However, make sure each side dries thoroughly before holding the bag up for use.

Through the Eye of the Artist

Puppetry takes many forms, from the ancient art of Bunraku in Japan, to the modern life-size puppets so often seen on television shows. Articles and pictures depicting various types of puppetry will not only broaden the child's knowledge of this art form, but will stimulate him to try creating different types of puppets on his own.

Suggestions

Indonesia—shadow puppets

Japan—Bunraku

Europe—Punch and Judy hand puppets

American Indian—Haida wooden puppets

Pinocchio—perhaps the most famous of all puppets.

Glossary

Hand puppet: a puppet which covers the hand and whose parts are manipulated by hand and finger movements

Marionette: a puppet with movable joints attached to strings which control their movements, when manipulated

Shadow puppet: an intricately carved and jointed puppet whose shadows are cast against a screen and manipulated by rods to create moving silhouettes

Bunraku—ancient Japanese art of manipulation of large puppets, each by several operators, accompanied by narration and samisen music

LESSON 4-4

New Life for Old Boxes

(box animals)

Materials

boxes—empty gift boxes; empty
 cookie, cereal, tooth paste
 boxes, etc.
white glue
scissors
colored construction paper-
 —assorted sizes and scraps
various scrap materials—felt,
 burlap, yarn, toothpicks, but-
 tons, etc.
clear tape—several rolls
tempera paints—liquid soap
 added (see Be Prepared, No.
 2)
brushes
water for cleaning brushes

Figure 4-4

Be Prepared

1. Collect empty boxes in a variety of sizes and shapes well before the start of the lesson. Because gift boxes are ideally suited to this activity, it is quite practical to present this project shortly after the December holiday gift seasons.

2. Many gift boxes are in themselves so attractively designed that they will require little or no background painting. Food boxes and the like, however, will need to be painted in order to cover all the printing. Add a small amount of liquid detergent to the tempera so that the paints will adhere to the shiny surfaces of the boxes. *Note*: this should be done in advance of the lesson so that the boxes will be dry.

3. Have work areas covered with newspaper for easy cleanup. Individual desks, or several pushed together, will suffice if tables are not available.

4. Art helpers should distribute scissors for each child. In addition, papers, several jars of white glue, and several rolls of clear tape should be brought to each work area. Glue and tape may be shared.

5. Have a central supply area where additional papers and assorted scrap materials will be available if needed.

6. Paints can be distributed in egg cartons and juice cans, or a central paint area can be permanently set up in a corner of the room. Clean plastic food containers make excellent paint receptacles. Coffee cans, partially filled with water, will aid in quick rinsing of brushes.

7. Have an area where finished projects may be stored until ready for display.

8. Allow time for cleanup!

Introduction of Lesson to Students

We all know that there are many kinds of animals: friendly dogs, cuddly kittens, ferocious creatures of the jungle! But, how many of you have heard of "boxy beasts"? We're going to create some today!

Instead of throwing away all these boxes, we have been saving them for a very good reason. Using the boxes as the body, we are going to design some most unusual animals. They might be wildly striped, colorfully spotted, or even plaid. We can cut ears, eyes, and noses out of paper or scrap materials. Whiskers could be toothpicks or wool. Whatever beast evolves will be completely up to you!

Procedure

1. Think about what kind of animal you would like to create. It can be similar to a real animal, such as a rabbit, or your may want to make one that is completely unreal and imaginary.

2. Study the shape and size of your box. It may help you to decide what you are going to create. That long glove box would make a great dachshund! What about an elephant for that big fat box? Be spontaneous and start working on your animal's features.

3. Tape any open parts of your box.

4. Cut eyes, ears, noses, tongues, collars, teeth, etc. from construction papers and scrap materials. Paws, tails, and body decorations may also be cut from these materials and pasted on to the boxes with white glue.

5. Use glue sparingly. A little goes a long way. Hold cut-out parts in place for a silent count of ten, so that they will be sure to adhere to the box.

6. Larger decorations, such as long ears, may be more securely fastened to the box by the addition of a little clear tape.

7. Two equal parts (e.g., eyes) may be made by folding paper in half, and cutting a shape through both halves at the same time. It is much more fun, however, to strive for variety, such as one closed, "winking" eye and the other one open.

8. Encourage spontaneity and free thinking.

9. When the "boxy beast" is completed, store in a designated area until ready for display.

Look Around You

We certainly have created a wonderful menagerie of unusual animals; we have truly given new life to old boxes! Although our creations are each different, what is one thing that almost all of them have in common? Look at their shapes. Right! They are mostly either square or rectangular. Are real animals shaped in these ways? How else do live animals differ from our make-believe ones? What about the texture of their fur? What about their natural colors? And how about the manner in which they move? Our beasts are static; they are very colorful and decorative, but they cannot move by themselves.

Look around you. How many objects do you see that are square or rectangular in shape? What kinds of boxes are shaped differently? How about hat boxes, or cylindrical cereal boxes? When you are home today, have your family help you to find some unusually-shaped boxes, and why not join together in finding new ways to re-cycle them.

Through the Eye of the Artist

Many sculptors and artists, particularly in modern times, have placed special emphasis upon the basic shapes of the square and the rectangle. A collection of prints to illustrate how these artisans have creatively used these shapes will enhance the meaning of this lesson.

Suggestions

Sculpture:

Marisol—"The Family"

Aeschbacher—"Figure XI"

Brancusi—"Torso of a Young Man"

Painting:

Mondrian—"Broadway Boogie Woogie"

Gris—"Guitar and Flowers"

Picasso—"Three Musicians"

Glossary

Three-dimensional: having the qualities of height, depth, and width

LESSON 4-5

Roll-Aways

(inner tube and string painting)

Materials

cardboard tubes—one per child
white glue
12″ x 18″ construction paper-
—black and white
heavy string or twine
cardboard scraps, particularly
the corrugated kind
18″ x 24″ paper—black and
white for mounting finished
prints
staplers and staples

Figure 4-5

Be Prepared

1. Collect cardboard tubes, the kind that comes inside rolls of paper products, in advance of the lesson. Each child will need one tube.

2. Pre-cut heavy string into lengths of approximately 24 inches. Each child will need one piece of string, but extra pieces should be available.

3. The teacher should make a "roll-away" printer ahead of the class lesson, so that one will be ready with which to demonstrate the project (see procedure, No. 3).

4. Have work areas covered with newspaper for easy cleanup. Individual desks, or several pushed together, will suffice if tables are not available.

5. Each child should have a smock to wear. A discarded man's shirt, with the sleeves cut off so that the student can work freely, is an ideal cover-up.

6. Have an area to spread finished prints out to dry.

7. All art projects appear more attractive after having been mounted. Upper-grade students may mount their own work. Provide a table with staplers and staples, plus mounting paper for this purpose. If no table is available, students can work on the floor, after it has been covered with newspaper.

8. Pre-cut scraps of cardboard (approximately 2″ x 4″). Have at least one piece for each child at the work area from the beginning of the lesson.

9. Sheets of black and white construction paper, 12″ x 18″, should be available at each work area.

10. Have art helpers distribute one cardboard tube and one piece of string to each child at the beginning of the period. Glue may be shared.

11. For this project, paints should be of a thick consistency. Paints can be distributed during the lesson in egg cartons, juice cans, or a central paint area can be set up in a corner of the room. Clean plastic food containers make excellent paint receptacles. Coffee cans, partially filled, with water, will aid in quick rinsing of brushes.

12. Allow time for cleanup!

Introduction of Lesson to Students

If we brush paint or ink onto the object and then press it against another surface, an impression of the first object will be made; we will have made a print.

Perhaps the most familiar examples of printing are newspapers and books. In these instances, machines press the inked letter type on to paper. For our print making today, we will be creating abstract designs, using the basic principles of relief printing.

How do you think we can possibly use such ordinary objects as cardboard tubes, string and paint to create prints? Watch, and we'll show you!

Procedure

1. Hold your cardboard tube in one hand, and with the other dribble a little glue up and down the sides of the tube. Think of the glue as forming abstract lines. If you are sharing the glue, wait just a few moments for your turn.

2. Next, still holding the tube in one hand, grasp the string at one end and wind it around and around the tube. Press the string so that it will adhere to the cardboard. Crisscross the string wherever you like, and if there is a piece left dangling, simply wind it up the tube until all the string has been used. No need to worry about what directions the string wanders. It is all part of the surprise that will happen very soon when we begin to print.

3. Now let your string-covered tube stand a moment to allow it to dry. In the meantime, we'll demonstrate with one that was made in advance.

4. Brush paint over the tube. It is not necessary to paint heavily, but it is wise to concentrate on covering the string. This is because the string is raised from the cardboard surface, and it is the part that will do the printing.

5. Now for the fun! Lay your tube gently upon a sheet of black paper and holding it at both ends, simply roll it in varying directions. Roll-away until all the paint is gone.

6. Repeat this "roll-away" process with another color. Since the previous paint will have been used up, you will be able to apply another color directly onto your tube!

7. Experiment! Try painting the open end of your roller tube, and printing it. Perfect circles will appear. Do the same with the scraps of cardboard that are at your work areas, but be careful not to apply the paint too heavily. Try repeating the lines and circles and try overlapping the various shapes. Use contrasting colors. Always keep in mind that your goal is a varied and interesting design (see Figure 4-5).

8. When you feel that your print is finished, bring it carefully to the designated area and set it down to dry.

9. Try another print on white paper this time. Remember not to let your designs become too crowded or busy. Attempt some different techniques. See what happens if you push the painted edge of the cardboard along the paper. Try swirling it. If you want to use another color, simply use a clean edge of the cardboard.

10. When your print is almost dry, you can mount it very carefully on a piece of black paper.

Look Around You

Let's look at our prints. From objects that would ordinarily have been throw-aways, we have fashioned printed "roll-aways." With them, we have created some unique graphic art: pictures produced by printing. Do you think the white or the black backgrounds are more effective? (It's often hard to say.) What other discarded materials do you think could be used for printing purposes? How about corks and bottle caps? What else? From now on, let's think twice before throwing away things that we can put to artistic use.

There are prints other than the graphics we created, that we often see. Think about tire prints along the road. How about thumb prints, foot prints, animal and bird prints? Look for interesting prints made in earth by pebbles and twigs. Indeed, Nature and Man provide an endless variety of printing materials, if only we are aware of them.

Adaptations

1. Mount and display these prints for a fascinating exhibit. People are sure to ask how they were made.

2. Allow prints to dry thoroughly. Paint underwater scenes, using the prints as backgrounds, for unusual effects.

3. Cut simple shapes (abstract or realistic) from construction paper and assorted materials. Paste them onto dry prints for striking collages.

4. Experiment with printing with found materials. Then hold a contest to see who can guess what objects were used to obtain each effect.

5. Create "group graphics" by spreading shelving paper along the floor or table and having several students work together. Experiment with printing

on textured surfaces such as fine sandpaper and burlap. Too rough a surface, however, will not produce a successful print.

Through the Eye of the Artist

Graphic artists often incorporate natural or man-made textures into their works. Woodcuts are particularly suited for this purpose. A display of reproductions of prints with interesting textured effects, followed by a class discussion of how these effects are achieved, will enrich this lesson.

Suggestions

Woodcuts:

Frasconi—"The Storm is Coming"
Japanese wood cuts

Glossary

Mono-print: one-of-a-kind prints; they cannot be precisely duplicated

Graphic art: designs or pictures that are produced through printing

Woodcut: print made by inking wood that has been cut to form a design, and then pressing paper over it

Relief printing: raised surfaces are inked or painted, then printed.

LESSON 4-6

What It Could Be Like

(ecological mural)

Materials

36″ rolls of mural paper in two contrasting colors, one bright, the other dull (e.g., yellow and grey)

construction paper—assorted colors such as blue, dark red, orange, brown, black and white, pre-cut into varied sized rectangles

1″ strips of construction paper—yellow, white, orange, grey

paste and paste sticks sketches
scissors newspaper scraps
crayons colored chalk (optional)
tempera paints straight pins or thumbtacks
water to clean brushes —for preliminary placement
scrap paper for preliminary of mural components.

Figure 4-6

Be Prepared

1. Have the mural papers tacked into place on the bulletin board before the lesson begins. Remember, each half of the mural should be equal in size. Paste together the edges where the two colors of mural paper meet.

2. Have a variety of crayons at each work area. Empty frozen dinner trays make excellent receptacles.

3. Art helpers should be asked to distribute the necessary supplies to each work area: scissors for each child, a variety of scrap paper, and paste. Empty baby food jars or small plastic paint jars filled with paste facilitate the distribution of supplies. Paste and paste sticks may be shared.

4. Pre-cut strips of white, yellow, grey, and orange construction paper to one-inch widths.

5. Have an assortment of various colored construction paper in differing heights and widths. (These will eventually form buildings so the dimensions can vary as you see fit.) The construction papers will also be used to form the other parts of the mural, such as cars, trucks, and people (see ''Introduction'' and ''Procedure'').

Introduction of Lesson to Students

We are all concerned about our environment. Our waters are becoming polluted, as is the air we breathe. Wild life is threatened with extinction, our countryside is being wasted, and our cities tend more and more toward a state of decline.

Suppose we make a mural that will emphasize what is happening to our cities, so that we can express our concern in a dramatic way.

If you look at the mural paper, you will notice that one side is a bright color, the other side is dull. You guessed it! On the bright half, we can show what our cities *could* be like with proper environmental concern, and on the other half, we can depict what will happen if we continue to pollute them.

What are some of your suggestions about what we might put into our un-polluted part of the mural? How about some parks with plantings of trees and flowers? Perhaps we can have a river next to our city. Then we can show people out in sail boats, fishing and enjoying the sun. We can add birds and children playing in the fresh air.

Now, what about the other half of our mural? How can we emphasize the miseries of pollution? What about litter and garbage? We can cut out ash cans from construction paper, and with paste, add torn bits of newspaper to make them look filled. We might show dead fish, trash, and oil tankers in the river. The walls of our buildings can be covered with chalked-in graffiti. Trucks, cars, and buses can also be pasted onto our mural to illustrate how they crowd the streets and pollute the air.

What other ideas do you have?

Procedure

1. Make two lists: one for all the suggestions the class has for the polluted side of the mural, and one for ideas pertaining to the non-polluted half.

2. Ask the students which half of the mural they would like to work on, and divide the class accordingly. One group of several youngsters might work on cars, trucks, and oil tankers; another group might work on graffiti-covered skyscrapers; and another might create various kinds of trash. For the non-polluted section, youngsters can divide into groups working on children, trees, sail boats, etc.

Keep in mind that all parts will eventually be cut from construction paper, with details crayoned in.

3. Each student should make a preliminary sketch of what he is going to make. Once the teacher has seen it and made suggestions, the student may go to the supply area and choose the construction paper must suited to his needs. Colors are important; they should relate to the part of the mural on which they are to be used. The polluted part should be drab, with darker colors used for buildings, cars, etc.

4. Details, such as advertising, facial features, designs on clothing, etc. may be added to the construction paper drawings with crayons. These should then be cut out and carefully placed in an area designated for either pollution or non-pollution.

5. Windows for tall buildings can be effectively made by cutting desired shapes from the pre-cut construction paper strips and then pasted onto the rectangles of paper. Doors, advertising signs, and other details can be crayoned in.

6. As the children progress, ask several youngsters to be on a committee to assemble the mural. Since it is very important to arrange all the parts of a meaningful and dramatic way, it is essential that the teacher be readily available for assistance.

Pins or thumbtacks should be used to place the mural parts temporarily into position.

7. While the class is working in their groups, several volunteers might go to the murals and paint large areas, such as rivers and parks. It will not be necessary to paint the sky, since the colors of the mural paper are most satisfactory. However, for a truly murky effect on the polluted section, grey chalk might be carefully rubbed in to specified sections.

8. When all mural parts have been pinned into place, have the class suggest any other ideas they may have. This is an opportune time to discuss composition and overlapping.

9. Have several children paste down the mural parts and remove the pins.

Look Around You

We read and hear about ecology every day. What do you see in our classroom that could be changed to help our environment? What about our school, our homes, our community? Can you think of places that you know that have changed for the worse? How about places you have visited during your vacations? What do you think we can do to make people more aware of how important it is to take care of our surroundings? Why don't you discuss this problem with your families and ask them for their suggestions?

Adaptations

1. Create murals with other ecological themes, e.g., animal life, forests, oceans and streams.

2. Make individual collages, realistically or abstractly depicting an environmental subject, e.g., trash, plant life.

3. Have students work in groups of five or six to create "mini-murals" depicting our environment.

4. Paint or draw posters about ecology.

5. Plan an ecological campaign to clean up and beautify your school and its grounds.

6. Display the murals, posters, collages, etc. as part of the campaign.

7. Invite parents to participate in, and to view, the results of the project.

Through the Eye of the Artist

Man and his environment was a favorite theme of the artist long before the term "ecology" came into common usage. Display reproductions of paintings depicting our country as it was in by-gone days, and by way of contrast, show art illustrating more modern scenes. Discuss how ecological changes have been portrayed in the paintings.

Suggestions:

Paintings:

> Morse—"View from Apple Hill"
>
> Inness—"Catskill Mountains"
>
> Homer—"The Herring Net"
>
> Hartley—"Northern Seascape"
>
> Marin—"Sea and Sky" "Lower Manhattan"
>
> Sheeler—"Classic Landscape"
>
> Shahn—"Handball"
>
> Luks—"The Butcher Cart"
>
> Dehn—"Spring in Central Park"
>
> Birchfield—"Pippin House, East Liverpool, Ohio"

Murals:

> Curry—"The Homestead"
>
> Bentley—"Mining," "The Art of Building"

Glossary

Mural—a painting, collage or drawing of large size, used to decorate a wall

Overlapping—one object placed partially over another

Composition—the placement of shapes into a pleasing and balanced arrangement

LESSON 4-7

Bottles Into Beauty

(bottle sculpture)

Session I

Materials

bottles—variety of shapes and
 sizes, one per child
styrofoam balls—3″ round, and
 2½″ egg shaped
oaktag
containers of water
plaster gauze
scissors
#7 wire and cutter
tape
cardboard tubes

Session II

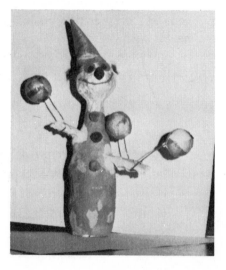

Figure 4-7-1

Materials

tempera paints
brushes

Session III

Materials

assorted materials for trims-
 —rickrack, felt, sequins,
 toothpicks, yarn, feathers,
 etc.
white glue
scissors
tempera
small brushes
felt markers

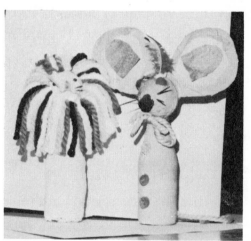

Figure 4-7-2

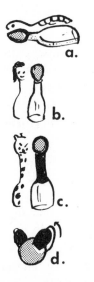

Figure 4-7a-d

Be Prepared

Note: This is really a foolproof lesson; everyone will feel successful. But, enough time must be allotted, so bear in mind that at least three art sessions will be required.

1. Discuss the project several weeks in advance of the lesson. Have the children collect clean bottles, especially ones that have interesting or unusual shapes, such as salad oil and syrup bottles with handles. However, individual-sized soda bottles will do very nicely.

2. Students should tape their names to the bottom of their bottles and a place where they can be stored safely should be set aside.

3. If possible, keep a supply of old scissors to be used especially for this project, since cutting plaster-coated gauze tends to dull scissors.

4. Pre-cut the rolls of plaster gauze so that each youngster will be able to start his project with a roll about 10 inches in length. More gauze should be available as needed.

5. Have tables covered with newspaper for easy cleanup.

6. Place foil broiling pans or cardboard paint buckets at each work area.

7. Each child should have a pair of scissors.

8. Have art helpers chosen for specific tasks: pouring water into foil pans or buckets at beginning of lesson, washing, drying, and storing scissors used for cutting the gauze, emptying the water from the foil pans and cleaning each work area.

9. Have an area to store the sculptures in between sessions.

10. As with all projects, it is excellent preparation to create a bottle sculpture yourself so that one will be completed to show to the class. Besides, it is really fun!

11. Caution: bottles are breakable, therefore, handle with care.

Introduction of Lesson to Students

Bottles, bottles! We've got the bottles. Having saved them from the trash pile, it is now up to us to create something exciting from them. They can be made into marvelous pieces of sculpture: people, birds, monsters, animals —anything from mice, elephants, and giraffes to turtles, scarecrows, and Martians! Your only limit is the bounds of your imagination. Here's how it is all done.

Procedure

Session I: Planning, forming, and covering the sculpture with plaster gauze.

1. We have a choice of two shapes of styrofoam balls, oval or round. We also each have a bottle, some of which are most unusual in shape. Planning is very important, so take a minute to examine your bottle. Turn it in various directions. By placing a salad oil bottle flat side down, and pressing an oval ball for a head to the opening, it begins to resemble the contours of a turtle (Figure 4-7a). An oval styrofoam ball on an upright bottle could be the start of a person (Figure 4-7b).

What happens if we add a cardboard tube between this upright soda bottle and a round styrofoam ball (Figure 4-7c)? It truly does take on the beginnings of a giraffe. The choices are up to you. In general, round balls suit animals, and oval balls are fine for people, but there are no set rules.

2. Having seen some of the possibilities open to you, make a simple sketch of your idea. Then choose the kind of styrofoam ball that best satisfies your design.

3. Press the ball gently over the bottle opening, pressing down gently, as if you were squeezing an orange.

4. Cut all protruding parts (e.g., wings, tails, and ears) from oaktag. To make two identical parts, such as ears, cut one and use it as a pattern to be traced for the other.

5. Brace such parts by cutting wire into lengths that are slightly larger than the part. Wire can be attached to the bottle with tape, or can be poked directly into the styrofoam ball. Bend any excess wire over the reinforced part (Figure 4-7d).

6. Now comes the all important step of covering the bottle with the plaster gauze. To do this, first cut strips of gauze approximately 4″ in length.

 a. Dip each piece into water and remove excess moisture by squeezing between fingers. Do one piece at a time.

 b. Cover entire sculpture (except bottom) by overlapping these wet strips of gauze. Keep smoothing the gauze with your hands.

c. One layer of gauze is sufficient, but reinforce all parts that have been added, such as ears, necks, etc. with several extra layers of wet gauze.

d. Arms may be formed by rolling guaze to desired length, soaking in water, then shaping it and pressing into place on the bottle. Small protruding features, such as noses, may be added in the same way.

e. Very fine details such as whiskers, may be added during the final session (see Session III, No. 6).

7. After the bottle is completely covered with plaster gauze, carry it carefully to the storage area.

8. The bottles should be left to dry at least twenty-four hours before proceeding to the next stage.

Session II: Painting the Sculpture.

1. All work areas should be covered with paper.

2. Paints, brushes, and water for cleaning them should be ready.

3. Allow time for the planning of colors. Fantasy or realistic colors may be used, or the child may wish to correlate his sculpture to the color scheme of his room.

4. For this session, the entire sculpture, except for the bottom, should be covered with a base coat of paint. Do not attempt to paint small details or designs at this time, because the paints will run into one another.

a. Children can carry their paints in egg cartons or juice cans from a central supply area. Have a good variety of colors available, including gold and silver, if possible.

5. After the bottle is painted, carefully carry it to the storage area where it should be allowed to dry thoroughly.

Session III: Decorating and Adding Details to the Bottle Sculpture.

1. A variety of trims such as rickrack, sequins, felt, yarn, toothpicks, feathers, and buttons should be placed in bins where they are readily available. Children may wish to bring extra trims from home, such as lace, netting, and ribbons.

2. Paints and small brushes should be ready for those who wish to add painted designs. At this stage, however, most of the decorations should be added with materials and white glue.

3. Scissors and white glue should be ready for use.

4. Some youngsters may wish to refer to their original sketches, but many may want to proceed in a more spontaneous manner.

5. Cut eyes, mouths, etc. from felt or other material. Colorful yarn makes wonderful hair and tails. Collars of lace, felt polka dots, and ribbon stripes are but a few of the many possibilities for decoration.

6. Use the end of a compass to poke holes into the styrofoam heads.

Colorful toothpicks can then be placed into them to become whiskers of animals. Feathers may be literally layered on to the bottles for the creation of exotic birds.

7. Allow the sculptures to dry, but be ready for the exclamations of delight and wonder as each child views his own and his classmates' bottles of beauty.

Look Around You

Let us make a list of all the various kinds of bottles that we used for this project. Do you think that all of them are designed to be beautiful as well as functional? How do you think some of them could be improved in their design? How do bottles differ in texture, color, and size? Bottles can be dangerous when broken, yet with care and imagination they can become objects of beauty.

What other found objects might be re-cycled into sculpture? What about used gaskets, cans, nails, bolts and washers? These could be used without covering the parts with gauze, and a completely different kind of sculpture would be created. Do you think the bottles we used limited us to some degree as to what we could design? Do you realize how individual and different the results of our efforts were even though we all started basically with the same materials? Imagination and creativity are truly wonderful gifts!

Adaptations

1. These sculptures make marvelous holiday gifts. Don't be surprised if adults ask how they were made, so that they can create them too.

2. A display of bottle sculpture is always exciting. After exhibiting them in your school, why not arrange to have them displayed in your local library. Let the community know what artistic re-cycling can be accomplished by youngsters.

3. Create sculpture around a central theme, such as historical figures.

4. Papier-mâché may be used as a substitute for commercially prepared plaster gauze (see Glossary).

5. Try other sculptures, using found objects. This time, omit the plaster gauze. Interesting junk sculpture can be created in this way.

Through the Eye of the Artist

Sculpture may be created through a variety of materials and techniques. Present reproductions to your class that illustrate varieties of style and approach. Place particular emphasis on modern sculptors, who incorporate found materials into their work.

Suggestions

Degas—''Young Dancer''
Indian—Hopi Kachena Dolls
Jenson—''Lure of the Turf''
Johns—''Painted Bronze''

Glossary

Sculpture: a design, abstract or realistic, that is three-dimensional

Found material: ordinary objects collected and put to artistic use

Papier-mâché: a mixture of flour and water stirred to a creamy consistency, into which strips of newspapers or paper toweling may be dipped to be used as a sculpting material.

WE ARE PART
OF ALL THAT IS NATURAL

CHAPTER 5

Art Activities Related to Nature

Children instinctively gather leaves, save scraps of wood, and collect rocks. To use such natural objects artistically and imaginatively, as well as to nurture a fuller appreciation of the beauty and wonder of all nature in their world, are the objectives of this chapter.

Art activities that incorporate pine cones, rocks, leaves, and wood are included. In addition to forming miniature sculpture, printing, pasting, cutting, and painting, children will also explore the colors, shapes and textures inherent in natural things. Symmetry, transparency, pattern, and function are also discussed, both in natural and man-made products. Bird, insect, animal, and aquatic life are examined through group activities and special bonus projects. Even natural fossils form the basis for a lesson on sand casting. Each lesson is further enriched with ''Through the Eye of the Artist'' segments, which introduce boys and girls to the tremendous influence of nature upon art and artisans throughout time.

As the child learns a more perceptive way of seeing and thinking through these art activities, it is hoped that he will also acquire a greater respect for Nature, and thereby establish a closer relationship with his natural surroundings, as well as with all living things in the world around him.

LESSON 5-1

The Face in the Stone

(painting on rocks)

Materials

stones and/or rocks
yarns
clear or white glue
tempera paints and small
 brushes
scissors

Figure 5-1

Be Prepared

1. Children should bring in medium-sized stones and rocks in advance of the lesson. These should be stored in boxes, with each child's name taped to his stone. Remind children to look for interesting shapes and textures, and to wash the stones before bringing them to class.

2. Cover all work areas with newspapers for easy cleanup.

3. Art helpers should distribute the necessary art supplies at the start of the lesson. Each child will need one stone. Yarns, scissors, and glue can be shared. Paints can be distributed in egg cartons or juice cans, or a central paint area can be set up in a corner of the room.

4. Designate an area where children can place their finished projects until ready for display.

Introduction of Lesson to Students

Some of our best art materials can be supplied by the world of nature! For example, nature fashions stones and rocks into varied sizes and interesting shapes. With the addition of our imagination and creativity, we can change these natural formations into unusual "portraits in stone." Remember, a por-

trait is a painting or drawing of a face. So let's begin . . . it is going to be exciting to see the results of our stone faces!

Procedure

1. Examine your stone carefully, turning it in many directions. Does its shape, indentations, and texture resemble a face? There are many possibilities for designs within each stone or rock, so plan carefully what kind of features you would like to fashion.

2. When a design has been decided upon, proceed to paint the details onto the stone. Will the face be happy, sad, or angry? Will it be realistic or imaginary? Lengths of yarn can be glued onto the rock to simulate hair (see Figure 5-1). Let your imagination be your guide. Remember, however, to leave much of the rock unpainted so that the natural color and texture remain visible.

3. When the project is complete, place it in the designated area to dry. Carry the rocks carefully to avoid dripping paints.

Look Around You

The portraits we have made from our rocks and stones are each different. How do the stones themselves differ from one another? Natural color, texture, shape, and size are the most obvious differences. Look closely at the stones again. Slight color variations within each stone can be seen. Sometimes smaller bits of wood or pebbles become lodged within crevices. How can natural elements, such as rain or water, affect the shape and texture of stones and other natural objects, such as wood and shells? How are stones and rocks used decoratively? In gardens, table displays, and centerpieces. How else? Do you think that the inside of a rock is the same in appearance as the outside?

Adaptations

1. These rock portraits can be used as unique paper weights.

2. Have several children work on large rocks to create truly striking birds and animals, as well as portraits.

3. Paint designs or realistic pictures within the rock shapes.

4. Make unusual rubbings by placing paper over a stone or rock and using the side of a peeled crayon to rub over them.

5. A visit to a local lapidary store will prove most enlightening to the students.

Special Bonus Project: Stone Sculptures in Miniature

Collect smooth stones and pebbles of varying sizes. Combine them to form shapes of animals, birds, and people, using epoxy glue to join the stones.

Paint designs and features using small brushes and tempera paints or felt markers. Ears, beaks, tails, etc. can be fashioned from felt, seeds, and feathers. When dry, the tiny sculptures can be sprayed with shellac for additional sheen and permanency.

Through the Eye of the Artist

Sculpture created from natural rock formations can be seen in such places as Stonehenge, Easter Island, and in Mexico where there are huge Mayan heads. Our own Mount Rushmore also examplifies the use of natural rock as a basis for design. Along with these examples, show the class pictures of Japanese stone gardens, which so adequately illustrate the enjoyment of the natural beauty within stones and rocks. Introduce reproductions of classical and modern sculpture from stone, as well (e.g., Michelangelo, Brancusi, etc).

Glossary

Texture: tactile quality, seen or felt

Portrait: picture of a person, most often of the face

LESSON 5-2

It's Magic

(leaf monoprints)

Materials

autumn leaves
dark paper—12″ x 18″
tempera paints and brushes
scrap paper

Figure 5-2

Be Prepared

1. Have children bring in an assortment of autumn leaves the day of the lesson. If leaves are brought in early, they may be preserved until ready for use, simply by pressing them in books that are kept in a cool, dry place.

2. Cover all work areas with newspapers for easy cleanup.

3. Paints should be mixed to a creamy consistency; watery paints will not produce satisfactory results. The prints will be most attractive if colors are confined to reds, oranges, greens, yellows, and browns.

4. At the start of the lesson, art helpers should distribute the necessary supplies. Each child will need several leaves and a sheet of dark paper. An adequate supply of scrap paper should also be available. Paints can be distributed in egg cartons or juice cans; or a central paint area can be set up in a corner of the room. Coffee cans, partially filled with water, will aid in the quick rinsing of brushes.

5. All children should wear smocks.

6. Designate an area for children to place their monoprints to dry.

Introduction of Lesson to Students

Do you think we can make a print with a leaf? We certainly can, and it will be a special kind, a monoprint. This means that each of our prints, made by painting a leaf and then pressing it onto paper, will be one-of-a-kind; the exact print cannot be repeated. What sort of lines will appear on our papers? Let's find out.

Procedure

1. Before attempting to make a complete leaf monoprint, it is wise to practice printing with a leaf on scrap paper. First, cover the side of the leaf that has *raised* veining, with paint.

2. Carefully place the leaf, paint side down, on a sheet of scrap paper.

3. Take another sheet of scrap paper and fold it so that it is approximately the same size as the leaf.

4. Place it over the top of the leaf and rub gently with your hand.

5. Carefully lift the top scrap paper and then the leaf. As if by magic, a detailed imprint of the leaf and it's veining will appear. If the print is blurred, too much paint has been used. The print should be clear.

6. Practice the same procedure several times. The same leaf may be used again and again, because most all the paint is removed each time the leaf is printed.

7. After several practice prints have been made, repeat the procedure on dark paper. Overlap the leaves as they are printed, and use several colors (see Figure 5-2). An interesting composition is quite important to the overall effect.

8. When the leaf monoprint is complete, place it in the designated area to dry.

Look Around You

Our leaf monoprints are not only beautiful, but they can teach us a great deal about the natural pattern and texture of leaves. Perhaps we have never before looked carefully at the veining on a leaf. How many of us have ever held a leaf to the light to examine it more fully? Have you ever realized that one side of a leaf, with its raised veining, has a texture more easily felt than the other side? How can autumn leaves be used decoratively in our homes? Leaf arrangements are beautiful in themselves, but combined with other natural colors and textures, such as pine cones, nuts, wood, and shells, they can form really unusual centerpieces. Shells, woods, rocks all have natural pattern and texture. Can you think of other examples? Leaves change color. What other things in nature change color? Flowers, chameleons, birds. What else? Our world of nature is filled with many wonders, all waiting to be seen, touched, and enjoyed.

Adaptations

1. Leaf monoprints make excellent program covers.
2. Experiment with printing leaves onto fabrics and other materials, such as cork.
3. Create unusual greeting cards and note papers with the techniques discussed in this lesson.
4. Mount the leaf monoprints on orange and yellow papers for an attractive autumn bulletin display.
5. Arrange leaves in attractive containers and paint or crayon still life pictures of them.

Through the Eye of the Artist

Leaves have been the inspiration for design motifs throughout time. Reproductions of such examples as ancient and medieval pottery and architecture, colonial quilts, art nouveau glass, ironwork, and ceramics, American Indian crafts, Oriental and European porcelains should be shown to the class. In addition, paintings of flowers and leaves should also be incorporated into this lesson.

Suggestions

Art nouveau glass by Tiffany and Carder

Art nouveau architecture by Horta

Paintings:

Audubon—bird and plant paintings

Wyeth—''Fungus'', ''Delphinium''

Van Huvsum—''A Vase of Flowers''

O'Keeffe—''Black Iris,'' ''Black Flower and Blue Larkspur''

LESSON 5-3

Pine Cone Critters

(creating with pine cones)

Materials

pine cones
white glue
scissors
scraps and various materials:
 felts, netting, colored papers,
 pipe cleaners, toothpicks,
 yarns, feathers, etc.
non-hardening clay

Figure 5-3

Be Prepared

1. Children should start collecting pine cones of various sizes well in advance of the lesson. Store them in bags or boxes, in a dry area, until ready for use.

2. At the start of the lesson, art helpers should distribute the necessary supplies. Each work area should have an assortment of pine cones (at least one per child, preferably two), and a variety of scrap materials. Glue and scissors can be shared. A small amount of clay may be placed in a central supply area for those who wish to use it.

3. Designate an area where children can place their finished projects until ready for display.

Introduction of Lesson to Students

Nature is a source of many wonderful art supplies! One of the best is the

pine cone. Its very shape and texture can suggest many possibilities for creating original animals, birds, fish, and people. Let us see what our imaginations will help us change our pine cones into!

Procedure

1. Examine a pine cone from every angle. Turn it upside down and notice the beautiful pattern on the wide end. Lay it sideways, and set it upright. All the while, be thinking of how the pine cone can be transformed into an animal, insect, bird, or person. Try placing two cones together, so that one forms a head, the other a body. Remember that the shape of the pine cone will become the form of whatever you choose to make. Features such as eyes, wings, etc. will be added from our scrap materials.

2. When an idea has been decided upon, proceed to decorate the pine cone. a) To form a turkey, two toothpicks can be pushed into a groove of a pine cone to make legs. The addition of a small amount of clay to form a base will enable the cone to stand. Glue feathers into the narrow end of the cone to create a tail. Next, bend a pipe cleaner to resemble neck and head. Then paste a small yellow paper beak to it. Finally, twist the pipe cleaner onto a prong of the cone. The finished product will be a delightful turkey (see Figure 5-3). To fashion a little squirrel, place two pine cones to form a head and body, and glue together. Add felt eyes and ears, plus a paper tail. Add a clay base to help the "critter" stand, if necessary (Figure 5-3).

3. Paper wings can be cut and glued onto pine cones to form insects and birds. Place the cones sidewards and add felt fins and eyes to fashion pine cone fish. Add yarns and felt features to create miniature people. There are truly no limits to the possibilities. It's up to you!

4. When the pine cone creation is complete, place it carefully in the designated area.

Look Around You

Our pine cones have certainly been an exciting art material. How else can they be used decoratively? What about using them combined with nuts to make table centerpieces? Arrangements could also be made by combining cones with fruits and dried flowers. Do you think that the natural colors within pine cones should be left untouched? Why? How does the pattern on the flat end of the cones differ from the natural design on the rest of it? Where else can we see designs and patterns in nature? Leaves, shells, nuts, wood. Where else? Could these objects also be used artistically? How? Why not go on a "nature treasure hunt" with your family and see how many things all of you can make from the materials you find.

Adaptations

1. These "pine cone critters" make delightful holiday gifts.

2. Use the creations as place cards, and tape small nameplates to them.

3. Glue a variety of cones and nuts onto sturdy cardboard to form attractive centerpieces.

4. Tiny pine cones can be securely glued to pins to become fashionable brooches.

5. A touch of white paint and a little silver glitter on the tips of the cone prongs transform them into miniature snow-covered trees, to be used in dioramas, as decorations, etc.

6. Securely glue various-sized cones around a candle to form a beautiful holder.

7. If cones are not available, shells and nuts can be substituted for many of the projects suggested in this lesson.

Through the Eye of the Artist

Objects found in nature have often been used by tribal peoples to decorate masks, form jewelry, enhance carvings, and clothing. Photographs of such use of natural materials, particularly by the American Indian, Oceanic tribes, and African peoples, should be shown and discussed by the class.

Glossary

Pattern: effect created by repetition of motifs

LESSON 5-4

Something Fishy!

(underwater environment; group project)

Materials

paper plates—assorted sizes
yarns
tissue and/or construction papers
scissors
paste and paste sticks

tempera paints and brushes
large carton
cellophane
small amount of non-hardening
 clay
clear tape
extension cord and bulb-
 —optional

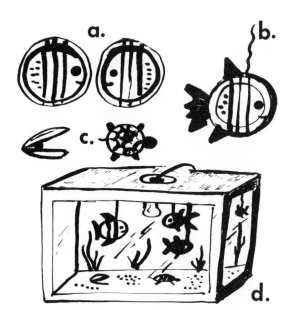

Figure 5-4

Be Prepared

1. One large carton will be needed in advance of the lesson. The teacher should cut out the front and two sides, so that the box resembles a large acquarium.

2. At the start of the lesson, divide the class into two groups: one to work on the acquatic environment (carton), and the other to create the marine life.

3. Art helpers should distribute the necessary supplies to the group that will be working on the marine life. Each child will need two plates of the same size, and a length of yarn. Tissue and/or construction papers, scissors, and paste can be shared. Paints can be distributed in egg cartons or juice cans, or a central paint supply area can be set up in a corner of the room. Coffee cans, partially filled with water, will aid in quick rinsing of brushes.

4. Those children who will be working on the carton will need paints and brushes, as well as lengths of cellophane, clear or lightly tinted. Dark colors are not suitable; they tend to interfere with a clear interior view of the carton.

5. All work areas should be covered with newspapers for easy cleanup.

6. Children should wear smocks.

7. Designate an area for children to place their projects to dry.

Introduction of Lesson to Students

Nature has provided an underwater world that is exciting, mysterious, and quite different from our everyday world. All kinds of marine life inhabit oceans, rivers, and lakes. Let's build our own colorful aquatic environment which will include fish, turtles, clams, plants, and whatever else our imaginations allow!

Procedure

Marine Life

1. Paint the *same* design of a fish onto two plates. Stripes, polka dots or zigzag lines will be fine. Remember to include a mouth and eyes (Figure 5-4a).

2. Carefully set the two plates aside, and cut out a colorful tail and two fins from tissues or construction paper.

3. Insert the fins and tail between the two plates, first spreading paste evenly around the interior rims. Then press the plates, together, making sure that the eyes face in the same direction (Figure 5-4b).

4. Poke a small hole in the top of the fish with a pair of scissors, and attach a length of yarn through it (Figure 5-4b).

5. The bottom of our undersea environment needs inhabitants, also. Clams can be fashioned by placing two plates at an open angle, and adding a small ball of clay to secure them (Figure 5-4c). Turtles can be made easily, simply by painting a design onto a plate to look like the shell, and then adding a cut out construction paper head, tails and legs, with paste (Figure 5-4c).

6. Place the finished projects in the designated area when completed.

Undersea Environment:

1. Both the inside and outside of the carton should be painted in colors that will give a feeling of deep water: perhaps a clear blue for the back of the carton and a yellow to simulate sand for the bottom. The outside might well be a bright purple or turquoise.

2. Seaweed and coral can be painted directly onto the background, or can be cut from tissues or construction paper and then pasted into place.

3. Dots of bright paint can be applied to the bottom of the environment to resemble pebbles or shells.

Completion of the Environment:

1. When all parts are completely dry, tape the fish, at differing heights, to the top of the carton (Figure 5-4d).

2. Paste clams, turtles, etc. to the bottom (Figure 5-4d).

3. Carefully cover all openings with cellophane. Apply glue, rather than tape, for a neat appearance.

4. For a truly dramatic final touch, cut a small opening into the top of the carton, and place an extension cord with a bulb through it. (*Note:* As a safety precaution, be certain that the lit bulb does not cast off too much heat).

Look Around You

How would we have to change in order to live under water? What do you think it would be like to live in the ocean? How are fish different from humans? How are plants that grow under water different from those that live on land? There are many marvelous textures and patterns to be found in the undersea

world. Shells, fish, pebbles, plants all have natural designs and unusual colors that can be found nowhere else. Nature provides us with objects of great beauty as well as things that meet man's practical needs. How can the marine world help man to live a fuller life in *his* world?

Adaptations

1. Paint the fish in the environment with fluorescent paint. When a black light bulb is used for illumination, the effect will be startling!

2. Paint or draw imaginative marine life and seascapes.

3. Make collages of undersea environments.

4. Add real shells and pebbles to projects relating to underwater life.

5. Paint a series of mini-murals portraying various sea adventures, e.g., "Whaling," "Pirate Battles," "Deep Sea Diving," etc.

Special Bonus Project: Fish Mobiles

Create giant "flying fish," by using the following procedure. Paint the same fish shape and design on two large sheets of construction paper. Cut out and staple both papers together, leaving a small opening. Stuff crumbled newspapers through the opening, and then staple the rest of the fish together. Hang from the ceiling of the classroom for a delightful fish mobile.

Through the Eye of the Artist

Collect reproductions of seascapes or paintings that deal with an aquatic theme. Discuss the various moods created by different artists.

Suggestions

Homer—"Breezing Up," "Northeaster," "The Herring Net"

Picasso—"Night Fishing at Antibes"

Turner—"The Fighting Temeraire Towed to Her Last Berth," "The Shipwreck"

Manet—"In the Boat"

Masson—"Battle of the Fishes"

Copley—"Watson and the Shark"

Glossary

Mobile: a design, containing various parts, that has the property of movement

Seascape: pictorial rendition of a scene at sea

LESSON 5-5

Nesting Plates

(collage and paint)

Materials

construction paper—12″ x 18″;
 shades of blue
tempera paints and brushes
paper plates—8″
paste
packing straw or strips of news-
 papers
chalk for sketching

Figure 5-5

Be Prepared

1. Cut 8″ plates in half, in advance of the lesson.

2. If packing straw is not available, cut thin strips of newspaper and store in a box until ready for use.

3. Cover all work areas with newspapers for easy cleanup.

4. At the start of the lesson, art helpers should distribute all necessary supplies. Each child will need a sheet of construction paper, a half plate, and a piece of chalk. Paste can be shared. Paints can be distributed in egg cartons or juice cans, or a central paint supply area can be set up in a corner of the room. Coffee cans, partially filled with water, will aid in quick rinsing of brushes. Put the box of packing straw or (newspaper strips), in an accessible place.

5. Designate an area for children to place their finished projects.

6. All children should wear smocks.

Introduction of Lesson to Students

What in the world are we going to make with half a plate? Do you think we could possibly make the plates into nests for birds? Surprisingly, we can! So let us "Think Spring" today, as we create some cozy nests, as well as the tiny birds to live in them.

Procedure

1. Carefully place a half plate onto the middle of the sheet of construction paper.

2. Trace an outline of the half plate with a piece of chalk, and then set the plate aside. The outline will resemble a nest.

3. Lightly draw an outline of a bird or two sitting in the nest. The figure "8" drawn so that it is tilted to the side is an easy way to start the drawing.

4. Paint the bird in realistic or imaginary colors. Remember to add an eye, a beak and tail features (see Figure 5-5).

5. Branches of a tree, as well as buds, flowers and leaves can be painted to add color and interest to the painting (Figure 5-5).

6. Apply paste along the chalk outline of the nest, then press the half plate into place (Figure 5-5).

7. Paint the plate to resemble a nest. Browns, tans, or yellows are quite suitable.

8. Carefully place several handfuls of packing straw or newspaper strips into the top of the plate (Figure 5-5).

9. Place the finished project in the designated area to dry. Carry the collage in tray-like fashion to avoid dripping paints.

Look Around You

Birds provide their young with comfortable nests made with natural and found materials. How many natural things does man use to build homes? Wood, stone, mud, straw—even ice—are but a few of the materials nature provides that can be used for shelter. What are some machine-made things that we use to build houses, apartments, etc? People paint and decorate their homes. Do birds? How do other creatures build or use natural formations, such as caves, for shelter? Through architecture, man creates buildings that are often huge in size. How do you think the size of a tree appears to a bird?

Adaptations

1. Paste these collage-paintings upon large mural paper for a bright and unusual spring display.

2. Paint pictures of birds at different times of the year. Bright birds upon white snow, with the addition of some silver glitter, are particularly effective.

3. Draw animals and their habitats.

4. Use actual feathers pasted onto the birds for especially attractive collages.

5. "Flying South" might be the title of a mural of birds that have been painted, cut out and then pasted upon bright blue mural paper.

Special Bonus Lesson: "A Bug's-Eye View of a Garden"

Further artistic discoveries about natural size relationships, patterns and colors, can be explored through the creation of a mural entitled "A Bug's-Eye View of a Garden." Have each child paint a very large flower, alongside an insect or animal (e.g., rabbit, butterfly, caterpillar, turtle, frog, etc.). Each should be cut out and pasted into an interesting composition upon bright mural paper.

Through the Eye of the Artist

Various styles of architecture and housing should be shown to the class. A discussion of how natural materials are used, as well as those that are machine-made, will enhance the lesson. Paintings depicting animals, insects, and especially birds will also broaden the appreciation of the project. Stress size relationships and natural colors.

Suggestions

 Audubon—bird drawings

 Rousseau—"Rabbit Eating a Carrott," "Exotic Landscape"

 Hicks—"The Peaceable Kingdom"

 Heade—"Passion Flowers and Hummingbirds," "Orchids and Spray Orchids with Hummingbirds"

Glossary

 Collage: various materials arranged in a pleasing composition and pasted onto a background

 Architecture: the art or science of building

LESSON 5-6

Insect Wizardry

(three-dimensional insects)

Materials

cardboard inner tubes pipe cleaners

white glue
tissue papers and colored cel-
 lophanes
scissors
yarn, glitter, foil, sequins-
 —optional

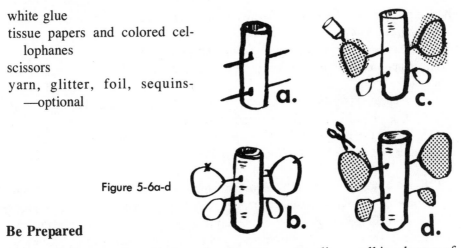

Figure 5-6a-d

Be Prepared

1. Collect cardboard inner tubes from paper toweling, well in advance of the lesson. Store them in a box until ready for use.

2. Cover all work areas with newspapers for easy cleanup.

3. Art helpers should distribute the necessary supplies at the start of the lesson. Each child will need one inner tube, a pair of scissors and several pipe cleaners. A selection of tissues and cellophane should be at each work area, and additional papers should be available if needed. Optional materials (yarn, glitter, etc.) should be placed in boxes in a central supply area. Glue can be shared.

4. Designate an area where children can place their finished projects until ready for display.

5. Scraps of tissue and cellophane can be saved and used in future collage projects.

Introduction of Lesson to Students

The world of the insect is mysterious and colorful. Bright winged, large-eyed creatures with many legs are all part of nature's designs for instects. Let's use these natural wonders as the basis for making our own three-dimensional and imaginary insect fantasies.

Procedure

1. With an open pair of scissors, carefully poke two holes, evenly aligned, approximately one-third down along the side of an inner cardboard tube. Push a pipe cleaner through the holes, so that an even amount comes through on both sides (Figure 5-6a).

2. Repeat this procedure once more (Figure 5-6a).

3. Form two sets of insect wings by twisting additional pipe cleaners onto

those already protruding. Shape the wings as desired, but bear in mind that they should appear as symmetrical, or even, as possible (Figure 5-6b).

4. Apply glue sparingly to one wing shape at a time, and carefully place tissue paper or cellophane over it, pressing the paper down firmly (Figure 5-6c).

5. Repeat this procedure on each of the remaining wing shapes.

6. Cut off all excess paper (Figure 5-6d).

7. Form the head of the insect by crumpling tissue paper into a ball, and inserting it into an open end of the cardboard tube. Secure with glue (see Figure 5-6).

8. Now for the real fun! Let your imagination really go to work decorating the insect. Add pipe cleaner antennae, curving and pasting them into place (Figure 5-6). Bright large paper eyes, and long cellophane tails can be cut and pasted. Insect's wings are symmetrical in design, so use overlapping tissue and cellophane shapes, but try to keep each set of wings similar. Paste strips of tissue around the body of the insect, and add cut-out cellophane shapes, if desired.

9. For extra sparkle, glitter can be sprinkled along the insect bodies and wings, and foil can be twisted over the pipe cleaner antennae and legs. Sequins, yarn, etc. can also be used for further embellishments.

10. When the design is complete, place the insect in the designated area to dry.

Figure 5-6

Look Around You

Have you ever thought that insects were beautiful? Often we are needlessly afraid of bees, grasshoppers, etc. and do not take the time really to look at these marvelous creatures. Have you ever watched a dragonfly as the sun shines through its wings, or a butterfly as it gently lights up on a leaf? The transparent wings, with light shining through, the evenly designed (symmetrical) patterns, and fantastic colors of bees, flies, etc. are truly wonders of nature. Watch a spider spinning its web, or a caterpillar as it wiggles gracefully across a branch. The world of the insect can open our eyes to fabulous color,

shape, texture, and design. How are our insect creations similar to real ones? How do they differ? Look around you. Become aware of fabrics, wallpapers, and other man-made products that have incorporated designs that can be found in insects. Look for paintings that stress the world of nature.

Adaptations

1. Attach lengths of nylon fishing line around the bodies of these insects, and suspend them from the ceilings. They will sway gracefully and make a most attractive room display.

2. Paint the inner tubes bright colors in advance of the lesson for extra color.

3. Use scraps of styrofoam (found in packaging) as the basis for forming insects.

4. Fashion delightful caterpillars from egg cartons cut in half, lengthwise. Paint the egg cups and add pipe cleaners to form legs.

5. Scraps of wood can be glued together, with cellophane and tissue wings added, to form attractive miniature paper weights. (See Lesson 5-7, "Marvelous Menagerie," for detailed procedures).

Extra Bonus Project: "Flutterbyes"

Fold a sheet of dark construction paper in half and then open it. Use the fold line as a guide for the body of a butterfly, and draw a wing on one half of the paper with chalk. Paint in one area of color at a time, and fold over the paper. Rub the folded sheet with your hands, and open the paper. An imprint will appear on the unpainted half. Repeat the procedure until the entire butterfly has been painted. These attractive monoprints can then be cut out and pasted upon mural paper for an attractive display.

Through the Eye of the Artist

Oriental art (scrolls, porcelains, etc.) often incorporates insects into its designs. Reproductions of such work, along with paintings that include insects in the compositions, should be shown and discussed with the class.

Suggestions

 Léger—"Big Julie"
 Benton—"July Hay"
 Audubon—bird paintings
 Miro—"Harlequin's Carnival"
 Van Huvsum—"A Vase of Flowers"

Glossary

Transparent: light passes through

Symmetrical: equal shapes on both sides of a dividing line which may or may not be visible

Three-dimensional: having the quality of height, width, and depth

LESSON 5-7

Marvelous Menagerie

(lumber yard scraps)

Materials

wood scraps
white glue
tempera paints and brushes
varnish or shellac—optional

Figure 5-7

Be Prepared

1. Visit local lumber yards (or carpentry shops) well in advance of the lesson. Dealers will often contribute scraps of wood that would ordinarily be thrown away. Children should also be asked to bring in odd pieces of wood that may have been discarded. Caution boys and girls to obtain parental permission before bringing in anything from home.

2. Cover all work areas with newspapers for easy cleanup.

3. Children should wear smocks.

4. Art helpers should distribute the necessary supplies at the start of the lesson. Paints can be distributed in egg cartons or juice cans, or a central paint supply area can be set up in a corner of the room. Coffee cans, partially filled

with water, will aid in quick rinsing of brushes. Glue can be shared. A supply of small wood pieces should be at each work area, with more available if needed.

5. Designate an area for children to place their finished projects until ready for display.

6. Have a large box for children to replace all usable scraps of wood.

Introduction of Lesson to Students

In our world, wood is used almost everywhere! It serves as building material and is the basis of paper products, fuel, and has countless other uses. Today, we are going to use scraps of wood as an art material with which to create unusual bits of animal sculpture. Strange alligators, funny lions, tiny squirrels . . . anything goes! We can let the shapes of the wood guide us as we create a marvelous menagerie!

Procedure

1. Choose one or two pieces of wood and examine them carefully. Turn them in different directions, look at the grain of the wood, and see if there are any indentations or markings that could be used as part of a sculpture of an imaginary or realistic animal.

2. When an idea has been decided upon, glue together the parts of wood that are needed. That long piece on top of that rectangular shape could form a wonderful giraffe (Figure 5-7a). Some shapes of wood might not need any other pieces added, such as that long form; it would be ideal for an alligator (Figure 5-7b). Perhaps the addition of a narrow wooden piece would be perfect as a squirrel's tail (Figure 5-7c). Or, you may wish to create a creature that no one has ever heard of before!

3. Hold the parts in place for a silent count of ten. Since the glue dries quickly, the sculptures can be painted once the parts feel secure. Facial features, designs, collars, ears, etc. all can be added to the sculpture with paint (see Figure 5-7a-d).

4. Once the sculpture is complete, carefully place it in the designated area to dry.

Look Around You

How many objects that are made of wood do you see in the room? The door, the floor, our desks, pencils, paper, window sills . . . the list is quite a long one. How many wooden objects can you think of that you see everyday at home? Ask your family to discuss this with you, but also talk about the natural beauty in wood. The colors, grains, and forms of wood are often not seen

because we do not *look* at them carefully. How does man change the natural appearance of wood? Our wooden menagerie used the forms of scraps of wood. Why not search with your family for driftwood, branches, etc. that could be made into natural sculpture simply by cleaning and displaying them.

Adaptations

1. Make these unusual figurines as gifts.
2. Use the same techniques to create insects, birds, fish, etc.
3. Add scraps of collage materials, such as felts and yarns, to the wooden creations.
4. Work in groups, using wood scraps to create objects related to a central theme, e.g., a circus, a zoo, a farm, etc.

Special Bonus Project: Abstract Assemblage

Glue or nail various scraps of wood into abstract designs. These constructions can stand alone, or may be nailed onto a large piece of wood as a background. For further embellishments, add screws, nails, bolts, etc. and other found materials.

Through the Eye of the Artist

Wood has been used by sculptors and artisans throughout time. Examples of the varying ways in which the artists used this natural medium should be discussed and shown to the class.

Suggestions

Carvings and masks by tribal peoples (African, American Indian, etc.)
Assemblages by Nevelson
Picasso—"Mandolin"
Moore—"Reclining Figure"
Medieval and ancient wooden carvings and sculpture

Glossary

Sculpture: a three-dimensional design created by carving, building, or modeling

Assemblage: constructions put together with various materials

LESSON 5-8

Instant Fossils

(sand casting)

Materials

sand
boxes of medium size—shoe
 boxes, gift boxes, etc.
containers for water, and sticks
assorted small objects—twigs,
 pebbles, shells, bottle caps,
 buttons, etc.
plaster of paris

Figure 5-8

Be Prepared

1. Cover all work areas with newspapers for easy cleanup.

2. If natural beaches are not nearby, sand can be obtained from brick and cement dealers.

3. Have children bring in boxes, with their names taped to the bottom, well in advance of the lesson. They should also bring in small objects that can be stored in boxes until ready for use.

4. All children should wear smocks.

5. Art helpers should distribute the necessary supplies at the start of the lesson. Each child will need a box and an assortment of small objects. Sand should be placed in a large plastic bag at a central supply area, and a container of water should be at each work area.

6. To facilitate the lesson, assign ''sand crews'' to partially fill each box with sand, before it is distributed. Plastic cups or coffee cans can be used to scoop the sand.

7. Another team of youngsters should be assigned to mix and distribute the plaster of paris to each work area at the appropriate time. Empty plastic food containers make ideal receptacles for this purpose.

8. Designate an area for children to place their completed sand castings.

9. Assign clean-up crews and allow time for this.

Introduction of Lesson to Students

Have you ever thought what it might have been like to live in the world when dinosaurs roamed the earth? Our clothes, our homes, our food, our surroundings . . . would all be very different from those we have today! Much of what we know about the pre-historic world has been learned from fossils, nature's unusual way of hardening and preserving objects for many, many years. Dinosaurs are no more to be seen, but with sand, water, plaster of paris, (and some imagination), we can create some exciting "fossils" of our own!

Procedure

1. Wet the sand in each box with water so that it is damp, but not soaked.

2. Pack the sand as you would a sand castle or mud pie.

3. Form a design by pressing various objects into the sand, and making impressions with sticks or your fingers (Figure 5-8a).

4. When the arrangement in the sand is complete, it is ready for casting. Follow directions on the package of plaster of paris for mixing. The usual rule of thumb is two parts plaster to one part water. Stir the mixture so that it is smooth and of a consistency that is not too thick to be easily poured.

5. Pour the plaster carefully over the sand to about an inch thickness and set the box aside to harden for about ten or fifteen minutes (Figure 5-8a). (This is an opportune time to discuss texture and shape in art, nature and manmade items. See "Through the Eye of the Artist").

6. When the casting is hard to the touch and is past the stage of feeling warm, carefully lift it from the box (Figure 5-8b). Should this prove to be difficult, simply cut away the sides of the box, but be certain to do this while working on newspaper, in order to catch any sand that may run out.

7. Turn the casting so that the plaster is on the bottom (Figure 5-8c). Rinse off any excess sand from the top, with water.

8. Place the castings in the designated area to dry thoroughly.

Look Around You

Fossils are petrified remains of *natural* things. Our sand castings differ, not only because they are not created by nature, but because we added *man-made* objects. We also changed the texture and appearance of these objects, as well as the plaster. Do the fossils change from their original appearance? How? Man often decorates and changes the color, shape, and texture of objects. How do natural forces change things? Think about rain and water on beaches and rocks. What else?

Adaptations

 1. Use the sand castings as unusual paperweights.

 2. Mount the castings using strong glue, to wood, cork or burlap-covered thick cardboard, for unusual wall hangings.

 3. If possible, visit a nearby beach and make sand castings directly in the sand, using objects found in the environs. This can also prove to be a marvelous *family* project. (See Chapter 6, "Where We Live," for other projects involving the environment.)

 4. Make hand impressions and cast them as "Fossils of 20th Century Man"; accompany the castings with imaginative drawings of hands of "Men of the Future." (See Chapter 10, "The Future," for other projects relating to the world of tomorrow.)

Through the Eye of the Artist

 Sand castings are used in many modern day buildings as decorative walls. Along with pictures of such lobbies, offices, and outdoor walls, examples of modern sculpture that incorporate plaster should be shown to the class.

Suggestions

 Dubuffet—"Abrantegas'"—plaster covered with painted paste

 Agostini—"Hurricane"—plaster

 Giacometti—"Figure"—plaster

Glossary

 Cast sculpture: sculpture made in a mold

 Texture: tactile quality, seen or felt

WE ARE AFFECTED BY WEATHER

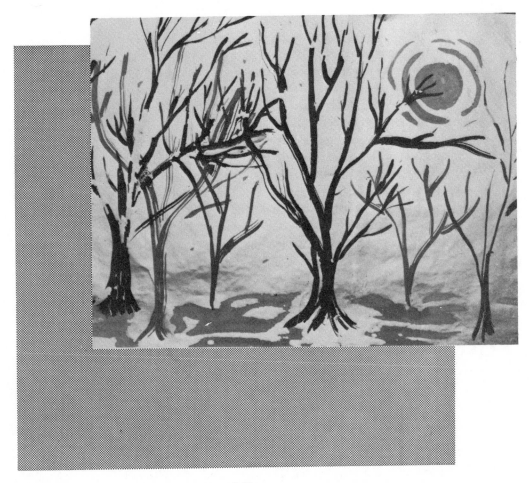

Art Activities Related to

Weather and Seasons

Rain, snow, fog, wind . . . the many moods of Mother Nature are expressed through the temperaments of weather and seasons. To help the child gain a better understanding and awareness of the vital influence the elements have upon their world, the routines of their daily lives, their modes of dress, and their surroundings, is the goal of this chapter.

Through varied media (pastels, stencils, cut paper, torn paper, collage materials, tempera, and metallic papers) children will explore techniques of artistically interpreting various kinds of weather. A life-size snowman, working on shapes related to weather, building an actual kite, and a number of special bonus projects, are also included among the features.

The teacher should feel free to inter-relate these weather-oriented activities with other methods and techniques within this book, and to adapt them to the interests of the students. Most importantly, it is hoped that boys and girls will gain greater insight and appreciation of *all* things natural in their world, as they expand their creative abilities while learning to use their minds and eyes as artistic weather watchers.

LESSON 6-1

This Snowman Won't Melt

(life-size sculpture)

Materials

two large paper bags
paper paint bucket
plaster-covered gauze; contain-
 ers for water
scissors
white glue
white paint and brushes
newspapers
felt scraps, yarns, etc.
one length of crepe paper; silver
 and blue glitter—optional
large box—optional
masking tape Figure 6-1

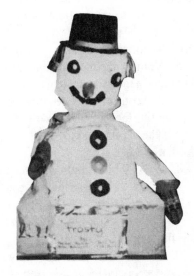

Be Prepared

1. Cover work areas with newspapers for easy cleanup.
2. Have an ample supply of newspapers for stuffing bags and forming limbs.
3. Children should wear smocks.
4. To facilitate the lesson, pre-cut gauze strips into lengths of approximately 12″. Extra rolls of gauze should be available if needed.
5. All supplies can be shared. Paint, poured into coffee cans, can be set in a central supply area, along with brushes, until ready for use. *Note:* An entire class will not be able to work on one snowman; therefore, it is advisable to choose a committee of five or six children for the project. Or, plan on making a snow "family" of several figures, so that all students can participate.

Introduction of Lesson to Students

Everyone likes to build a snowman, but no one enjoys seeing it melt. So, let's build one today that will last even during the summer months; one that will be as large as a real one. We won't even have to wait for a snowy day to begin.

Procedure

1. Crumble newspaper into the two large paper bags so that they are rounded and full, making one bag larger than the other. (Bags that blankets or bath rugs are packaged in are particularly suitable in size.)

2. Tape the smaller bag onto the larger one, and secure it by wrapping strips of plaster-covered gauze that have been dipped into water around it, at the place where the two bags join.

3. Roll lengths of newspapers to form ''arms''; tape into place on the body, and repeat the same procedure.

4. Begin to cover the entire body and limbs of the snowman with strips of wet gauze. Two layers of covering are generally sufficient to form a sturdy figure. Make sure that all strips overlap.

5. Turn a paper paint bucket upside down, and tape it to the top of the snowman's head. Cover it with one layer of wet gauze strips.

6. A protruding nose may be fashioned from wet gauze strips and attached to the face in the same procedure that has been used throughout.

7. The snowman can be allowed to dry before painting, or can be painted while still wet.

8. Eyes, mouth, buttons, etc. can be cut from bright felt scraps and glued into place, as well as strips of yarn for hair. Other embellishments such as a crepe paper scarf and real mittens can also be added (see Figure 6-1).

9. For extra sparkle, silver and blue glitter can be sprinkled over the body while the paint is still wet.

10. For extra height, the entire snowman can be placed upon a large box that has been painted or covered with bright paper (Figure 6-1).

Look Around You

We have built quite an attractive snowman. How is it like a real one? How does it differ? Not only won't it melt, but the texture is completely different from real snow. The temperature of our snowman is not cold, either. Is it possible to keep snow from melting in warm weather? Have you ever put a snowball into the freezer, and waited to take it out in the summer? Why not suggest this to your family, and perhaps you can wrap some snow in freezer paper, and preserve it until a special warm weather occasion. When you remove it, see if it has changed in color or texture. You will have changed your world of weather in a special way!

Adaptations

1. Almost any kind of figure can be built for display, school theatrical productions, study projects, etc. using the procedures in this lesson. Boxes and cartons can be substituted for bags. Really complex figures can be shaped from

chicken wire, then covered with gauze strips. Be daring: attempt whatever suits you and your class . . . whether it be realistic sculpture or imaginary subjects.

2. Newspaper strips, soaked in a papier mâché mixture of water and flour, stirred to a creamy consistency, is a most suitable substitute for plaster gauze.

3. Make a life-size zoo or circus using these techniques for a truly spectacular project.

4. Have each child make a three-dimensional head of himself using these procedures.

Through the Eye of the Artist

A discussion of theatrical props and commercial window displays that are three-dimensional, might properly follow this lesson. Reproductions of sculpture used by tribal peoples for rites related to crops and weather will also broaden the appreciation of the lesson.

Suggestions

American Indian
African
Oceanic } carvings, masks, etc.

Glossary

Three-dimensional: having the quality of height, width, and depth

LESSON 6-2

Neither Will This One

(torn paper collage)

Materials

18″ x 12″ paper—blue, black,
 purple
scrap paper—white
paste and paste sticks
crayons

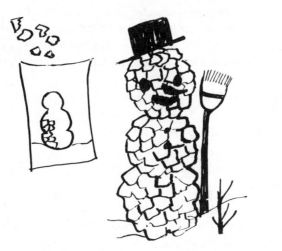

Figure 6-2

Be Prepared

1. Have art helpers distribute the necessary supplies at the start of the lesson. Each child will need a sheet of construction paper and several small pieces of white scrap paper. Paste and crayons should be at each work area and can be shared.

2. Have a torn paper snowman ready to show the class. This will acquaint the teacher with the creative procedures of the lesson, and will provide the students with a visual example of the completed project.

3. Designate an area where the children can place their collages until ready for display.

Introduction of Lesson to Students

When snow falls, one of the first things we probably think about is making a snowman. Balls of snow are packed and rolled until they are large enough to form a head and body. The snow is soft to the touch, and we can enlarge the snowman by adding handfuls of it to the body. Let's imagine our white paper is snow, and we will "build" a snowman very much the same as we would a real one.

Procedure

1. Lightly sketch a snowman onto the construction paper, using any color crayon.

2. Tear a small piece of white paper. Look carefully: do you notice a soft, fuzzy edge in the place where the paper was torn? Tear some more pieces and think of them as handfuls of soft snow.

3. Proceed to apply a small amount of paste to an area of the drawn

snowman. Place pieces of torn paper onto that area and press them so that they stay in place (see Figure 6-2). Overlap the paper so that very little of the background construction paper shows. Continue to apply paste, and fill in with torn bits of white paper until the snow man is completed.

4. Add embellishments with crayon, such as a tall hat and broom. Crayon facial features onto the snowman, as well (Figure 6-2). Backgrounds, such as trees and snow, also add interest to the composition.

5. Place the finished project in the designated area.

Look Around You

Do our snow collages resemble real snowmen? The color, the shape, the texture of the pieces of paper, how are they different? Our paper ones are permanent and won't melt, for one thing. For another, our "snow" is not cold. Are there uses for artifical snow? Ski areas, decorations, displays, etc. Where else? Are there artifical grass and man-made plants? Where else have you seen or read about man-made copies of nature? Which do you like better: natural plants, snow, and grass, or manufactured ones? Why? Do you really stop to observe the differences in temperature, color, scenery, etc. that are created in your world by weather? Would you dress the same for snow as you would on a summer's day?

Adaptations

1. These collages make delightful bulletin board displays.

2. Use them for covers of booklets pertaining to stories and poems about winter.

3. The same methods may be used for other seasonal pictures, e.g., torn paper for leaves of summer, or autumn trees. (Use appropriately colored scraps of paper for the leaves, and crayon the tree trunks, grass, etc.).

4. Paint may be used for backgrounds and decorations, rather than crayon.

5. Add scraps of fabric to the collages for scarves, buttons, eyes, etc.

6. Make a very large drawing of a snowman (or lady), and have groups of children fill it in with torn paper.

7. Be ambitious and create an entire snow family in this manner.

8. Draw seasonal pictures and compare colors, trees, landscapes, etc. (*Note:* For other methods of using torn paper, see Lesson 1-2: "Scaredy Cats.")

Through the Eye of the Artist

Paintings depicting winter are found in many styles and periods. A display of such reproductions, followed by a discussion of the techniques used by the artists to portray snow, and the choice of subject for the composition, will enhance this lesson.

Suggestions

Sloan—"Backyard, Greenwich Village"
Kent—"Winter," "Mount Equinox, Winter"
Metcalf—"Icebound"
Brueghel—"Hunters in the Snow"
Glackens—"Central Park, Winter"

Glossary

Collage: various materials arranged in a pleasing composition and pasted onto a background

Overlap: an object placed partially over another

LESSON 6-3

Rain-Washed Cities

(stencil rubs)

Materials

oaktag or other firm paper
white paper
pastels or chalks
tissues
black crayons or felt markers
scissors
rulers

Figure 6-3

Be Prepared

1. Cover work areas with newspapers for easy cleanup.

2. Art helpers should distribute the necessary supplies at the start of the lesson. Each child will need two pieces of paper, one white and one oaktag. *The papers must be the same size.* Scissors, chalks, and rulers can be shared. A supply of small tissues should be available at each work area for rubbing. (*Note:* This is a particularly good lesson in which to use up broken chalks and pastels.)

3. All children should wear smocks. A discarded man's shirt, with the sleeves cut so that the child can work freely, makes a suitable cover-up.

4. Have a pastel rubbing made in advance of the lesson for demonstration purposes.

5. Designate an area for students to place the finished projects until ready for display.

Introduction of Lesson to Students

Have you ever seen tall buildings just after a rain? There is something very soft and misty about the appearance of a city when the skies and streets have been "washed" by rain. We are going to attempt to capture that very special look through the use of pastels and stencils, or shapes cut from cardboard. The method is somewhat unusual, and the results will truly surprise you. Buildings silhouetted against the sky are called skylines, and through our art, we are going to make some special ones today.

Procedure

1. On a sheet of oaktag, draw a simple outline of a sky of a city (Figure 6-3a). Use a crayon and don't worry about having the lines perfectly straight at this time. Be sure to vary the height and width of the buildings, which actually resemble rectangles.

2. When satisfied that there is variety to the skyline, straighten the lines by going over them, this time using a ruler.

3. Cut out the silhouette of the buildings so that there are now two pieces of oaktag forming two stencils. Mark the top one with an arrow pointing downwards, and the other stencil with an arrow pointing upwards (Figure 6-3a).

4. Take the top stencil and rub the bottom with different colors of chalk (Figure 6-3b).

5. Place the stencil onto the white paper, carefully aligning the top edges, and begin to rub downwards along the chalked edges with a piece of tissue (Figure 6-3b). A soft textured effect will be produced, and when the stencil is lifted the outline of the skyline will be left.

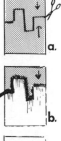

Figure 6-3a-c

6. Repeat the procedure with the bottom half of the stencil, this time rubbing *upwards* (Figure 6-3c). When the stencil is lifted, both halves of the white paper will have been filled in with chalk, and a rubbing of the entire skyline will appear, as if by magic.

7. Accent the shapes of the skyline with black crayon or felt markers. Several windows, street lights, vehicles, etc. can be added in like manner (see Figure 6-3 for finished project).

Look Around You

The world around us changes in appearance along with changes in the weather, season, and the time of day or night. Our rainwashed cities appear soft and even delicate. How would such a city look during a dark thunder storm or snow blizzard? Would the color of the sky change? How would the buildings change in appearance? Are there times that skylines look less clear? Think of fog. Night lights in windows and on streets, reflections of ice and rain also produce changes. Wherever we live—in a city, a small town, or in the country—weather not only affects our activities, but the appearance of our surroundings. What would the world be like if it never stopped raining?

Adaptations

1. Experiment with other color effects, using the same techniques but limiting the pastels to white and blue, and the background paper to black. The effect will be a soft snow storm.

2. Paint or draw pictures of the same locales during differing weather conditions.

3. Collect newspaper and magazine pictures of outdoor scenes during different climatic conditions.

4. Use different media, such as water colors, and experiment with ways of depicting weather.

5. Divide into groups of five or six and paint mini-murals depicting snow scenes, rain, etc. Do not limit the subjects to landscapes, but include seascapes, animal life, etc.

Special Bonus Project:

Cut realistic or abstract shapes (stencils) from oaktag. Chalk all edges, and place onto construction paper. Rub all edges with tissue in an outward direction. Lift the stencil and repeat the procedure, overlapping the forms from time to time. Unusual patterns and designs can thus be achieved.

Through the Eye of the Artist

Children's appreciation of the artist's attempts to capture the effects of weather in paintings (particularly of cities) can be enhanced by following this lesson with reproductions of such art. Especially interesting are the paintings by the artist, Monet, depicting the same scenes at different times of day.

Other Suggestions

Glackens—"Central Park, Winter"

Tobey—"San Francisco Street"

Dehn—"Spring in Central Park"

Burchfield—"Rainy Night"

El Greco—"View of Toledo"

O'Keeffe—"New York Night"

Rousseau—"Road in the Suburbs"

Renoir—"Le Pont Neuf"

Glossary:

Skyline: buildings as they appear silhouetted against the sky

Stencil: shape cut from a material, such as paper or cardboard, that produces a design by rubbing crayon, paint or pastel over or around it.

LESSON 6-4

"Raindrops Are Falling on my Head. . . ."

(collage: glossy paper plus painting)

Materials

glossy papers

construction papers—dark colors, or all blue, 12″ x 18″

collage materials—yarns, wall papers, rickrack, cellophane, etc.

paste and paste sticks

tempera and brushes

scissors
construction papers—assorted
 colors
crayons or chalk

Figure 6-4

Be Prepared

1. Cover all work areas with newspapers for easy cleanup.

2. To facilitate the lesson, have art helpers cut large raindrop shapes from construction papers in advance of the lesson. Squares of glossy paper should also be pre-cut, approximately 8″ x 8″.

3. Each work area should have an assortment of collage materials, paste and paste sticks, and scissors. Each child will need one raindrop-shaped paper and a piece of chalk or a crayon. All other materials can be shared. Extra collage materials should be available if needed.

4. Paints can be distributed in egg cartons or juice cans, or a central paint area can be set up in a corner of the room.

5. Designate an area for children to place their finished collages until ready for display.

Introduction of Lesson to Students

Rain can be fun! Even songs have been written about wet weather: "Singing in the Rain," "Raindrops Are Falling on My Head," and the familiar chant "Rain, Rain Go Away," to name a few. Let's go for a pictorial walk in the rain today. So get out some paper umbrellas and raincoats and even those big raindrops won't get us wet.

Procedure

1. What are some special clothes we wear in the rain? Boots, raincoats, rainhats, and umbrellas. Imagine all these things as you begin to create a boy or girl (perhaps yourself) strolling in the rain. Almost everything can be drawn starting with the basic shape of a "U." Select a piece of glossy paper and draw

an upside down "U" on the back with crayon. Cut it out, and you will have the basic shape of a raincoat. Now select a scrap, and make another, wider "U" for the hat. Choose a colorful piece of wallpaper, and still drawing a wide "U," draw an open umbrella. (*Note:* See Lesson 3-2, "From A to Z," for further ideas on incorporating letter shapes into drawings.)

2. Arrange all these parts onto a raindrop-shaped paper. Be sure to leave room for a head; which will eventually be painted on, along with legs and feet.

3. Paste the various parts into place, using the glue sparingly.

4. Paint a head, legs, boots, arms, grass, etc. (see Figure 6-4).

5. Add further materials, such as yarn hair or a cellophane puddle, with paste, to create more interest.

Look Around You

Would ordinary paper have been as attractive as the glossy paper we used to make raincoats and hats? Do you think the raindrop shape adds interest to our collages? How does weather affect what we wear? How does weather affect our activities? Do temperature and climate determine the kinds of housing we need? How does a rainy-day sky differ from a sunny or snowy one? Is the sky always blue? Do the same objects or things appear differently in various kinds of weather? Think of a ship in sunlight, in a storm, and in a fog. Our weather affects our lives in many ways: the appearance of our surroundings, what we wear, and what we do.

Adaptations

1. Display these raindrop collages, individually or pasted together on a mural background.

2. Use this lesson and adapt it to other weather and seasons, such as collages or paintings depicting snow scenes or sunny days.

3. Play a game of "Weather" by listing song and story titles, as well as books and plays, that incorporate words pertaining to weather. The person or team with the most titles wins.

4. Make comedy drawings of wrong attire, landscape details, etc., such as swim trunks in the snow.

5. Paint unusual themes such as "If Flowers Bloomed in the Snow."

Extra Bonus Lessons

1. Using the ideas in this lesson, make a mural of activities related to weather. Combine the shapes of clouds, sun, snowballs, and raindrops onto a large background paper and have children crayon, collage, or paint related activities into the shapes.

Figure 6-4a

2. Divide a sheet of white paper into four equal sections. Using crayon draw one object (house, tree, etc.) or person as they would appear during four seasons (see Figure 6-4a).

Through the Eye of the Artist

Reproductions that depict various kinds of weather, particularly those that include people and their attire, should be shown to the class. Discuss the colors used, the shape of trees and plants, and the brush strokes employed to achieve the desired effects of weather. This is also an opportune time for a simple introduction to painting on shaped canvas.

Suggestions

Monet—"Westminster"

Renoir—"The Swing"

Sisley—"Boat During a Flood," "Snow at Louveciennes," "Banks of the Seine in Autumn"

Brueghel—"Hunters in the Snow," "The Harvest"

Glackens—"Central Park, Winter"

Glossary

Shaped canvas: works on non-rectangular shapes; early examples are religious painting on altarpieces; later examples have ranged from circles to alphabet shapes to irregular forms.

LESSON 6-5

By the Silvery Moon

(painting on metallic paper)

Materials

metallic papers—gold, silver, blues, purples, etc.—approximately 12″ x 18″

manila paper—same size as metallic

tempera paints—black, grey, purple, blue, violet, magenta, white, brown

mounting papers—assorted dark colors, larger than the metallics

staplers

pencils

small brushes

Figure 6-5

Be Prepared

1. All tempera should be mixed with a small amount of liquid detergent in advance of the lesson, so that the paint will adhere to the metallic papers.

2. Cover all work areas with newspapers for easy cleanup.

3. Art helpers should distribute the necessary supplies at the start of the lesson. Each child will need a sheet of metallic paper, a sheet of manila paper, and a pencil. Paints can be distributed in egg cartons or juice cans, or a central paint area can be set up in a corner of the room. Coffee cans, partially filled with water, will aid in the quick rinsing of brushes.

4. Designate an area where students can place their finished paintings to dry.

5. These metallic papers require a backing to prevent buckling. Have a supply of contrasting construction paper, larger in size than the metallic papers, along with staplers for children to mount their finished work.

6. All children should wear smocks.

Introduction of Lesson to Students

Have you ever looked out your window on a particularly cold and clear winter night? Everything seems to take on a strange, shining look, especially by the light of a full moon. Let's use these beautiful metallic papers to capture the feeling and mood of such an evening.

Procedure

1. Sketch a winter scene with pencil upon the manila paper. Think of a cold and bright evening. Perhaps bare trees, silhouetted against a full moon (see Figure 6-5), or houses snuggled against a mountain. A city skyline, stark against a shining sky, might be still another choice of subject matter. You may even wish to show a scene as viewed from a window.

2. After the sketch has been teacher-approved, place it on top of a sheet of metallic paper and proceed to trace the outlines of the drawing. When the manila paper is lifted, the outline will appear on the metallic paper.

3. Use these outlines as a guide for your painting. They need not be followed exactly, and you may wish to add things as you go along. Keep the composition relatively simple, however, because most of the metallic paper should be left unpainted so that its shine and color can be seen.

4. Place the finished paintings in the designated area to dry. Always carry them in "tray-like" fashion to prevent dripping of paints.

Look Around You

Let's look at our paintings with the lights in the room turned off. The effect is really special! The glow and shine of the metallic papers are quite unusual. Do you think we have captured the feeling of cold weather? Why? The metallic paper adds greatly to the wintry mood. How about our choices of color? Do you think a great deal of warm colors, such as yellows and oranges would have helped or spoiled the mood? How do the different seasons create changes in light, color, and shapes within landscapes. Do our appearances change with the temperature? How? Can our moods change with the weather? How?

Adaptations

1. These paintings make a particularly striking display.
2. Paintings on metallic papers are also appropriate for holiday pictures.

3. Still life paintings and abstract designs should be attempted, using the same procedures.

4. Cut silhouettes from black paper and paste onto backgrounds of metallic papers.

5. Use these techniques on small paper to create unique greeting cards.

6. Ordinary household cooking foil can be used if metallic art papers are not available. Cut the foil carefully, to avoid crinkling.

Through the Eye of the Artist

A series of reproductions depicting various seasons, followed by a discussion of how varying effects are achieved by the artists, will broaden this lesson. An explanation of tinsel painting and reverse painting on glass will also add dimension to this project. (see Glossary)

Suggestions

Glackens—"Central Park, Winter"

Sloan—"Backyards, Greenwich Village"

Tryon—"Twilight—May"

Inness—"Autumn Oaks"

Blakelock—"Moonlight"

Rembrandt—"Landscape with an Obelisk"

Brueghel—"Hunters in the Snow," "The Harvest"

Sisley—"Banks of the Seine in Autumn"

Glossary

Reverse painting on glass: first produced in the 16th century; often found later as examples of American folk art. The technique consisted of painting on glass so that the painting is viewed *through* the glass.

Tinsel painting: particularly popular in the 19th century in the United States, and related to reverse printing. Simplified figures are painted on glass, which is then backed with crinkled tinfoil.

LESSON 6-6

Go Fly a Kite

(paper flat kites)

Materials

wood strips—approximately ⅛″,
 thick; spruce, balsa, or pine
strong string or fishing line
paper—brown wrapping
scissors
white glue or rubber cement
crayons, felt markers, or
 paints—optional
strips of cloth (rags)
several art blades (in handles)

Figure 6-6

Be Prepared

1. Lumber yards will often sell and cut left-over wood strips at a nominal cost. Have enough strips so that each child will have two, one longer than the other. The actual dimensions can vary, depending upon the size of the kite desired.

2. Large sheets of brown wrapping paper should be pre-cut to facilitate the lesson. These should be larger than the desired kite size. Each child will need one sheet. Glue and scissors can be shared.

3. Ask children to bring in their own string or fishing line in advance of the lesson. This can be wrapped around a wooden stick or branch, so that the string can be easily unwound. Boys and girls should also bring in cloth strips.

4. Cover all work areas with newspapers for easy cleanup.

5. Art helpers can be assigned to help younger children notch the two kite sticks. Older children should be cautioned to use art blades very carefully, and should use them only under careful teacher supervision.

Introduction of Lesson to Students

Having the wind catch a kite and lift it majestically, is exciting to watch,

but it is even more fun actually to *make* a kite and fly it. We'll create our own kites today, and on the first windy day we can all "go fly a kite."

Procedure

A. We each have two sticks, one longer than the other. This is the upright stick, the shorter one is the cross stick. Place the two sticks so that they crisscross, with the shorter stick approximately one fourth down from the top of the upright stick (Figure 6-6a).

2. Secure the two sticks by wrapping around string at the point where they join. A small amount of glue added to the area will add additional adhering strength (Figure 6-6b).

3. Carefully notch each end of the sticks with an art blade. (See *Be Prepared* for suggestions)

4. Run string around the ends of the sticks, in the notches, to form the frame of the kite (Figure 6-6c).

5. Place the frame onto large brown wrapping paper, and cut a similar shape, approximately two inches larger.

6. Cut the paper at each corner (Figure 6-6d) and fold over the edges of the paper over the string.

7. Paste the edges down.

8. Turn the kite over so that the sticks do not show. If decorations are to be added, now is the time to do so. Bright paints, crayons, or felt markers may be used to create abstract or realistic designs. Since the kite will actually be seen from a great distance, keep the designs simple but bold.

9. Attach strings to each corner of the kite so that they form a pyramid shape. These are called bridle strings (Figure 6-6e).

10. Tie a length of string to the bottom of the kite to form a tail and add strips of cloth about six inches apart to it (Figure 6-6f).

11. To complete the kite, tie the remaining string (kite line) to the bridle (Figure 6-6f).

Look Around You

After we fly our kites, several adjustments may have to be made. If the kite dives, we may have to add more cloth strips to its tail, or even to shorten it. If the kite still does not fly well, we may have to adjust the bridle strings. But in the end, these experiments and adjustments will all be well worth the effort as our kites take flight and soar. Do you think that the kites will appear differently in the sky? Will the size seem smaller and the designs not as distinct? Do airplanes appear differently on the ground than in the air? How about birds and insects such as butterflies? Is the wind essential for them to fly also? Will the *kind* of wind affect the flight of our kites? How else can wind affect our lives?

Adaptations

1. Have a class kite-flying contest. Give awards for the highest flying, the most beautifully decorated, the most original, etc. (*Note:* Remember, that kite flying should always take place in open area, away from electric wires.)

2. Experiment with different coverings, e.g., tissue papers, cellophanes, and cloth.

3. Try unusual shapes, abstract or resembling fish and birds.

4. Make drawings of original designs for kite structures and build them. Perhaps several youngsters will enjoy working on such a project together.

Extra Bonus Lessons

1. Crayon Resist:

Draw pictures depicting snow scenes in crayon that has been applied heavily. Then cover the entire paper with diluted white paint to achieve unusual snow-like effects. Yellow paint can be used in like manner to portray sunny weather (see Lesson 10-1, "Blast Off,") for detailed procedures and methods).

2. Imagination and Weather:

Paint imaginary or dreamlike pictures pertaining to weather, e.g., "The Night the Sun Shone," "When Flowers Bloomed in the Snow," etc. (See Chapter 2, "Our World of Imagination and Fantasy," for detailed ideas.)

3. Weather Calendar:

Create an unusual weather calendar by having children draw or paint pictures depicting the weather of each day of a specified month as it actually occurs. Paste the pictures onto a large calendar that has been painted upon mural paper.

Through the Eye of the Artist

Have the children research the various kinds of kites and uses for them, both practical (weather readings, etc.) and artistic. Oriental kites are considered an art form by many, and if possible, bring in such kites or show reproductions of them. Kites shaped like fish, birds, butterflies, and even dragons are particularly exciting.

Glossary

Flat kite: two sticks crossed and used as the kite form
Eddy kite: tailless kite, using a bowed cross stick
Box kites: three-dimensional kites, shaped like boxes

WE ARE PART

OF OUR ENVIRONMENT

Where We Live

The young artist, like the adult, enjoys portraying subjects with which he is most familiar. Boys and girls, therefore, will find the art activities that follow particularly interesting and self-motivating because they deal primarily with the child's most recognizable world: his immediate environment.

Home, community, parents, and occupations are themes that are incorporated into lessons designed to stimulate the child's appreciation of his own surroundings, as well as gaining insight about the environs of others. Through individual and group projects that include collage, painting, and three-dimensional work, children will be encouraged to explore new ways of improving upon, as well as preserving, various aspects of their environment. Through the use of such readily obtainable materials as empty cans and cartons, boys and girls will also find a simple, yet intriguing, introduction to interior design and building. The many jobs performed in a community and the vital roles they play are also examined and expressed in visual form.

Whether the child lives in a seaside village, a city, town, or on a farm, all projects can be changed and related to his particular interests. For example, the procedures for the lesson "Cities by Sunset" can readily be altered to "Farms by Sunset." In addition, the activities in this chapter inter-relate particularly well with the sections on Nature and Ecology.

The child's environment is the most familiar part of his world. Through his art, he can develop a more creative concept of his immediate surroundings, as well as the world around him.

LESSON 7-1

Salute to Mother

(family paintings)

Figure 7-1

Figure 7-1a

Materials

construction paper—16″ x 22″
tempera paints and brushes
wallpaper scraps—approxi-
mately 6″ x 9″
chalk
paste and paste sticks

Be Prepared

1. To facilitate the lesson, pre-cut wallpaper into rectangles approximately 6″ x 9″. Scraps of fabric, however, can be substituted for the paper.

2. Cover all work areas with newspapers for easy cleanup.

3. Art helpers should distribute the necessary supplies at the start of the lesson. Each child will need a sheet of construction paper, chalk, and a piece of wallpaper. Paste can be shared. Paints can be distributed in egg cartons or juice cans, or a central supply area can be set up in a corner of the room. Coffee cans, partially filled with water, will aid in the quick rinsing of brushes.

4. Children should wear smocks. A discarded's man's shirt, with the sleeves cut so that the child can work freely, serves as a suitable cover-up.

5. Designate an area, even if it is the hall floor, where children can place their finished paintings to dry.

Introduction of Lesson to Students

Have you ever really given thought to what your mother does each day to make your life more pleasant? Think about some of the many things Mother does during an ordinary day. Clothes are laundered and ironed; the house is kept clean; perhaps a member of the family is ill and needs special care; someone needs a ride to the store or the movies; food must be bought and cooked . . . the list can go on and on. Perhaps Mother works in an outside job as well. More than likely, she still finds the time to do all these things and still have time to read stories with you, go on family outings, help with homework, and even have a hobby. Let's salute Mother in our paintings, today!

Procedure

1. Decide on a theme that will show your mother in one of her activities. Remember, she does many, many things!

2. On the unprinted side of the wallpaper, draw an upside down "U". This is an easy way to form a dress or blouse (see Figure 7-1). Cut it out and use the excess paper to form sleeves if desired.

3. Paste the blouse or dress upon the construction paper, making sure to allow room for painting the rest of the figure.

4. Use chalk to sketch the remainder of the picture; perhaps an ironing board (Figure 7-1), a kitchen, the living room, the outdoors, or an office.

5. Paint the remainder of the picture, stressing bright colors for a more attractive painting. You may wish to exchange scraps of leftover wallpaper and cut them into shapes that will become part of the overall composition.

6. When the paintings are complete, place them in the designated area to dry.

Look Around You

When we look at our paintings, we can realize how many roles mothers play in our everyday lives. Have you ever thought about how important your family is to one another? How do you think families differ in various parts of our country and in other parts of the world? Do you think that the environment, or *where* a family lives, affects their housing, their jobs, their recreational activities? How? How can families help one another appreciate and enjoy their surroundings more fully? Discuss this with *your* family.

Adaptations

1. Display these paintings at a "Back to School Night" or as a "Mother's Day" exhibit.

2. The same procedures can be used for portrayals of a "Salute to Father," "Grandparents," etc.

3. Paint mini-murals portraying family groups or outings, such as a visit to grandparents, a birthday party, brothers and sisters.

4. Use family themes for greeting cards.

Special Bonus Lesson: In My Yard

Use the same procedures and materials for paintings depicting life in the home, e.g. "The Clothesline" (see Figure 7-1a), "Our Garden," etc.

Through the Eye of the Artist

Portrayals of mothers and families have long been a favorite theme of artists. Display such reproductions and discuss the similarities and differences of family life as portrayed by various artists during different eras and in differing environments.

Suggestions

Paintings:

> Renoir—"Madam Charpentier and her Children"
> De Hooch—"Mother and Child," "Courtyard of a Dutch House"
> Cassatt—"Young Mother Sewing," "Mother and Child"
> Whistler—"Portrait of the Artist's Mother," "The Music Room"
> Brook—"Georgia Jungle"
> Moses—"Christmas at Home"
> Picasso—"Mother and Child"
> Manet—"Washday"

Glossary

Composition: the placement of shapes into a pleasing and balanced arrangement

LESSON 7-2

Cities by Sunset

(construction paper)

Materials

12″ x 18″ construction paper
—black, blue, yellow, grey,
and orange
chalk
scissors
paste
crayons
rulers

Figure 7-2

Be Prepared

1. Art helpers should distribute all necessary supplies at the start of the lesson. Each child will need one sheet of black construction paper and one of another color (see "Materials"). All other supplies can be shared.

2. If possible, have reproductions of art or photographs depicting city skylines at various times of day, ready to show the class.

3. Designate an area for children to place their finished projects until ready for display.

4. All reusable scraps of construction paper should be stored for future use.

Introduction of Lesson to Students

Think of a city by night, at sunset, or on a smoggy morning. Have you ever noticed that the time of day or night can affect how the outline of the buildings looks because of the changes in light? Imagine that you could choose to stay up at any hour, in any kind of weather, as we create some unusual construction paper skylines!

Procedure

1. With chalk, outline a city skyline onto black paper. Remember to vary the height and width of the different buildings. Bear in mind, too, that the roof tops of skyscrapers also vary in shape (see Figure 7-2). Draw a few windows at different places along the buildings, as well.

2. Next, with the aid of a ruler, straighten the lines that have been drawn.

3. Carefully cut out the silhouette of the city, including the windows on the buildings. Place the leftover scraps of construction paper in the designated box and set the city skyline aside.

4. The remaining sheet of construction paper will serve as the background for the skyline. What time of day does the yellow paper suggest? Perhaps lightly crayoning some red and orange streaks onto it will suggest a sky at sunset or dawn (Figure 7-2). Streaks of black or blue across the grey paper might well illustrate a smoggy morning. Yellow dots on the dark blue paper will surely give a feeling of a starry night. Perhaps you would like to add rain or snow with your crayons, as well.

5. When the background is complete, carefully paste the black construction paper skyline onto it. Be sure to have the bottom of the silhouette even with the bottom of the background paper (see Figure 7-2).

6. Place the finished city skylines in the designated area to dry.

Look Around You

Even though our city skylines are very much alike in shape, each one is different because of the backgrounds. How else do they differ? The size of buildings, the placement of windows, the distances between each building. How do actual cities differ from one another? How is it that we can recognize certain cities by looking at untitled photographs of them? When construction is going on, does the silhouette of a city skyline change? Look at buildings in your own environment, and notice how their appearance alters because of changes in light, weather, and seasons. Do sounds change according to the time of day? Ask your family to discuss with you ways in which your city or nearby town has changed appearance through the years. Discuss, too, ways to improve the city, such as more parks, fewer billboards, etc.

Adaptations

1. Write poems or stories to accompany these city skylines and display them along the halls or bulletin boards.

2. Research old pictures of a specific city at differing times of history and create silhouettes of its changing skyline.

3. Paint pictures of a city skyline during field trips, from memory or imagination. Include bridges, waterways, ships, etc. for greater interest.

4. Enlarge this project to create a striking mural.

5. See Lesson 7-3, "Rain-Washed Cities," and Lesson 10-6, "Cities of the Future," for additional ideas.

Special Bonus Project: Cereal Box City

Collect varied-sized cereal and cookie boxes well in advance of the lesson. Paint them with tempera that has liquid detergent added so that the paint will adhere to the waxed surfaces of the boxes. Add cut paper windows, signs, doors, etc. to fashion buildings from the boxes. Arrange them along a table to create a three-dimensional city. Clay figures of people and animals, sponge trees, etc. can all be added for further embellishments. Stress landscaping for beauty.

Through the Eye of the Artist

Reproductions of paintings depicting cities will not only serve to illustrate varying techniques and artistic styles, but will also serve to indicate differing kinds of architecture, throughout various times and in differing locals.

Suggestions

El Greco—"View of Toledo"

Florsheim—"Night City"

O'Keeffe—"New York Night"

Sloan—"Pigeons"

Monet—"Rouen Cathedral"

Guardi—"The Rialto"

Renoir—"Le Pont Neuf"

Glossary

Skyline: buildings as they appear silhouetted against the sky

Silhouette: the contour of a form or object, usually filled with black.

Background: area in back of the main subject matter in a composition

LESSON 7-3

Newsprint Farm

(collage: newspapers and construction paper)

Materials

construction paper—assorted
 colors; 12″ x 18″ and scraps
newspaper
yarns
scissors
paste and paste sticks
crayons
scrap paper for preliminary
 sketches

Figure 7-3

Be Prepared

1. Pre-cut squares of newspapers and assorted lengths of yarn to facilitate the lesson.

2. Art helpers should distribute all necessary supplies at the start of the lesson. Each child will need a sheet of 12″ x 18″ construction paper. All other supplies can be shared.

3. A scrap box should be accessible for children to place all reusable construction paper. Another such box should be ready for unused lengths of yarn.

4. Designate an area for children to place their finished projects to dry.

5. Caution children to carry their collages in "tray-like" fasion, to avoid parts dropping off.

Introduction of Lesson to Students

A farm is indeed a bustling environment. The farmer and his family, animals, plants, machinery, chicks, and ducks all contribute to the sights and sounds of a busy farm. Today, newspapers are going to serve as the basis of our own farmyard collages as we journey, through our art, to the country.

Procedure

1. Decide upon a central theme for your farmyard collage. Perhaps you would like to stress chickens or horses. You might want to concentrate on portraying a farmer and his family. The barn and surrounding fields are a suggestion. Make some preliminary sketches with crayon upon scrap paper if you wish.

2. Once an idea has been teacher-approved, proceed to draw the various parts of your collage onto newspaper and scraps of construction paper. The newsprint creates a very pleasant pattern that can be used quite effectively for feathers, fur, hay, or even a farmer's shirt. Use yarn to create horses' manes, rope, or perhaps a worm for the chickens (see Figure 7-3). Put your imaginations to creative work as you cut out plants, grass, flowers, and other parts for your collage.

3. Once satisfied that the collage is complete, place it carefully in the designated area to dry.

4. Place all reusable scraps in the appropriate storage boxes.

Look Around You

Often we take our own environment for granted. If we live on a farm, we daydream about dwelling in a city. Those of us who live in urban environments sometimes wish we could live on a farm, even though we may have never seen one. All environments are interesting though different. What are some of the pleasant things about living on a farm? What is unpleasant? How do you think living on a farm differs from living in a city or near the ocean? Our newspapers have been used quite effectively in our collages about life on a farm. How might they be used in a collage showing life at the ocean, in a city, or a small town?

Adaptations

1. Display these newspaper collages for an effective exhibit of farm life.

2. Add yellow pages from old telephone books for extra color.

3. Rather than make individual collages, divide the class into groups and create a large mural portraying farm life (or city life, dwelling by the sea, etc.).

4. Paint and draw pictures of farm environments from imagination or following a field trip.

5. Look to the future and create water colors and collages about farming the sea. (See Chapter 10, "The Future," for more ideas.)

Special Bonus Project: Life-size Scarecrow

Stuff a paper bag or burlap sack with newspapers to form the head of a scarecrow. Paint on facial features. Have children bring in some old clothing,

and stuff the shirt and trousers with more newspapers. Decorate the scarecrow with colorful patches, packing straw or hay and add an appropriate hat. Place the finished scarecrow against the bulletin board where the farm collages are on display. For added excitement, have each child create just the head of a scarecrow and then have the class vote upon the one they wish to place on the finished body.

Extra Bonus Project: Farmyard Montage

Cut out various pictures and printed matter relating to farm environments. Have the children paste them onto a construction paper background in an overlapping and interesting composition. Accents of color may be painted to add interest to the overall arrangement.

Through the Eye of the Artist

Illustrate the multi-faceted aspects of a farm environment through reproductions of varied styles of painting, interpreting such a theme. Compare them to city portrayals (see "Cities by Night").

Suggestions

Paintings by Grandma Moses
Prints by Currier and Ives
Monet—"Two Haystacks"
Wood—"American Gothic"
Curry—"Wisconsin Landscape"
Benton—"July Heat"
Seifert—"Wisconsin Farm Scene"
Millet—"The Angelus," "The Gleaners"

Glossary

Collage: various materials arranged in a pleasing composition and pasted onto a background

Montage: parts of various pictures and printed matter glued onto a background in an overlapping manner; visual texture is thereby created, as opposed to tactile texture in collages

LESSON 7-4

Cannery Row

(seaside dioramas; cans)

Materials

clean, empty fish tins
collage materials and scraps of
 papers (yarns, netting, cel-
 lophanes, toothpicks, metallic
 papers, sequins, etc.)
crayons
scissors
white glue
construction paper—approx-
 imately 6″ x 6″

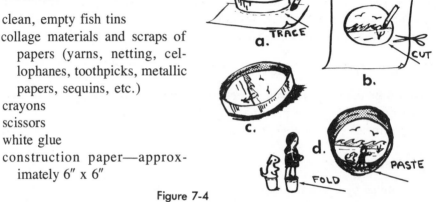

Figure 7-4

Be Prepared

1. Make a collection of oval and round fish tins (containers for cat and
dog food are also ideal) well in advance of the lesson. Caution children to bring
in cans that are clean and that are completely smooth along the opened edges.
As an extra precaution, the teacher should check all cans as they are brought in.
Store the tins, with each child's name taped to the bottom of his can, in a box
until ready for use.

2. Children should also bring in collage materials to add to those already
in supply.

3. Pre-cut squares of construction papers approximately 6″ x 6″.

4. Cover all work areas for easy cleanup.

5. Art helpers should distribute all necessary supplies at the start of the
lesson. Each child will need a can. All other supplies can be shared. Extra
collage materials should be accessible in boxes if needed.

6. Designate an area for children to place their finished projects until
ready for use.

Introduction of Lesson to Students

Cans, cans! Everywhere there seems to be bright, and shining cans! Do
you think we can possibly use them for dioramas? Usually, such scenes are

made in a box, with three-dimensional parts, and looked at through an opening. Well, ''Cannery Row'' is the title of a famous book about life in a California seaside village. So, why not be different and use actual cans in which to show environments near the ocean? Sound unusual? Well, it is, and it's fun, as well! Here's how it can be done.

Procedure

1. Trace an outline of the bottom of the can onto a small piece of construction paper (Figure 7-4a).

2. Draw and paste various parts of a composition showing life near the sea, within the outlined shape. Perhaps an empty stretch of beach, with cellophane depicting the ocean, and yarn seagulls (Figure 7-4b).

3. Cut out and paste the background into the bottom of the can. (Figure 7-4c).

4. Add additional parts to the diorama along the edges of the can. A small figure of a child and a dog can be cut from construction paper and pasted into place, for example. In order to make such figures stand upright, however, it is always necessary to allow for a small paper tab that can be folded and pasted into place (Figure 7-4d).

5. Tiny twigs to simulate driftwood can also be glued wherever desired. Cotton clouds, a small boat, actual tiny pebbles . . . are just some of the many objects that can also be included in the seaside dioramas. A coastal village, a shipyard, a seaside shop or resort are still other possible ideas.

6. When the miniature environment is complete, carefully place it in the designated area to dry. It may be necessary to prop each can against a book or to lean them along the wall so that they can remain upright.

Look Around You

Look around! Our seaside environments are beautiful! How do such communities differ from cities and farms? What are some of the objects (shells, and driftwood, for example) that are special to ocean surroundings? Can we hear the roar of waves on a mountain or inland farm? Name some other sounds, sights, and textures that can be found only near the sea. What are some similarities of life near the ocean, and living in a city or farm? Are cities ever built near the ocean? How does living near rivers or lakes differ, or resemble, life near the ocean? The next time you go on a family outing, play games to see how many *new* things you can discover in already familiar surroundings.

Adaptations

1. Tape gummed hangers to the backs of these dioramas, and either hang them on the bulletin board or suspend them mobile-fashion from wire hangers.

2. Cover the openings of the dioramas with lightly tinted or clear cellophane, if desired.

3. Use bigger cans (e.g., ham tins) or shoe boxes to create larger dioramas, depicting other environments.

4. Paint pictures of people in occupations related to seaside environments, e.g., fishermen, sailors, ship builders, etc. (See Lesson 7-5, "Alarm, Alarm," for other ideas)

5. Illustrate well known poems, songs, and stories about the sea, including fantasies, such as mermaids.

6. If possible, make a field trip to the ocean and collect objects (shells, driftwood, sand, etc.) that can be used in future art projects.

7. Paint pictures of underwater environments.

Through the Eye of the Artist

Many art works relate to the sea or oceanside environments. Reproductions of such work, with emphasis on a variety of artistic styles and interpretations, will enhance this lesson.

Suggestions

Marsh—"Negroes on Rockaway Beach"

Ryder—"The Toilers of the Sea"

Homer—"Maine Coast," "The Herring Net," "The Gulf Stream"

Marin—"Movement—Sea and Sky," "Seascape Fantasy, Maine"

Evergood—"American Shrimp Girl"

Turner—"Dutch Fishing Boats"

Van de Velde—"Calm Sea with Ships," "Entrance to a Dutch Port"

Glossary

Diorama: a three-dimensional representation of a scene, viewed through an opening

Three-dimensional: having the quality of height, width, and depth

LESSON 7-5

Alarm: Alarm!

(community helpers; group mural)

Materials

large mural paper—black or
 bright blue
construction paper—assorted
 colors and sizes
crayons and/or chalk
scissors
paste and paste sticks
tempera paints and brushes-
 —optional
thumbtacks or straight pins

Figure 7-5

Be Prepared

1. To facilitate the lesson, place assorted construction papers in stacks according to color. Red and yellow must be included. This is also an ideal time to use scrap papers that have been previously saved.

2. Cover all work areas with newspapers for easy cleanup.

3. Cut a sheet of mural paper to the desired size and tape or tack it into place upon a bulletin board.

4. Organize children into work groups (firemen, trucks, buildings, people, background details) at the start of the lesson.

5. Have art helpers distribute the necessary supplies. Each group will need scissors, paste, and crayons. Construction papers should be readily accessible so that children can choose the colors they wish to use.

6. It will be most helpful to have a group of pictures pertaining to a fire department for reference.

Introduction of Lesson to Students

What would our community be like if there were no policemen, firemen, mailmen, doctors, lawyers, nurses, teachers, and dentists? These are some of the many people who help their fellow citizens daily. Today, let's "sound the alarm" as we create a mural about the excitement of our firemen in action.

Procedure

1. Think of what subject you are going to show in the mural. Will your fireman be driving a truck, setting up a ladder, rescuing a child? Will a person be running from a burning building? Houses should have doors, windows, and roofs. Perhaps you wish to work on a department store or an apartment. Remember the category of your work group, and then choose a sheet of construction paper suitable in color for your project; red for fire engines, white for ambulances, yellow or black for the firemen's uniforms, etc.

2. Make a contour (outline) drawing of the figure or object that you are going to show, and crayon in all necessary details in appropriate colors. Perhaps you will prefer to cut out and paste parts of your project, such as windows for buildings, or firemen's boots (see Figure 7-5).

3. As you complete your assignment, bring it to the mural paper and tack or pin it to the place you wish.

4. Return all usable scraps to the supply area.

5. When everyone has finished, we will rearrange the mural, if necessary, so that the overall composition is satisfying to us all.

6. A committee can then be chosen to paste the parts of the mural into place.

7. Crayons or chalk can then be added to give the idea of flames and smoke.

8. Optional step: paint highlights of grass, flames, and other embellishments.

Look Around You

A fireman's work is dangerous as well as exciting! No matter what time of night or day, or what kind of weather, the call of the fire alarm must be answered. Firemen are recognizable by their uniforms. Can we always identify a person's occupation by his clothing? How do fires affect our environment? How can we help to prevent fires? How do the jobs of others affect the appearance, as well as the life, in our surroundings? Think what would happen if there were no firemen, no policemen or doctors, no electricians, bakers, bankers, or druggists. Each person has a contribution to make to his community as well as to his environment. No one should ever be taken for granted.

Adaptations

1. Take field trips to the local fire station and make crayon sketches during the trip. These can later be enlarged into full-sized or mini-murals. Invite members of the department to view the finished work.

2. The same procedure can be applied to murals depicting other occupations (police, farmers, etc.).

3. Paint or draw pictures of individual "Community Helpers."

4. Paint pictures depicting: "What I Would Like to Be When I Grow Up."

5. Use oaktag as the basis for creating figures of firemen, policemen, doctors, etc. Decorate them using actual fabrics. Cut out the finished collage figures and paste them along a strip of bright paper, for a striking "Community Workers" display.

Through the Eye of the Artist

Reproductions of art portraying people in various occupations should be shown to the class. Discuss the similarities and differences that exist in equivalent fields of work in bygone eras. Compare the environments depicted in the backgrounds.

Suggestions

Vermeer—"The Lace Maker," "The Milkmaid"

Hopper—"Nighthawks"

Homer—"The Herring Net"

Neagle—"Pat Lyon at the Forge"

Wood—"American Gothic"

Sloan—"The Lafayette"

Rivera—"Woman Grinding Maize," "The Flower Vendor"

Opper—"Fire Engine"

Fildes—"The Doctor"

Rembrandt—"Dr. Tulp's Anatomy Lesson"

Van Gogh—"The Postman"

Glossary:

Mural: large decorative painting, usually on a wall

Contour: the shape of an object

LESSON 7-6

Open House

(furnished cartons and boxes)

Materials

empty supermarket food cartons

small boxes (e.g., empty cos-
metic, thumbtack, toothpaste,
and soap boxes)

construction paper—assorted
sizes and colors

various materials—fabrics,
metallic papers, wallpapers,
carpet remnants, etc.

white glue

rulers

scissors

crayons and/or felt markers

cardboard or other strong
paper—assorted sizes

scrap paper for preliminary
sketches

tempera paints, brushes,
sponges, clay—optional

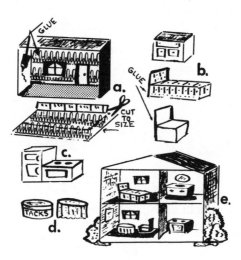

Figure 7-6

Be Prepared

1. Children should bring in empty, clean cartons and small boxes well in
advance of the lesson. Caution them to obtain adult permission for these items.

2. Before the start of the lesson, assign children to small groups, each of which will work on the making of a particular room for the house, e.g., kitchen, bedroom, etc.

3. Each group will require one carton and an assortment of small boxes from which to fashion furnishings. In addition, there should be a supply of materials (fabrics, wallpaper, etc.), scissors, glue, scrap paper, and markers and/or crayons at each work area. Art helpers should distribute these supplies at the start of the lesson.

4. All work areas should be covered with newspapers for easy cleanup.

5. Storage boxes should be available for children to place all reusable leftover supplies.

6. Designate an area for children to place their projects until completed. (*Note:* This project will require at least two sessions.)

Introduction of Lesson to Students

What environment is most familiar to you? How many would say it is your own home? After all, this is where you live. Have you ever wanted to redecorate or change a room in your house or apartment? Today, let's join in groups to design a very special house that will be *open* for all to see. So let's begin—you're all invited to an "open house."

Procedure

1. Each group has been assigned a specific room on which to work. Remember that the part opposite the open end of the carton will serve as the back of the room, and the remaining two sides as the other walls (Figure 7-6a).

2. Decide among yourselves what color scheme you wish, whether or not you want to use actual wallpaper samples for coverings, or if you would rather design your own on construction paper. Perhaps solid-covered construction paper will be preferred for the walls. Be sure to include windows and doors in the design. How many pieces of furniture will be needed for an attractive arrangement? What will be a functional or workable kitchen plan, one that really serves its purpose? Make some preliminary sketches of ideas.

3. After the room sketches have been teacher-approved, begin to decorate the cartons as planned. Measure the box "walls" with rulers, and cut the needed wall coverings, windows, doors, etc. from appropriate papers; and paste into place (Figure 7-6a).

4. Furniture and appliances can be made from the small boxes. That soap box can be traced onto brown paper, the parts cut out and then glued onto it to fashion a desk or end table. Crayon or felt markers can be used to add details (Figure 7-6b). A bed can be made from that paper clip box. Simply cut out some fabric or printed wallpapers to fit for a spread, and paste it over the box. A head board can be cut from cardboard and covered with the same fabric or

paper, and then pasted into place (Figure 7-6b). The same procedure can be used on a smaller box to make a chair (Figure 7-6b) and adding felt markers or crayon details to form a kitchen and bath appliances (Figure 7-6c). Round adhesive tape containers or thumbtack boxes are excellent for making tables. These, too, can be covered with actual cloth or wallpaper to resemble table-cloths (Figure 7-6d).

5. Draw pictures that can be used as paintings for the walls, and cut out wallpaper or fabric drapes and curtains. Metallic paper is excellent for mirrors. Carpet remnants are very attractive as floor coverings, or again, use construction paper or wallpapers (Figure 7-6e).

6. When all rooms are complete, stack them side by side and on top of one another to form a house or apartment (Figure 7-6e).

7. Optional step: for further embellishments, a cardboard roof can be cut and taped into place, and outside greenery can be made by dipping small sponges into suitably colored tempera to simulate plants. In addition, the outside of the cartons can be painted. Decorative lamps, dishes, ashtrays, etc. can be made easily with clay.

Look Around You

If we were all tiny, we could move into our beautiful house! Do you think our house would be a *comfortable* home if it were actually built? Do you think it is attractively furnished? Why do we need houses? Is ours practical; that is, does it serve its purpose, as well as being beautiful?

Is it important to consider the land and surroundings on which a home is to be built when first designing it? Are trees and greenery important to an attractive home environment? Can too many things be put into a room? Is it important to have furnishings that are in proper proportion and scale to a room size? There are many, *many* design problems to solve through good interior and architectural design. Discuss this with your family, and perhaps you can start a family project of collecting magazine examples of what you consider to be good and bad home designing. Perhaps one day you will become a fine interior decorator or great architect!

Adaptations

1. Display this three-dimensional dwelling and invite others to come in and enjoy an "open house" with your class.

2. Use this project to illustrate safety problems during a study of "Fire Prevention Week," by adding paper, trash, etc. to the rooms.

3. A different approach can be made by assigning children to work in groups, using large rectangles of paper for each room. When complete, this pictorial residence can be pasted together onto large mural paper.

4. Smaller homes can be fashioned from shoe boxes.

5. Work in groups to design and build apartment dwellings, ranch homes, and other styles of architectural residences.

6. Draw ideas for redesigning school classrooms, libraries, cafeterias, etc.

7. Have children draw "Houses of the Future." (See Lesson 10-6, "Cities of the Future," for related ideas.)

8. Paint pictures of "My Dream Room," "My Ideal Home," "If I lived on a Riverboat," etc.

Through the Eye of the Artist

Examples of architectural design should be shown to the class, along with a discussion of the varying functions and the styles and materials used. In addition, pictures of room furnishings should be shown and discussed, with emphasis on color schemes, scale, function, and beauty.

Suggestions

Homes by Frank Lloyd Wright, Edward Durell Stone, Mies Van Der Rohe, Philip Johnson, Marcel Breuer

Interiors and exteriors of Japanese, European, and Islamic homes

Colonial homes—e.g., Monticello, Williamsburgh, Mt. Vernon

Greek, Roman, and Egyptian interiors and architecture

Glossary

Architecture: the art or science of building

Interior design: art or science of decorating interiors

Proportion: relationship of size of one part to another

Scale: relative size

Functional: useful; serving a purpose

WE ARE PART

OF THE WORLD OF THE PAST

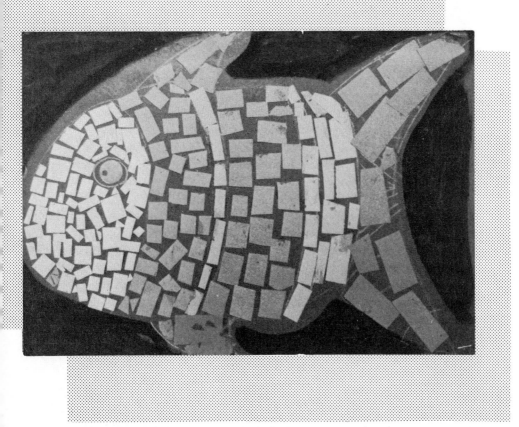

CHAPTER **8**

Art Activities Related
to Crafts of Old

The patience, skill, and pride of the craftsmen of yesteryear are qualities not easily understood by children in whose world things are mass-produced. Machines bring forth thousands of "instant" products daily, ranging from pre-cooked foods to pre-fabricated houses. So that the child can gain a better understanding and appreciation of the crafts of old, the art activities that follow are based upon the traditions of the past, but are up-dated to include readily available materials and contemporary techniques.

The ancient arts of batik and mosaic are explored, as well as the pageantry and color of medieval banner-making. Weaving is introduced in a simple, but extremely rewarding, lesson and a virtually cost-free method introduces youngsters to the old craft of candle making. A lesson on copper tooling produces work by children that is often astonishing to adults. At all times, the child is encouraged to expand his own interpretation and skills.

By bringing the crafts of yesteryear into the child's modern perspective, he will gain a fuller understanding of the world's art heritage and its influence upon the present. In addition, he is sure to gain insight into the differences between man-made and machine-produced things. Hopefully, he will also become more discriminating in his own work, and more appreciative of the creativity of others.

LESSON 8-1

In and Out

(paper weaving)

Materials

construction paper—12″ x 18″;
 dark colors
construction paper strips in a
 variety of colors
chalk
scissors
paste and paste sticks

Figure 8-1

Be Prepared

1. To facilitate the lesson, pre-cut strips of assorted colors of construction paper approximately 1″ x 18″.

2. Art helpers should distribute all necessary supplies at the start of the lesson. Each child will need a sheet of 12″ x 18″ construction paper, a pair of scissors, and chalk. An assortment of paper strips should be at each work area, with more available at a central supply station if needed.

3. All art projects appear more attractive when mounted. If possible, have a supply of 18″ x 24″ white paper, plus staplers, available as backing for the finished works of art.

4. Designate an area for children to place their finished projects until ready for display.

Introduction of Lesson to Students

If we wish to purchase fabric today, we simply go to a store, and choose what we want. Long ago, however, fabrics had to be woven by hand. Weavers often spun and dyed the yarns for their looms, and it usually took many days to complete the cloth. We see so many machine-woven fabrics in our stores nowadays that we don't think about the care and patience it takes to weave cloth by hand. We are going to learn something about the art of weaving today,

but we are going to work with *paper*! It won't take us as long to finish *our* weavings and you will be quite amazed by the beautiful results.

Procedure

1. Hold the sheet of construction paper vertically and fold it in half (Figure 8-1a).

2. With chalk, draw a margin on all but the folded edge, approximately one inch in front of the edge (Figure 8-1b). This will merely be a guide line and need not be perfectly straight.

3. Beginning at the folded edge, draw chalk lines toward the margin that has just been made. Zigzag, curved, or straight lines can be mixed or repeated (Figure 8-1c). Be certain, however, to stop the lines at the chalk margin, and to allow at least a half inch or more between each line.

4. Carefully cut along the lines (after they have been teacher-approved) making sure not to cut into the margin.

5. Open the folded paper carefully and turn it so that the cut lines run vertically (up and down). Your paper loom is now ready for weaving. The slits formed by the cut lines will act as the warp (vertical threads on a loom) and the construction paper strips will act as the weft (the threads woven across the warp).

6. Choose several paper strips for your weaving. (*Note:* limiting the colors to two or three hues allows for a more effective and unified pattern.)

7. Slide a construction paper strip (weft) over and under the warp of the weaving sheet. Push the woven strip to the top of the paper loom, and start the next row, being certain to reverse the procedure by beginning under and over the warp. Continue weaving in and out, with each row beginning alternatively under or over the warp (Figure 8-1d).

8. To secure the design, apply a small amount of paste to the ends of the woven strips so that they adhere to the paper loom.

9. Replace all usable paper strips in the central supply station.

10. Staple the finished weaving onto white paper, making sure to leave even margins, and place it in the designated area.

a.

b.

c.

d.

Figure 8-1

(a-d)

Look Around You

Would you like to have been a weaver long ago? Why? How do our designs differ from hand-woven cloth? The textures and materials are quite different, of course. In addition, our patterns came about largely by chance; we had no design planned in advance. Think about this whenever you look at hand-woven rugs, fabrics, and wall hangings. The artisans who made the weavings had carefully worked out their patterns and colors before they began to weave their designs. Look carefully at machine-made cloth as well. Who

designed *those* patterns; who set the machinery so that the patterns could be produced; who chose the dyes and the kinds of yarns to be used? Perhaps we have even taken machine-made fabrics too much for granted!

Adaptations

1. These weavings make striking bulletin board displays.

2. Symmetrical checkerboard patterns can be achieved by measuring straight "warp lines" that are evenly spaced, and then weaving with paper strips that are equal in size. These can be made into actual checkerboards by mounting the finished weaving upon cardboard. Make checkers from matching construction paper cut into circles.

3. Experiment with incorporating different kinds of papers (e.g., metallic, velour, and glazed) into the weavings.

4. Narrower strips of paper can be cut and woven on top of those already in place for added contrast (see Figure 8-1).

5. Use ribbon, rickrack, and yarn in combination with the paper weaving, for added texture.

6. Cut abstract and realistic shapes (fish, birds, etc.) and weave them as directed in this lesson. Such an approach can be used to create unusual seasonal displays, e.g., Halloween pumpkins, Valentines, and holiday ornaments.

7. Mount the paper weavings on strong cardboard, and apply several layers of shellac to create colorful placements.

8. Limit the designs to black and white, and thereby create "OP" weavings (see Lesson 9-2, "It's Op to You").

Through the Eye of the Artist

Samples of actual hand-woven, as well as machine-woven, fabrics should be shown to the class. Reproductions of weavings ranging from intricate medieval tapestries and tribal designs (e.g., African and Indian), to more modern abstract wall hangings, will add to the students' understanding and appreciation of the lesson.

Glossary

Loom: machine or framework used for interweaving threads or yarns

Warp: vertical threads on a loom

Weft: the threads or yarns that are woven horizontally across the warp

Woof: another term for weft

LESSON 8-2

Fascinating Mosaics

(cut paper)

Materials

construction paper—various
 colors
12″ x 18″ black paper
scissors
chalk
paste and paste sticks
small pieces of facial tissue

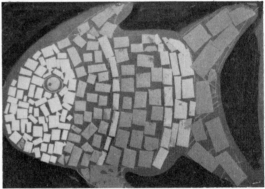

Figure 8-2

Be Prepared

1. To facilitate the lesson, pre-cut strips of assorted colors of construction paper, approximately ½″ in width.

2. Art helpers should distribute the necessary supplies at the start of the lesson. In addition to an assortment of construction paper strips, paste and paste sticks should be placed at each work area. Each child will need a sheet of black paper, chalk and a pair of scissors.

3. Designate an area where children can place their completed mosaics until ready for display. Caution children to carry their projects in "tray-like fashion" to avoid parts dropping off the paper.

4. A box should be available for children to place all reusable scraps of paper.

Introduction of Lesson to Students

Who knows what is meant by "mosaic"? You're right! It is a picture or design made up of small, separate bits of materials, such as wood, ivory, glass, tile, or marble set into a material, such as cement, that will hold them. Did you also know that mosaic art has fascinated people since as long ago as the early

days of Egypt? Let's up-date this ancient art form as we use paper to learn about making some marvelous mosaics of our own!

Procedure

1. With chalk, make a simple contour (or outline) drawing upon black paper. Nature is an excellent source of ideas because leaves, fish, birds, butterflies, etc. are particularly suited to mosaic pictures. Make the drawing large and simple. If mistakes occur, simply rub out the chalk with a small piece of tissue.

2. Select several colors of paper strips and cut them into rectangles approximately ½" x ¾". Do not cut the paper too small or it will be difficult to handle.

3. Carefully spread a little paste within an area of the contour drawing. Press the cut paper rectangles onto the paste, making sure to leave a little space between each piece (see Figure 8-2).

4. Continue this procedure until the entire mosaic is complete. It is often easier to work from the middle toward the outline of the drawing. As the edge is reached, it may be necessary to cut the rectangles smaller, in order that they fit.

5. Place the finished projects in the designated area to dry.

6. Optional step: When completely dry, the mosaics can be cut out and pasted onto contrasting construction paper (Figure 8-2).

Look Around You

We have learned that the art of mosaic is an ancient one. Are mosaics made today? Look around the room. Is there anything resembling a mosaic? That brick wall is similar, and so is the tile over the sink. Look at buildings, houses, and stores for mosaic work. Often the bath or kitchen contains designs made up of small pieces of tile, with space in between that is filled with a cement called grout to hold them together. What are other materials that can be used in making mosaics? How about small shells, pebbles, nuts, or spices? Perhaps you can start a family mosaic project using materials found in the kitchen or yard. Look for interesting textures and colors, as well, and before long you will have made some wonderful modern mosaic designs of your own.

Adaptations

1. Paper mosaics make particularly attractive wall displays.

2. For extra sparkle, cut metallic papers into rectangles, triangles, or squares and use the same procedure.

3. Work in groups to achieve large mosaic designs and pictures.

4. Use adhesive-backed materials in unusual patterns to fashion mosaics.

5. Cut up old greeting cards, stamps, or magazine pictures and use them to make mosaic pictures.

Special Bonus Project: Florentine Mosaic

Cut simple shapes for pendants from firm paper or cardboard. Punch a hole in one end and attach a colorful length of yarn. Decorate the cardboard shape with tiny beans, seeds, or cast-off costume jewelry or beads brought from home, using the mosaic technique to create designs or pictures. Such jewelry makes excellent gifts for holidays.

Extra Bonus Project: Valentine Cut-Ups

Attractive and unique Valentine cards can be created by using the procedures for making mosaics. Cut velour papers, tissues or red foil and paste onto pre-outlined heart shapes on parchment, cork, or white bristol board. Trim with ribbon and/or paper doilies. These "broken hearts" lend themselves readily to original poems and limericks.

Through the Eye of the Artist

Examples of Egyptian, Greek, and Roman use of mosaic on floors, walls and ceilings will enhance this lesson. Byzantine architecture and Italian churches abound with examples on this art form, also. The library of the University of Mexico is one of the most famous examples of modern use of mosaic, as are the beautiful mosaic streets along Copacabana Beach, in Rio de Janeiro, Brazil.

Glossary

> Mosaic: a picture or design made up of small, separate bits of material, such as glass, paper, stone, etc. set into an adhering material, such as cement or grout

> Grout: a fine cement or mortar used to adhere the bits of material used in mosaics

LESSON 8-3

Herald It!

(felt (or burlap) banners)

Materials

felt and/or burlap

decorative trims—sequins, yarn, rickrack, lace, beads, feathers, etc.

scrap materials—brocades, printed cottons, satin, felt, etc.

scissors

white glue

straight pins

chalk

scrap paper for preliminary sketches

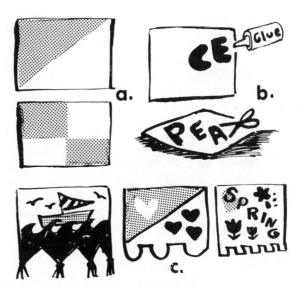

Figure 8-3

Be Prepared

1. To facilitate the lesson, pre-cut felt (or burlap) into rectangles of a pre-determined size. Commercially cut felt is available in 9″ x 12″ size, and larger.

2. In advance of the lesson, have children bring in scrap materials and decorative trims from home. Store the items in bins or boxes until ready for use. Caution boys and girls to obtain adult permission for the items.

3. Cover all work areas with newspapers for easy cleanup.

4. At the start of the lesson, art helpers should distribute all necessary supplies. Each child will need one felt (or burlap) rectangle; a pair of scissors, scrap paper, and chalk. An assortment of scrap materials and decorative trims should be available at each work area. Glue can be used directly from the bottle and can be shared.

5. Designate an area for students to place their completed banner.

6. *Note:* This lesson lends itself particularly well to a central theme, such as *Peace, Ecology, Historical Events, Holidays, School Events,* etc. Such a theme should be decided upon in advance of the lesson. However, children can work very successfully on individual and separate ideas.

Introduction of Lesson to Students

What do you think it would have been like to live in medieval times? In those days, bright and beautiful banners were displayed in different ways, often as battle standards and for special events. Would you like to make a wonderful banner today? Let's use our felts and trims to create a *modern* wall hanging. Here's how.

Procedure

1. With chalk, sketch an idea for a banner on scrap paper. The design can relate to a central idea, or an individual one (see "Be Prepared": 6). The colors of the felts and materials are so bright and gay that thoughts of sunny days, trees, birds, happy people, sailboats, and friends come quickly to mind. Surely you can think of even more ideas.

2. After the preliminary sketch has been teacher-approved, begin to cut out the various parts of the design from the assorted fabrics. Perhaps you would like to keep the background all one color, or you may prefer to divide the banner into sections with diagonal or vertical parts in different colors of felt (Figure 8-3a). Work freely and directly upon the materials, cutting each shape carefully. Lettering can also be cut easily from felt, and can be part of the design (Figure 8-3b). You can use chalk to write words or letters, onto the felt, and then cut them out (Figure 8-3b).

3. Arrange all the cut parts upon the banner, and if necessary, use pins to secure them to the background.

4. Carefully glue each part of the banner in place. Remember that a small amount of glue is enough.

5. Add decorative trims where desired, and paste them into place. Sequins add beautiful glitter to the already colorful banner, yarns create bright lines, rickrack can be used to form waves, feathers lend still another texture, etc.

6. Individual banners can be completed by cutting the bottom edge into triangles or other geometric shapes. Yarn-fringe can then be pasted or stapled to the edge (Figure 8-3c).

7. Carry the completed banners to the designated area, after replacing all usable materials and trims.

Look Around You

Creating a banner today can be every bit as exciting as it was in medieval times! How do our methods differ from those of the banner makers during the middle ages? Careful stitching and appliqué (or sewing one material to another) were the methods used for the various parts of the banners. Certainly many of

the materials we used, such as plastic sequins, were not available in that bygone era. Medieval banners were used to identify craft guilds, troops, kings, and nations. How are banners used today? Think about school banners, state banners, club banners. What else? Do you think that flags are similar to banners? How else do you think banners can be used in today's world?

Adaptations

1. Individual banners can be stapled to dowels that have been pre-cut to the desired size.

2. An extremely dramatic project is to machine-stitch all the banners together to create one large hanging. This, however, is a job for a proficient seamstress. Surely a parent, teacher, or high school student will offer to contribute their talents. The final project can then be hung in the school as a permanent wall hanging.

3. Design new school emblems or banners, using the techniques and procedures in this lesson.

4. Paste a felt rectangle to a shirt cardboard and cut off any excess fabric. Cut forms from materials and trims to create abstract or realistic pictures. These make most attractive gifts.

5. Paint pictures about what it might be like to have lived in medieval times.

Special Bonus Project: When Knights Were Bold

Collect velour and flock wallpaper samples to create collages of medieval knights and their ladies. Use the wallpapers for the effect of brocade and velvet clothing. Add metallic papers for armor, and construction paper to create castles, horses, etc. (See Lesson 8-1, "Salute to Mother" for detailed procedures.) This project adapts very well to large and effective murals.

Extra Bonus Project: Shields of Our own

Cut shapes resembling shields from large sheets of oaktag or bristol board. With tempera paints and/or felt markers decorate them with symbols depicting the family name, interests, and hobbies of each child. The shield can be decorated with gold and silver paints for special highlights.

Extra Bonus Lesson: Stained Glass Windows

To create beautiful medieval-type "stained glass", cut abstract shapes from folded black construction paper. Paste various colored cellophane scraps over the openings. Display on windows so that the light comes through.

Through the Eye of the Artist

Banners have been known to date from early Egyptian civilization when they were used as identifying battle standards. Originally, they were fashioned as a solid object, but later, under the rule of Constantine, were made from cloth. Illustrations of medieval banners along with more modern ones, such as those used in Japanese and Mexican festivals, as well as the outstanding banners created by Norman Laliberté, will greatly enrich this lesson.

Glossary

Appliqué: sewing or attaching one material onto another, usually for decoration

LESSON 8-4

Foiled Again!

(metal tooling; copper foil)

Materials

copper foil
modeling tools—e.g., orange
 sticks or leather working tools
newspapers or soft covered
 workbooks
drawing paper
pencils
steel wool—grade 0
liver of sulfur
paper toweling
clay—optional
clear lacquer
masking tape or paper clips
backing for mounting the metal-
 craft e.g., burlap, cardboard,
 wood

Figure 8-4

Be Prepared

1. Allow several sessions for the completion of this project.

2. Metal foil is generally sold in rolls. To facilitate the lesson, pre-cut copper, using scissors, to the desired size. Since the edges of the copper are a little sharp, care should be taken during this procedure.

3. Pre-cut sheets of the drawing paper to the same size as the copper.

4. At the start of the lesson, art helpers should distribute all necessary supplies. Each child will need one piece of copper, a sheet of paper, a pencil and a modeling tool. A soft surface is needed upon which to tool the copper; newspapers or soft covered workbooks are quite suitable for this purpose.

5. The day the copper is to be antiqued, mix liver of sulfur with water and store in clean, closed containers until ready to use. The strength of the solution is best determined by testing it on a piece of scrap metal. If the antiquing appears too black, dilute the solution with more water. Cover the work area where this procedure is to be done with newspapers, and have a supply of paper towels and steel wool nearby.

6. When the antiquing of the copper is to be done, clay and clear lacquer should also be ready for use. Aerosol containers of lacquer are recommended because the use, and subsequent cleaning, of brushes is eliminated.

7. Metalcraft is most effective when mounted on wood, burlap on cardboard, or black construction paper on cardboard. To facilitate the lesson, these can be pre-cut to the desired size. The finished copper work can either be nailed directly onto the wood, or stapled onto the others.

8. Designate an area where the completed projects can be stored until ready for display.

9. Allow time for proper cleanup.

10. Children should wear smocks, especially during the antiquing and polishing procedures.

Introduction of Lesson to Students

Did you ever think that you could draw a picture on metal? It is not a new idea! As long ago as the early days of Greek civilization, metal coins were being stamped into beautiful designs. Since that time, the art of working on metal, or metalcraft, has come to include special techniques: "embossing," or pressing back a background, "repoussé," working from the back of metal, and "tooling," or indenting and raising a design. Working creatively with metal is as interesting as it is rewarding because the results are truly beautiful and unusual. Let's become craftsmen for today as we take our foil and learn about metal tooling.

Procedure

A. *Tooling the Metal:*

1. With pencil, work out the design to be used on the copper. Nature provides marvelous subjects, because the feathers of birds, the scales of fish, the texture of leaves and flowers can all be worked successfully in the copper. Sailing ships, people from other lands, clowns, etc. are also fine choices. Remember to avoid tiny detailed drawings, however, because they will be rather difficult to tool. Bold, clear drawings are best.

2. After the sketch has been teacher-approved, carefully tape or clip it onto the copper.

3. Place the copper (with its drawing) on a soft surface, such as newspapers or soft covered workbooks, and carefully trace over the drawing with a pencil. Do not press too hard.

4. Remove the paper and an outline of the traced drawing will be clearly visible on the copper.

5. Turn the metal over, and still working on the soft surface, raise the areas that are to be high by pressing inside the outlined area with the modeling tool. Varying degrees of light and heavy lines will be produced according to the pressure applied. Bear in mind, however, that this is a gradual process and the metal should be raised slowly.

6. Turn the metal over again and start to tool the background areas by gradually pushing *back* the metal. Again, work on a soft surface.

7. Repeat the process—outlining and raising on both sides of the copper until the design is complete. Remember that the main part of the design is worked from the *back* of the copper, and the background is worked on from the *front*.

B. *Antiquing the Copper:* (See "Be Prepared," Steps 5 and 6)

1. Lightly rub the steel wool over the front of the copper. It may be necessary to fill in the back of the raised areas with a small amount of clay to avoid denting in the copper during this procedure. *Note*: Lacquer can be applied at this stage, if an antiqued effect is not desired.

2. Apply the liver of sulfur solution to the front of the copper by applying a small amount to a paper towel, and rubbing gently over the entire design. The copper will oxidize and turn black.

3. Rinse the solution off with a small amount of water.

4. Rub steel wool over the front of the copper once again. The antiquing will remain primarily in the indented areas, and a lovely effect will be produced on the remainder of the copper.

5. Apply clear lacquer to the metal for a permanent sheen.

C. *Mount the Copper:*

1. See "Be Prepared," Step 7

Look Around You

Do you usually think of metal as *soft* or hard? Our copper was soft and our tooling has produced not only beautiful works of art, but we have changed the texture and color of the metal during the process. Do you think that an antiqued look can be as beautiful as a very shiny appearance? Silverware is often embossed, as are coins and jewelry. Leather goods are often worked in methods similar to metal tooling. Can you find other things that are decorated in these ways? Notice metal shade pulls, raised printing on greeting cards, and letterheads. Most often, these designs are made by machines today. Do you think it is as satisfying to create something through a mechanical process as it is to do so by hand? Why? Handcrafted objects require skill, patience and imagination, but each result is special and one-of-a-kind.

Adaptations

1. After they have been attractively mounted, exhibit the finished copper work in a cabinet or hall display case.
2. The finished works can be given as gifts.
3. Cigar boxes can be painted, or covered with burlap, and the copper tooled designs or pictures can be tacked to the top to create beautiful jewelry boxes.
4. Other soft metals can be used in place of copper, such as thin aluminum and brass.
5. Older children can cut out designs or realistic shapes from the soft metal and mount them onto small fabric-covered boxes or wood blocks to create unusual paper weights.

Special Bonus Project: Aluminum Wonders

Paste medium-weight string into an abstract or realistic contour drawing on shirt cardboard. Cover the entire surface with ordinary kitchen aluminum cooking foil, and press the surface so that it adheres to the cardboard. The string will raise the foil. Rub thickened black tempera over the entire surface, and wipe away excess paint so that an antiqued appearance is achieved.

Through the Eye of the Artist

Along with actual examples, reproductions of varying metalcraft techniques used during different periods of time should be shown to the class. It is also interesting to compare metal worked in relief with bas-relief sculpture.

Suggestions

Bas-relief on Greek, Roman, medieval, and modern architecture

Modern and ancient coins and jewelry

Mexican tinware

Hammered silver—antique and modern

Glossary

Bas-relief: sculpture that is raised from a background

Embossing: pressing back a background so that surface design is in relief; the procedure is done from the *front*

Repoussé: raising the surface design by working and pressing from the *back*

Tooling: indenting or raising metal or leather to produce a design

LESSON 8-5

Candles on the Table

(new candles from old; candle making)

Materials

old used candles

string—ordinary household string; medium weight

disposable molds—paper cups, ½ pint milk and cream paper cartons, cardboard frozen juice cans, etc.

double boiler, with a pouring spout and ladle

stove or burner

bright, used crayons—optional

pencils or tongue depressors

scissors

masking tape

paper clips

hammer—optional

Figure 8-5

Be Prepared

1. Make a collection of old used candles well in advance of the lesson. Any colors and shapes are suitable. Caution children, however, to obtain parental permission before bringing supplies from home.

2. Children should also bring in disposable molds, (See ''Materials'') with their names taped to the bottom.

3. Cover all work areas with newspapers for easy cleanup.

4. Children should wear smocks.

5. To facilitate the lesson, pre-cut string to approximately 7″ lengths.

6. The actual melting of wax should be carefully supervised by an adult. Perhaps a parent or student teacher can come in the day of the lesson to aid in the project. Children are delighted by a new face, and it is always fine to have parental participation.

7. The day of the lesson arrange for use of the school kitchen stove, or to have a burner and double boiler available.

8. At the start of the project, art helpers should distribute all necessary supplies. Each child will need a mold, a length of string, and a paper clip and a pencil or tongue depressor. Scissors and tape can be shared.

9. Designate an area for children to place their candles to harden.

Introduction of Lesson to Students

What do you think it was like to live by candlelight? In the days before the invention of electricity, candles were a necessity. Today, we usually think of candles for a special event, perhaps a holiday or a birthday party. We have collected used candles that ordinarily might have been thrown away. We'll not only create some entirely *new* candles from old ones, but we'll obtain some *handcrafted* ones from the process.

Procedure

1. Place several candles into the top of a double boiler. (If they are too large, they can easily be broken into smaller pieces by hitting them with a hammer.) Heat the wax, stirring often, and watching constantly. Do not allow the wax to boil.

2. While the wax is melting, the children should prepare their molds. Secure a length of string to a paper clip, and tie the other end to a pencil or tongue depressor (Figure 8-5a).

3. Drop the paper clip end into the mold, and wrap any excess string around the pencil or tongue depressor so that the string will be fairly taut and centered when the pencil is placed across the top of the mold (Figure 8-5b). If the pencil or depressor rolls, add a little tape to hold it in place.

4. If color is desired, old broken crayons can be added to the melting wax. All paper, however, must be removed first.

5. When all the candles in the pot have liquefied, several children should place their molds in an accessible spot, so that the teacher or parent can carefully pour the melted wax into the mold, filling it *no more* than one inch from the top (Figure 8-5c).

6. The candles should be set aside to harden while a new batch is melted for each remaining group of boys and girls.

7. Candles can be unmolded the next day, or after they have completely hardened (at least several hours). The molds can then be torn away and discarded (Figure 8-5d).

8. The wicks should be cut about ¼″ from the top of the candle (Figure 8-5d).

9. *Note:* excess string and wicks from melted candles can be saved for future candle-making projects.

Look Around You

Do you think we take electricity for granted? Do we waste it? Do you think that people who used only handmade candles wasted them? How does the light from candles differ from that of electricity? Does the color of a light bulb change as it burns? Does the shape of a lamp change as it is used? We altered our old candles in many ways, not only changing them from solid to liquid, but back again to solids entirely different from the original shapes. What about differences in the original colors and textures?

Why not discuss with your family ways of saving electricity, while finding new uses for candles. Look, too, for unusual candles, especially those that may be made by hand, and compare them to machine-made ones. Encourage your family to make new candles from old ones as a family project. (*Note:* caution children not to melt wax by themselves.)

Adaptations

1. Handcrafted candles make delightful gifts or can be sold for school fund-raising events.

2. Paint pictures of candles, incorporated into still life arrangements, stressing shadows and light given by the flames.

3. Create collage greeting cards of candles cut from wallpaper.

4. Draw illustrations of how it might be like to live in a world with only candlelight as a source of illumination.

5. Candles can be made in metal molds such as fruit cans, gelatin molds, and custard cups. Immerse the hardened candles in very warm water for several seconds to loosen the wax from the sides of the metal, and unmold.

6. Striped candles can be made by allowing one color to set, and then pouring another color over it.

7. Dipped candles can be made by attaching several strings to a long stick or dowel and dipping the strings repeatedly into melted wax. Each dipping must be done quickly, so as not to melt the previously hardened wax. The procedure can be repeated until the desired candle shape is created.

8. Use unusual containers, such as natural shells, for the candles and do not unmold them.

9. Add sequins or glitter to the candles for extra sparkle.

Special Bonus Project: Sand-Casted Candles

Place beach or construction sand into a pail or other medium-sized container. Add water to dampen the sand, and form a mold by pressing a shape into the sand and removing it, or by shaping one with your hands. Make certain the sand is packed firmly, and pour the melted wax over a wick that has been placed into the mold (as in the procedures to this lesson). Do not fill the wax to the top of the mold, however, or it will run into the sand. After the candle has hardened, lift the candle carefully from the sand. An interesting texture is thereby achieved, as well as an unusual shape.

Through the Eye of the Artist

Illustrations of old candle molds, as compared to mechanical methods of candlemaking, will prove most interesting to the class. In addition, reproductions of art in which the candle is part of the composition, should be shown. Discuss not only the varying techniques of the artist, but the use of the candle in the particular theme portrayed. This is also an opportune time to introduce and discuss the term "chiaroscuro" (see "Glossary").

Suggestions

Pinney—"Two Women"

Moses—"Christmas at Home"

Van Eyck—"Jan Arnolfini and His Wife"

De Hooch—"Mother and Child"

Hogarth—"Marriage a la Mode"

Paintings by Rembrandt and de la Tour stressing light and shadows

Glossary

Chiaroscuro: the treatment and contrast of light and shade in painting; Rembrandt is considered the master of this technique

LESSON 8-6

Dip It, Dye It

(crayon batik)

Materials

old, broken crayons, bright colors

cold, liquid dye—one or two dark colors such as navy blue, brown, or black

containers for dye—e.g., enamel pans or aluminum foil boiling pans

wax melters or an electric skillet and small, clean cans.

unsized cotton fabric

cotton swab sticks

pencils

cardboard

newspapers

electric iron

newspapers and toweling

felt markers—optional

Figure 8-6

Be Prepared

1. In advance of the lesson, have children bring in unsized cotton fabric pre-cut to approximately 9″ x 12″. Old sheets are ideal for this purpose. Note, however, that synthetic fabrics contain chemicals that make them unsuitable for batik. If new cotton is to be used, make sure to wash it first to remove the sizing. Children should also bring in clean, small cans with no jagged edges.

2. Low heat, electric wax melters are available from art supply dealers, but if this is not feasible, have one or two electric fry pans ready at the start of the lesson. These should be lined with aluminum foil, and set to medium heat, but do not start until ready to melt the crayons. *Note:* crayons will also melt in cups or cans placed on a sunny window sill.

3. In advance of the lesson, have art helpers remove all paper wrappings

from old broken crayons, and place several (of one color) into the compartments of the wax melters, or into cans that are then placed into the electric pans. The equipment need not be turned on to melt the crayons until ten minutes before they are to be used. Caution children not to touch heated pans. It is preferable to have the wax melting in the center of each work area, but if this is not feasible, a selected group of helpers should carefully carry the containers of melted wax (using toweling to guard against heat) from a central supply station to each work area. *Note:* the melting point for crayons is low, and even though the wax is quite safe, children should be cautioned to work carefully.

4. Work areas should be covered with newspapers for easy cleanup. Several tables or desks should be pushed together so that children can share the containers of melted wax.

5. At the start of the lesson art helpers should distribute the necessary supplies. Each child will need a pencil, fabric, and a piece of cardboard larger than the fabric. A supply of cotton swabs should also be available at each work area.

6. When ready for dying, several pans of cold water liquid dyes should be placed on a newspaper-covered floor, with a supply of additional newspapers readily available.

7. Prepare an area where fabrics may be left to dry.

8. *Note:* Allow several sessions for the completion of this project.

Introduction of Lesson to Students

"Batik" is an ancient and very unusual method of printing designs on fabrics, and is still used today. Javanese and Balinese batik date back as far as the 13th century! To make batik, clear melted wax is painted onto cloth. After the wax cools, it is "crackled," (or cracked by crumpling the fabric). Then the cloth is dipped into dye, which will penetrate every part of the cloth (including the cracks) that is not covered by wax. This produces a very special veined pattern. To achieve different colors, the fabric must be waxed over again and again, and be placed each time into a different color dye. Later, the wax is removed by ironing. Our batiks will be made much faster because we will be using colored wax crayons instead of clear wax. But the results will give us a very good idea of the beauty and method of making batik.

Procedure

1. Sketch a design or drawing with pencil directly onto the fabric. Birds, fish, plants, and flowers are fine subjects, but imaginative drawings of monsters, fantastic butterflies, funny clowns, etc. are also fine ideas. Just remember to avoid tiny, complicated details. Work freely and boldly.

2. When the drawing has been teacher-approved, place it on top of the piece of cardboard, and proceed to paint in the desired areas with melted crayons. Dip one end of the swab stick into a color and apply it quickly and fully. Turn the fabric over constantly because the wax should penetrate or go through the fabric. This is absolutely necessary to the making of batik, and should be checked very often. It may be necessary to work on both sides of the fabric, if the wax does not go fully through the cloth on one side.

3. Both ends of the swab sticks can be used, and should be placed in the center of the work area to be used by others if needed.

4. Leave part of the background uncovered by crayons.

5. When the painting is complete, and the wax has hardened, crinkle the fabric so that cracks appear in the crayoned areas.

6. Wet the fabric in cold water, then squeeze out any excess moisture, and place it into the cold water dye. Immerse the cloth for several minutes, because a dark background color is desirable.

7. Lift the batik from the dye and press it flat between some newspapers.

8. Hang the fabrics to dry.

9. When the batiks have thoroughly dried, the wax should be removed. Place the fabric between newspapers and iron the fabric at a medium setting. Check the fabric to see that all wax has been removed in this manner; it may be necessary to place the fabric between fresh sheets of newspapers and repeat the procedure several times.

10. Accents or details may be added with felt markers (optional).

Look Around You

Look closely at our batiks. Wherever the dye went through the cracks in the wax, the veined effect that is special to batik appears. Can you imagine the time and patience required to make a hand-made batik fabric in a long length, especially when there are to be many repeated dye baths? Remember, that in true batik, clear wax is used before each color of dye, so that a design is first placed in the lightest color, dyed, waxed again and dipped into another color, and so on, until the design is complete. Often a special tool called a "tjanting" is used to apply wax. Do you think that machine-produced patterns can be made more quickly? Are artists needed to design the original patterns, even for machine-prints? Are specialists needed to choose the best color schemes? Artisans are still needed in the fabric industry for many jobs. Look for handpainted scarves, ties, fabrics, etc. in stores. Look, too, for machine-printed batik designs. Try batik work at home with your family. Perhaps you can produce a future family heirloom such as a scarf, a pillow covering, or a wall hanging that all can cherish for years to come.

Adaptations

1. Older children can attempt batik with a melted mixture of household paraffin and beeswax. However, adult supervision is necessary at all times for safety supervision.

2. Crayon batiks make most attractive wall displays. Mount them on contrasting construction paper.

3. For a very unusual effect, stretch several designs on embroidery hoops and display them.

4. Cotton T-shirts can be successfully covered with batik designs by using the procedures in this lesson, but be sure to allow for shrinkage.

5. Absorbent paper (e.g., Japanese rice paper) can be folded and the edges dipped into vegetable dyes to achieve a kind of "paper batik."

6. Regular crayon can be applied to the rice paper first, before being folded and dipped at the corners into vegetable dyes. The crayon will resist the dye.

7. See Lesson 10-1, "Blast Off," for other crayon-resist techniques.

Through the Eye of the Artist

Illustrations (or preferably actual fabrics), of Javanese, African, Indian, and Japanese traditional and modern batiks should be shown to the class to enhance the understanding and appreciation of the lesson.

Glossary

> Tjanting: a tool used in batik to allow a controlled flow of wide or thin wax lines

> Crackle: the veining effect achieved in batik by cracking the hardened wax before dying

WE ARE PART

OF THE WORLD OF TODAY

We Are Now

Every era has its own styles of creativity, be it music, dance, architecture, literature, or art. Children today live in an especially fast-moving and ever-changing world. The art activities in this chapter are aimed at familiarizing youngsters with some of the more current trends in art, and by so doing, adding to their understanding of the modern world.

"Pop Art," "Op Art," "hard-edge" paintings, abstract designs, and "collographs" are introduced and explained through lessons that will not only intrigue youngsters with their uniqueness, but will serve as stepping stones toward the better understanding of why and how these styles came about. Stress is placed upon modern materials (e.g., polystyrene), and scientific knowledge (e.g., the working of the eye), of the twentieth century, that have led to such experimentation with art methods and media. Youngsters will be highly motivated by the unusual materials used in these projects, and the idea of creating their own "modern art."

In today's world, boys and girls are often well acquainted with the latest trends in music, films, and fashion. They are not as likely to be as familiar with the "now" world of art. Yet, such art is a reflection of our life and times. By relating his own artistic activities to those of modern artists, still another dimension will be added to the child's understanding and appreciation of his world.

LESSON 9-1

"POP" Is Not the Weasel

(collages from commercial symbols; POP art)

Materials

12″ x 18″ white paper or bristol
 board
scissors
white glue
felt markers—optional
commercial symbols: e.g. labels
 from canned goods, gum
 wrappers, candy wrappers,
 super market receipts, comic
 strips, advertisements, T.V.
 listings, etc.

Figure 9-1

Be Prepared

1. Have children bring in labels, wrappers, etc. ("Materials") well in advance of the lesson and store them in boxes until ready for use.

2. At the start of the lesson, have art helpers distribute the necessary supplies. Each child will need a sheet of white paper and a pair of scissors. All other supplies can be shared.

3. If tables are not available, it will facilitate the lesson to push desks together to form work areas.

4. All art projects appear more attractive when mounted. If possible, have a supply of bright construction paper, larger in size than 12″ x 18″, and staplers available so that children can mount their finished works.

5. Designate an area for children to place their completed collages to dry.

6. Allow time for cleanup, and replace all usable collage materials for use in future projects.

Introduction of Lesson to Students

Have you ever thought about how many meanings the tiny word "pop"

can have? "Pop" is another word for Dad; some people call soda "pop"; a jack-in-the-box can "pop" up; firecrackers can go "pop"; even the well known song ends: "Pop Goes the Weasel." Did you know, however, that today this wonderful word has taken on still another meaning: "POP" art?

This modern style of art uses as subjects everyday objects and familiar things, especially those that we see advertised and that are made or printed by machines. For example, POP artists have created pictures and sculptures about everything from ordinary soup cans to comic strips. Now maybe you can guess why we have been collecting food labels, advertisements, wrappers, etc. for an art project. Right! We are going to change them into POP collages. So be prepared for some fun, and some surprising results as we begin!

Procedure

1. Select several of the labels, wrappers, etc. that we have collected. Look them over carefully and see if you have a variety of colors, shapes, and sizes among your choices.

2. Begin to arrange the different items into an interesting design upon your white paper. Remember to overlap, or to place part of one object on top of another. Perhaps you would like to cut out sections from your labels and wrappers. That part of the comic strip would look perfect in the corner! How about a small circle cut from that advertisement? (see Figure 9-1.)

3. When you are satisfied with your design, carefully paste all the parts onto the white paper. Remember, a small amount of glue is all that is needed.

4. If felt markers are used, apply colors to form areas of lines of accent.

5. Mount the finished collages onto construction paper, and carry them carefully to the designated area to dry.

Look Around You

We have done something very unusual today! We really have been POP artists. We have taken advertisements, comics, etc. that are so much a part of our everyday world, and with paste, scissors, and imagination, changed them into bright and colorful POP collages. The materials we used all had designs that were printed onto them by machines. Can you think of machine-made things that have *shapes* designed into them? How about egg cartons, steering wheels, or waffle irons. Ask your family to join you in a hunt for machine-made shapes and designs on ordinary things around the house. Be sure to look at floors and ceilings, as well as wallpapers. Perhaps you can find some objects that are about to be thrown away that you can make into a family POP art project! Remember that if you lived long ago, when machines did not produce objects, you could not have created in the POP art style.

Adaptations

1. Display these unusual POP collages for an interesting hall or bulletin board exhibit.

2. Make a collection of pictures depicting life long ago and modern-day living. Have the class compare the differences in the amount of handmade and machine-made items.

3. Divide into teams and see which one can list the largest number of commercial objects found in the classroom or at home.

4. Create POP sculpture from cast-offs, such as empty food cartons, by pasting them together with strong glue into interesting arrangements. Be sure to have children obtain parental permission before bringing in objects from home.

5. Paint or draw realistic pictures that include advertising, and pictures of commercial products (e.g., hi-fi sets, T.V. sets, etc.) as part of the overall design.

Through the Eye of the Artist

POP artists have found both beauty and humor in our modern day world of comics, advertisements, machine-made gadgets, and gimmicks. An introduction to this art movement through the use of reproductions of such works, will intrigue students and enhance this lesson.

Suggestions

Paintings:

Wesselmann—"Still Life No. 33"

Warhol—"Dick Tracy," "Marilyn Monroe," "Four Campbell's Soup Cans"

Lichtenstein—"As I Opened Fire," "Big Painting"

Rosenquist—"F-III," "1, 2, 3, and Out"

Sculpture:

Oldenburg—"Hamburger, Popsicle, Price," "Bacon, Lettuce and Tomato"

Dine—"Shovel"

Warhol—"Brillo Boxes"

Segal—"The Dry Cleaning Store"

Johns—"Painted Bronze"

Glossary

Pop Art: art movement, particularly during the 1960's, in which artists stressed commercialism as a basis for their art

Collage: various materials made into a picture or design and pasted to a background

LESSON 9-2

It's "Op" to You

(felt markers; Op art)

Materials

felt markers—black
white paper—9" x 12"
pencils
rulers

Figure 9-2

Figure 9-2a-c

Be Prepared

1. It is extremely exciting for children to see examples of "optical illusions" created through art. To illustrate a simplified version of how the eye can play "tricks" with what we see, in advance of the lesson, prepare several optical drawings. Two lines, exactly the same in length, appear different in size if arrows are drawn in opposite directions at the top and bottom (Figure 9-2a). Two lines can be made to appear as if they are going back into the distance, by converging them at one end (Figure 9-2b). Such diagrams can be drawn onto white paper with a black felt marker and can serve as an introduction to "perspective" as well as "optical illusion."

2. In addition, have several examples of "Op Art" (particularly in black and white) to show the class at the start of the lesson. (See "Through the Eye of

the Artist'' for suggestions.) The use of an opaque projector will be most helpful since pictures from books and magazines can be shown on an enlarged scale.

3. Art helpers should distribute the necessary supplies at the start of the lesson. Each child will need one sheet of white paper, a black felt marker, a ruler, and a pencil.

4. All art appears more attractive when mounted. If possible, have a supply of black paper, somewhat larger than the white, plus staplers, as backing for the finished projects.

5. Designate an area for children to place their completed work until ready for display.

Introduction of Lesson to Students

Everyone loves a magician! He seems to make things appear and disappear. He plays tricks that are really ''optical illusions.'' What does that mean? It means that we see something *differently* from what it *really* is. Artists can be magicians, too. For example, two lines that are identical in measurement can *seem* to look different in size depending simply on how two arrows are drawn at both ends of the lines (Figure 9-2a). Two lines can *seem* to go back into the distance if they are drawn closer together at one end (Figure 9-2b). When we are able to create this feeling of distance, or going off into space, we are creating not only an optical illusion, but ''perspective'' as well. This is also true, when we draw something that appears to have depth and width. Today, scientists have discovered how and why the eye works to create these illusions. These modern discoveries have actually led to an art style that is called ''Op Art'', which is short for ''Optical Art.'' Do you think we can possibly play some magical art tricks with our eyes and create some ''Optical Art'' of our own? Let's see how well we succeed . . . it's all ''Op'' to you!

Procedure

1. One of the easiest ways to create optical illusions is to use only black and white, as we are today. When we place black and white side by side, our eyes see ''after-images'' or spots of grey, that are really not there! (*Note:* See ''Through the Eye of the Artist'' for specific suggestions of Op Art that will illustrate this to the class.) Keep in mind, also, that by bringing two lines closer together at one end (Figure 9-2b and c), we can create distance, or perspective that will also add to our magician's bag of ''art tricks.''

2. Draw pairs of lines (two at a time) that are closer together at one end. Repeat this procedure over and over until you have filled the page as much as you like (Figure 9-2c). Do you see all the shapes you have made?

3. Now, think of a checkerboard, and begin to ink in every *other* shape that you have made, with your black felt marker. Work slowly and carefully,

and think about what you are doing. Before long you will have made an "Op Art" design!

4. When the entire design has been inked with the felt marker, mount it carefully onto black paper and place it in the designated area (see Figure 9-2).

Look Around You

Let's take a real look at our "Op" art. These designs are quite something to see! For one thing, we have created a feeling of distance. How? If you look carefully, how many of you can see an after-image, that is, grey areas that seem to appear on the white even though they are not *really* there? Can you think of other optical illusions that we often see? Think about the sunset. Does the sun *really* fall into the ground or ocean? When we ride a car or bus, does the land *seem* to be moving in an opposite direction? How many of you have blown a paper pin-wheel where the design seems to change as it spins? Watch moving cartoons and television commercials for examples of optical illusions. Collect advertisements that use this effect. Be thinking of these "tricks" our eyes play as you ride past a fence, or see a pattern on a fabric that seems to "jump" when you look at it for a while. Ask your family to help you find some more "optical illusions."

Adaptations

1. These black and white "Op" designs make a most effective wall display.

2. Experiment with optical effects in weaving, by using thin white paper strips to weave into black paper. (See Lesson 8-1, "In and Out," for techniques and suggestions.)

3. Cut out shapes in black and one other color and arrange them into an abstract design upon blue or white paper and see what effects of distance can be achieved.

4. Make crayon or felt marker pictures stressing simple perspective, e.g., houses and mountains in the distance, boats in different areas upon a lake, etc.

5. Try designing "Op" patterns for fabric, book covers, greeting cards, posters, etc.

6. Encourage youngsters to research scientific explanations of how the eye works.

Special Bonus Project: Let's Be "Mod"

Everyone loves a gift, especially when it is handmade. Create striking "mod" bracelets by first taping a strip of cardboard (approximately 2″ x 8″) into a bracelet shape. Completely cover the form with strips of papier mâché

(newspaper or toweling dipped into a mixture of flour and water that is of creamy consistency) or use strips of plaster-covered gauze, dipped in water. Three or four covering layers are sufficient. When the bracelets dry, paint them with "Op" designs. The finished jewelry can be shellacked for extra durability and sheen.

Through the Eye of the Artist

Along with modern reproductions of "Optical Art" (especially in black and white) the class should be shown reproductions of works of other artists who also achieved optical illusions in their works. Discuss the styles and methods that were used (e.g., Pointillism, perspective, Impressionism, etc.).

Suggestions

OP *Artists:*

> Vasarely—"Supernovae," "Zebras"
> Riley—"Intake," "Movement in Squares"
> Poons—"Nixe's Mate"

Others:

> (Optical effects; Surrealism)—Dali—"Slave Market with Invisible Bust of Voltaire," "Old Age," "Adolescence and Infancy"
> (Pointillism)—Seurat—"The Island of La Grande Jatte," "The Circus"
> (Perspective)—Breughel—"The Suicide of Saul," "Hunters in the Snow"

Glossary

> Op Art: art movement of the 1960's in which the artist attempts to involve the viewer with the painting through the effects of optical illusion, based very often upon scientific data of how the eye performs
>
> Pointillism: an art movement that was an outgrowth of Impressionism, in which the artists used dots of color to achieve form and subtle color changes
>
> Perspective: the art of creating the effect or illusion of distance, height, width, and depth upon a flat surface
>
> Impressionism: the artists are primarily concerned with depicting the effect of light upon objects as it is reflected. This movement started in France around 1870

LESSON 9-3

Colorful Collographs

(styrophene and cardboard; printing)

Materials

shirt cardboard or other compar-
 able weight paper
white paper—the same size as
 the cardboard
polystyrene meat trays from the
 super market
white glue
scissors
pencils
felt markers—assorted colors
tissue scraps—optional
rulers—optional
inking plates—glass or metal
water-soluable printing ink-
 —assorted colors and black
brayers

Figure 9-3

Be Prepared

1. Make a collection of shirt cardboard well in advance of the lesson.
Cardboard from cartons or boxes can be pre-cut approximately 4″ x 7″ if shirt
cardboard is not available.

2. Also in advance of the lesson, collect clean polystyrene meat trays.
(This material is also available in sheets with adhesive backing, from art supply
companies.)

3. This is a very safe way to introduce printing, since no sharp cutting
tools are needed. However, allow time for the completion of the project;
usually two sessions are sufficient.

4. To facilitate the lesson, pre-cut white paper to the same size as the
cardboard.

5. Cover all work areas with newspapers for easy cleanup.

6. Art helpers should distribute all necessary supplies at the start of the lesson. Each child will need one piece of cardboard and a polystyrene tray. Scissors, markers, and paste can be shared.

7. When students are ready for printing, each table should have at least two inking plates (a glass, or preferably metal, rectangle) on which to spread ink. Glass can be cut to approximately 6″ x 9″ by a glazier, but should be taped on all edges before using. Metal inking plates, which are available from art supply companies and stores, are preferable because they are unbreakable. Two children can share a brayer. Each work area should also have two tubes of printing ink, and at least four sheets of paper per child. More paper should be available at a central supply area.

8. All children should wear smocks.

9. All art work appears more attractive when mounted. If possible, have a supply of staplers and contrasting construction paper as backing for the children's prints.

10. Designate an area for children to place their prints to dry.

11. Assign cleanup crews to wash and store the brayers and inking plates, and to put away the tubes of ink.

Introduction of Lesson to Students

We live in a very exciting modern world! New materials and new words become part of our lives all the time. Even the plastic for meat trays that we have been collecting was not invented until quite recently. The special material for these trays is called "polystyrene" (that's quite a word isn't it?), and we are going to use them to make "collographs." (That's quite a word, too!) This means that we will be pasting shapes onto a cardboard backing, then inking and printing them. We will be using a special art tool to spread the ink, a "brayer." We've just learned some very unusual words; now, let's create some unusual art. Here's how!

I. Procedure: Preparing the Collograph

1. To make a "collograph," or the design on cardboard that we are going to ink and print, cut out several interesting and varied shapes from the polystyrene tray. These can be free-form or carefully ruled geometric shapes, such as triangles and squares.

2. Place the shapes onto the shirt cardboard and arrange them into a pleasing composition. Does it look too empty? Add more shapes, but be sure to make them of differing sizes, for greater interest.

3. Experiment! Polystyrene can be marked or indented easily with a pencil. Remember, however, every line that you draw will show up on your print.

4. After your arrangement has been teacher-approved, glue each shape onto the cardboard. Your collograph is now ready for inking and printing.

II. Procedure: Inking and Printing

1. Carefully squeeze some ink from the tube, onto the "inking plate." This must be of metal or glass, because paper will absorb the ink.

2. With your brayer, roll the ink back and forth until it looks smooth.

3. Your brayer is now coated with ink. Roll it back and forth on the top of your cardboard design, or collograph. Be sure to particularly coat the polystyrene shapes.

4. Place a sheet of paper over the inked collograph being sure to keep the edges of the paper and cardboard even.

5. Rub the entire surface of the paper with your hand. The more ink you have applied, and the harder you rub, the darker your print will be.

6. Lift the paper very carefully and you will see that you have created a print of your design.

7. Make several prints. Experiment! Try applying more or less ink. Use varying degrees of pressure. Not every print has to be a perfect one; it is more important to learn and understand why you are getting differing effects.

8. If tissues are going to be added for extra color in the print, pieces should be torn or cut into interesting shapes and placed onto the prints while the ink is still wet. This eliminates the need for glue, since the shapes will stick to the ink as it dries (see Figure 9-3).

9. Other lines of interest may be added with felt markers (Figure 9-3).

10. As each print is completed, place it in the designated area to dry.

Look Around You

Our collographs could not have been made one hundred years ago. Polystyrene and our white glue were not available to artists then. Even our felt markers, which we are so familiar with, were not yet invented. Ask your parents and grandparents to tell you about the art supplies they used when they were children. You will be surprised at how many are the same as yours, but also at how many more things are yours to use because you live in today's world! Can you name some synthetic fabrics? What about nylon and acetate? How long a list can we make for the use of plastics? Have you ever thought about the many materials that we take for granted, that were not in use before the twentieth century? Our world is a very exciting one. Perhaps one day *you* will invent a new material.

Adaptations

1. These polystyrene collographs make a most attractive bulletin or hall display.

2. Very striking results can be achieved by using wallpapers, pre-cut to the desired size, as the paper to be printed. The designs add a great deal of interest to the prints.

3. Experiment with pasting all kinds of materials onto cardboard to create even more complex collographs: e.g., mesh, string, toothpicks, etc.

4. After the prints have been made, spray the cardboard designs black. After they have dried, rub antiquing paste onto them. The results are most unusual.

5. Try printing cardboard inner tubes that have been covered with string. (see Lesson 4-5, "Rollaways," for methods.)

6. Use these prints for attractive program covers or booklets.

7. Make unusual greeting cards, using the procedures of this lesson.

8. Simple prints can be made by drawing pictures with pencil, pressing so that the lines are recessed into the polystyrene.

Through the Eye of the Artist

A discussion of various printing techniques during different eras, such as woodcuts and etchings, will greatly enhance this lesson. Reproductions of such prints should be shown to the class along with a discussion of the varying techniques, subject matter, and effects achieved.

Suggestions

Woodcuts:

Frasconi—"The Storm is Coming"
Japanese woodcuts

Collographs:

Romano—"Ljubljana Night"

Etchings

Rembrandt, John Sloan, Edward Hopper

Glossary

Collograph: materials are pasted onto cardboard and then inked and printed

Print: design or picture made by inking or painting one surface and then pressing it upon another

Woodcut: print made by inking wood that has been cut to form a design or picture

Etching: lines are eaten into metal by acid; printing then produces detailed linear effects

LESSON 9-4

Hard Can Be Easy!

("hard-edge" painting)

Materials

black construction paper—
 12″ × 18″
white paper—14″ x 20″
tempera paints and brushes
chalk
scissors
paste and paste sticks

Figure 9-4

Be Prepared

1. Allow two sessions for the completion of this project; one in which to paint an abstract design; the other to cut and paste it into a "hard-edge" composition.

2. An example of the project should be prepared in advance of the lesson. This will not only serve to acquaint the teacher with the creative procedures of the lesson, but will be an aid for demonstration purposes.

3. Cover all work areas with newspapers for easy cleanup.

4. For the first session, art helpers should distribute a sheet of black paper and a piece of chalk to each child. Paints can be distributed in empty egg cartons or juice cans, or a central supply area can be set up in a corner of the room. Coffee cans, partially filled with water, will aid in the quick rinsing of brushes.

5. For the second session (cutting and pasting the composition) each child

will need a pair of scissors and a sheet of 14″ x 20″ white paper, and his previously painted abstract design. Paste and paste sticks can be shared.

6. All compositions appear more attractive when mounted. If possible, have a supply of 18″ x 24″ contrasting paper and staplers, available as backing for the finished works of art.

7. Designate an area for children to place their paintings until ready for display.

Introduction of Lesson to Students

If we talk about the "edge" of something, what do we mean? Right! The outline, or border. Think about the edge of a rock: would you say it was soft or hard? The edge of a feather, or of cotton, would most certainly feel soft. When we talk about the edge of a *shape*, we often think about the way it feels. But what about the way a shape *looks*? Tear a tiny piece of paper from a corner of the newspapers that cover our tables and look at it. The torn edge looks softer than the untorn edge of the paper, which is even and straight. Artists today, are very often interested in creating paintings that have only "hard-edge" shapes in them; that is even, clear, precise forms. We are going to experiment ourselves, with a very interesting way of creating our own "hard-edge" paintings, and when we do, any "puzzlement" you may feel about such art will be answered.

Procedure: Painting an Abstract Design

1. Pictures do not always have to be of real things. We can create beautiful art with only colors and interesting shapes. Such art is called "abstract" or "free form." Keep this in mind as you draw a series of interesting shapes onto the black paper with chalk.

2. Be sure to have differing sizes in your composition, and avoid tiny forms that will be difficult to paint. Experiment! You may wish to have all triangles and rectangles in your composition. Perhaps you would like to swirl some lines and invent shapes as you go along.

3. When your design has been teacher-approved, begin to paint it. Use bold, bright colors, and paint the shapes carefully and evenly. Remember, we are trying to create "hard-edge" shapes, so we wish to avoid dripping or runny paint.

4. When the painting is complete, carry it in "tray-like" fashion (to avoid unnecessary dripping of paint) to the designated area.

Procedure: Cutting and Pasting a "Hard-Edge" Composition

1. Think about a jigsaw puzzle: it is made up of many shapes that fit into one another. We are going to cut our abstract paintings (now that they have dried

thoroughly) so that they are in shapes very much like puzzles. Just remember to cut each shape carefully, so that it will keep a "hard-edge"—even, not ragged (see Figure 9-4).

2. As you cut your painted design, place each piece upon the white paper, leaving a small area of white in between each shape. This white area is called "negative space" since it is not the most important part of the design. The painted shapes, which are more dominant, or important, are called "positive space." Do not cut the shapes too small, or they will be difficult to handle.

3. When the entire abstract painted design has been cut and arranged, paste each part onto the white paper. (Remember, always leave some space in between each shape.)

4. When everything has been pasted, you may wish to add further interest to the "negative space," by painting some lines or dashes (Figure 9-5).

5. Place the completed "hard-edge" paintings in the designated area.

Look Around You

How many things do you see in the room that are "hard-edge" shapes? The books, papers, boxes, the bulletin board. What else? How many things do you see that have "soft-edges"? Liquid paint, inks, and torn paper scraps. What else? Would you say there seem to be more "hard-edge" shapes than "soft-edge" shapes? Our world is full of interesting forms; we have to learn to *see* them. Ask your parents to help you find both kinds at home, and see which list is longer. Look for such shapes outdoors, especially among natural objects such as leaves, flowers, sand, rocks, and wood. Look for billboard signs with clear, evenly-edged lettering. How do you think we might make some "soft-edge" paintings? Perhaps we'll try that in our next lesson. Our compositions look a little like jigsaw puzzles. Is the term "hard-edge" painting a puzzle to you any longer?

Adaptations

1. Create "soft-edge" paintings, using such media as inks and water colors, and torn tissues. (See Lesson 2-8, "Daydreams," and Lesson 1-7, "Private Worlds, Inner Dreams," for specific procedures.)

2. Display both the "hard-edge" and "soft-edge" paintings together for a striking modern art display.

3. Such compositions, on smaller paper, make interesting book covers.

4. Try "hard-edge" designs using cut construction paper. Fluorescent papers on black would be particularly effective for this project.

5. Incorporate "hard" and "soft edge" shapes into realistic pictures.

6. Divide the class into teams and take a short outdoor walk. Play games to see which team can make the longest lists of "hard" and "soft-edge" shapes that they have discovered.

Through the Eye of the Artist

Although other artists have included ''hard-edge'' forms in paintings and sculpture, examples of works by *modern* artists who particularly stress this style should be shown to the class to highlight the lesson.

Suggestions

Hard-Edge:

 Kelly—''Two Panels: (Blue, Red,'' ''Blue/Green,'' ''Red White''

 Glarner—''Relational Painting''

 Matisse—''The Snail''

 Stella—''Tuftonboro I,'' ''Sinjerli Variation IV,'' ''Hagmatana III''

Soft-Edge:

 Louis—''Aleph Series II''

 Gottlieb—''Blast I,'' ''Chrome''

 Pollock—''Number 12''

 Still—''1960-F''

Combination of Both:

 Johns—''Edingsville''

 Hofmann—''Autumn Chill and Sun''

Glossary

Hard-edge: term for art stressing shapes with clean precise edges

Negative space: the areas of space created between the dominant shapes within a design

Positive space: the dominant areas of space within a design

Free form: generally non-realistic; not representative of natural shapes

Abstract: art that creates new forms and shapes which may be derived from natural forms

LESSON 9-5

"String-a-Longs"

(abstract designs with yarn)

Materials

yarns—assorted colors
shirt cardboard or oaktag
scissors
assorted construction papers (the
 same size and larger than the
 cardboard)
chalk
paste
tape Figure 9-5

Be Prepared

1. To facilitate the lesson, pre-cut yarns into lengths approximately 12″.

2. Prepare an example of the project before the lesson. This will not only acquaint the teacher with the creative procedure, but will serve for demonstration purposes.

3. Art helpers should distribute the necessary supplies at the start of the lesson. An assortment of yarns should be at each work area; more should be available at a central supply station. Each child will need two sheets of construction paper (one dark, the other light), a piece of cardboard, a pair of old scissors, and some chalk. Paste and tape can be shared.

4. All art appears more attractive when mounted. If possible, have staplers and contrasting papers as backing for the finished works.

5. Designate an area for children to place all finished work until ready for display.

6. Have a box in which children can place all usable scraps.

Introduction of Lesson to Students

Today's art can be every bit as exciting as today's music and fashion. Modern artists feel free to experiment with new materials, just as musicians experiment with new sounds. You have all heard of a musical "sing-a-long". . . . Let's be different and create some artistic "*string*-a-longs." Here's how.

Procedure

1. With chalk, draw a *large*, interesting shape. It should not resemble anything that is real, but should be "abstract" or "free form."

2. After your outline has been teacher-approved cut it out.

3. Place it onto a sheet of dark paper, and trace the shape.

4. Now cut out the shape from the dark paper, and paste it onto the cardboard.

5. Begin to cut *small* (about ¼") slits all around the edge of the paper covered cardboard. Space each slit, approximately ¼" to ½" apart.

6. Take any color yarn you may wish and make a small knot at one end.

7. Place the knotted end behind the cardboard and pull the rest of the string through a slit. Pull the yarn over the front of the paper-covered cardboard shape, and through a slit on an opposite edge. (It need not be *exactly* opposite; see Figure 9-5.) If there is enough string, bring it behind the cardboard to another slit, and repeat the procedure.

8. As you come to the end of the string, pull it fairly tightly to the back of the cardboard, and secure it with a piece of tape.

9. Choose other colors of yarns as you repeat the procedure of pulling the yarn in different directions. Crossover yarn; try creating interesting shapes as you go along (Figure 9-5). If the yarn is pulled too tight, the cardboard will bend. If the yarn is not tight enough, the design will appear loose and uninteresting. As you work, you will get to know the right amount of pressure. When all the slits have been filled with yarn and the design is completed, take the lighter piece of construction paper and cut still another shape, not identical to the cardboard one.

10. Paste the complete "string-a-long" design onto it with an interesting angle (Figure 9-5).

11. Place the completed project in the designated area.

12. All usable scraps can be put into the special box.

Look Around

We have really created some interesting designs today. Do you think ancient artisans could have worked with these materials? Would you say that line is very important to our compositions? What about the open spaces in between

the yarn? These are also very necessary to the total effect. Where in nature do we see such space formed within lines? How about spiders' webs. What else? Where can we see examples of such space in man-made things? How about bridges and the girders on buildings. Look closely at cloth that is loosely woven. Examine some crochet work or lace. Have you ever really thought about the spaces that are created in this way? Ask your family to join you in a search for "volume," or space within or surrounded by a form. Watch for fences, telephone wires, and branches of bushes and trees that cross one another. You are all in for quite a discovery! Modern inventions allow us to find volume in places that people of the past could not have seen. Think about the burners on electric stoves or the racks in the ovens and refrigerators. What are examples of "old times" volume? Think about windmills and spinning wheels. What else?

Adaptations

1. These "string-a-longs" make a most unusual display.

2. Experiment with other material, such as carpet warp, gift wrapping string, or ordinary white string, ribbons, etc.

3. Paste the strings down and print them. (See Lesson 9-3, "Colorful Collographs," for procedures.)

4. Wrap string or yarn around inner tubes and create unusual prints. (See Lesson 4-5, "Rollaways," for suggestions.)

5. Paste scraps of materials and wallpapers to the shape *before* proceeding with making a "string-a-long." This adds color, texture, and dimension to the design.

Special Bonus Project: "Nail-a-string"

Collect scraps of lumber, especially rectangular shapes, and outline a design with nails that are hammered part way into the wood. Tie the yarn to a nail, and proceed as in this lesson. These three-dimensional constructions are particularly effective when the wood is sprayed with black paint, *before* starting to work with the yarn or string.

Through the Eye of the Artist

With the help of modern technology, a number of twentieth century sculptors have experimented with creating space, or volume, between metal or wire lines, built into three-dimensional forms. Reproductions of such works, along with paintings that stress line, will greatly expand the children's appreciation of this lesson. In addition, youngsters will find it particularly interesting to compare such works with more traditional sculpture (e.g., Greek, Roman, Renaissance).

Suggestions

 Gabo—"Spiral Theme," "Linear Construction," "Linear Construction; Variation"

 Lippold—"Variation within a Sphere," "Variation Number 7," "Full Moon"

 Moore—"The Bride"

 Paintings:

 Stella—"The Bridge"

 Hartung—"Painting"

 Dali—"Mama, Papa is Wounded"

 Picasso—"The Studio"

Glossary

 Volume: space within, or surrounded by, a form

WE ARE PART

OF THE WORLD OF TOMORROW

The Future

The world of the future belongs to the children of today. Youngsters are already aware of current marvels of scientific and technological advances: men on the moon, travel in outer space, supersonic planes, satellite television are all part of the world for modern boys and girls. To stimulate the child to think creatively and to explore beyond such astounding accomplishments, and thereby to help form his own imaginative concepts of the wondrous possibilities for tomorrow's world, is the goal of this chapter.

The very topic "world of tomorrow" is sure to act as a catalyst for motivation and interest as the child explores art activities that range from easy, yet effective, crayon-resist drawings of rocket ships to more elaborate constructions of cities of the future. Various art media are utilized and boys and girls will be encouraged to work in groups as well as individually, as they build a robot, learn about volume and space with toothpicks, create futuristic masks, and actually make their own imaginative slides of outer space. Special bonus activities are included, as well.

The teacher will be helped to establish an inter-relationship of life in the past, present, and future with her class through the sections "Introduction of Lesson to Students," "Look Around You," and "Through the Eye of the Artist." Thus the child, through his actual art experiences and his developing sensory awareness, will gain not only a greater insight to the wonders of his heritage and present world, but will be introduced to the fascinating possibilities in the intriguing world of tomorrow.

LESSON 10-1

Blast Off!

(crayon-resist)

Materials

crayons—assorted colors and
 white
white drawing or water color
 paper—12″ x 18″
water colors or diluted tempera
 paints
brushes—water color or tempera

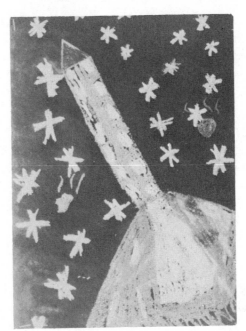

Figure 10-1

Be Prepared

1. Cover all work areas with newspapers for easy cleanup. Several desks pushed together will suffice if tables are not available.

2. Art helpers should distribute the necessary supplies at the start of the lesson. Each child will need one sheet of white paper and a brush. Crayons and paints can be shared. If tempera paints are to be used, dilute several colors such as red, blue, and black, with water and in advance of the lesson test to see that the crayon resists the paint; if the tempera is too thick, it will cover the crayon. Coffee cans, partially filled with water, should also be at each work area to facilitate the quick rinsing of brushes. Water color paints can be used directly from their containers since they are available in solid form; temperas can be distributed in empty juice cans or plastic cups.

3. All children should wear smocks.

4. Designate an area for children to place their finished paintings.

5. All art work looks more attractive when mounted. If possible, have a supply of contrasting paper (larger in size than the drawing paper), plus staplers, available as backing for the finished works of art.

6. Tape a sheet of white paper to the board, where it can be easily seen by the class, for demonstration purposes.

7. Allow time for cleanup.

Introduction of Lesson to Students

Imagine how exciting it would be if every time you wanted to take a trip, you could ride a rocket! In the world of tomorrow, years from now, spaceships may very well be as common as cars and buses are today. So get ready for an imaginary journey through space, as we get set with paper, paint and crayon to ''Blast Off''!

Procedure

1. Crayons can be very special, especially when they are combined with paints. When crayon is applied heavily to paper and paint is brushed over it, the crayon will resist or ''push away'' the paint. Only those areas where crayon has *not* been applied will be covered with paints. Keep this in mind as you draw a large rocket onto your white paper with crayon. It is easy to draw the rocket: simply make a rectangle and attach a triangle to the top (Figure 10-1). Or, design your own shape!

2. Crayon designs, windows, lettering, etc. onto the drawing of the rocket. Remember to press heavily, and to cover all the spaceship with color. Use bright colors and white wherever possible.

3. Add crayon to the background by drawing stars, planets or perhaps another spaceship in the distance, or a spaceman. Red, orange, greens, and yellows can be added to look like burning fuel. Remember, we are thinking as though we were living in the future! Do not, however, crayon in the entire background.

4. Now for the fun! Carefully apply paint all over the paper. That's right—bring your brush right *over* the crayoned sections. Look what is happening! The paint is being ''pushed away'' by the crayon, and not sticking. Use your brushes carefully, and think about the colors of paint you are choosing. Dark paints make light-colored crayons, especially white, show up very well. If you wish to use more than one color, make certain to rinse off your brushes each time so that the paints do not become muddy.

Look Around You

Look carefully at our wonderful space rockets. Do you see how different crayoned areas look when paint has been applied over them? There is an

appearance of texture that is quite unusual. Notice, too, how lighter colors such as yellow and orange look. When white was applied to the white paper, you could hardly see it. Our rocket ships are certainly the vehicles of travel in the future. How many ways do we have for travel today? The list will surprise you! What are ways of travel from the past that we still use? Bicycles, wagons, sleds are a few. Can you name more? Today, we can travel below the sea, under the earth, (think about tunnels) and in the sky as well. How has our world been changed by new and different ways of travel? Think of the roads, airports, bridges, etc., that have been built for transportation purposes. Discuss this with your family, especially your grandparents, and hear how they think their surroundings and lives have been affected by changes in transportation.

Adaptations

1. These crayon-resist paintings make effective room displays.

2. Use the drawings as covers for booklets about space travel and exploration.

3. Have the children design and draw new ways of travel, e.g., "A Car of the Future," "A Bike of the 23rd Century," etc.

4. The procedures in this lesson can be used effectively for other subjects, e.g., weather, holidays, city scenes, underwater scenes, and abstract designs.

5. Use crayon-resist for especially striking Halloween pictures. Ghosts, pumpkins, goblins, and witches take on an eery appearance with this method!

Extra Bonus Project: Bleach Bottle Rocket

Build three-dimensional spaceships, by covering clean, empty bleach bottles (no handles, please) with aluminum foil. Tape on construction paper "tail fins" or other embellishments, including crepe paper streamers to simulate fuel exhaust.

Through the Eye of the Artist

This is an opportune time for children to become more aware of how the artist functions as an historian of his time. Reproductions of art depicting various modes of transportation throughout history, as well as a discussion of the styles and techniques used in the paintings, will greatly enhance this lesson.

Suggestions

Greek, Roman, and Egyptian art depicting chariots, barges, etc.

Rembrandt—"The Polish Rider"

Renoir—"Le Pont Neuf"

Turner—"Grand Canal, Venice"

Pickett—"Manchester Valley"
Eakins—"Max Schmitt in a Single Scull"
Cassatt—"The Boating Party"
Currier and Ives—prints

Sculpture:

Egyptian, Greek, and Roman statuary depicting horses, boats, etc.
Roszak—"Spectre of Kitty Hawk"
Dallin—"Appeal to the Great Spirit"

Glossary

Background: the areas in a composition behind the main subject matter

LESSON 10-2

Futuristic Faces

(masks, plaster-covered gauze)

Materials

Session I:
paper plates—10″
plaster covered gauze
scissors
containers for water—e.g.,
 foil broiling pans
tempera paints and brushes
paper and crayons for pre-
 liminary sketches-
 —optional
oaktag or other firm paper
newspapers
masking tape

Figure 10-2a

Session II
assorted materials for
 trims—e.g., rickrack,
 toothpicks, feathers,
 felt, etc.
scissors
white glue
felt markers
tempera and small brushes

Figure 10-2b

Be Prepared

Note: This is really a foolproof lesson; everyone will feel successful. But enough time must be allotted, so bear in mind that at least two art sessions will be required.

1. Discuss the project in advance of the lesson so the children can have time to think of ideas. If possible, show pictures of tribal masks (e.g., African, Oceanic, or American Indian) to the class. Ask children to begin collecting unusual trims for their masks, e.g., macaroni, sequins, feathers, etc. to increase the class supply. Store all such trims in a box until ready for use.

2. If possible, have a supply of old scissors to be used especially for projects involving plaster-covered gauze, since cutting the gauze tends to dull the blades.

3. Pre-cut rolls of gauze so that each youngster will be able to start his mask with a roll about ten inches in length. More gauze should be available as needed, and can be placed in a central supply area.

4. Paints can be placed in juice cans in a central supply station near the extra gauze. Coffee cans, partially filled with water, will aid in quick rinsing of brushes.

5. Cover all work areas with newspapers for easy cleanup.

6. Place containers for water and a roll of masking tape, at each work area, along with a pair of scissors and a paper plate for each child. Newspapers and oaktag, or other firm paper, should be at the central supply station.

7. Assign art helpers for specific tasks: pouring water into the pans at the beginning of the lesson; washing, drying, and storing scissors for cutting the gauze; emptying the water from the pans and cleaning each work area.

8. Designate an area for children to place their projects in between sessions.

9. As with all projects, it is excellent preparation to create a futuristic mask yourself, so that one will be completed to show the class. It will not only help acquaint you with the creative procedures, but it really is fun!

Introduction of Lesson to Students

Do you think the men of the future will look the same as we do? Think for a moment: do we still resemble pre-historic men? Let's journey millions of years into time today, as we create masks of tomorrow, "futuristic faces." Animals, birds, men from other planets—anything your imagination suggests, can be the starting point for an excellent idea. Who knows what the end results will be? Let's find out!

Procedure

Session I: *Planning, Forming, and Covering the Mask With Plaster Gauze.*

1. The shape of our masks, or "futuristic faces," will be based upon the shape of our plates. However, we can cut away parts of the plate or add to it, if we wish. For example, a trunk of a strange "Elephant from Earth" can be created by rolling some newspaper into the desired shape and attaching it to the plate with tape (Figure 10-2a). That "Man from Mars" can have a weird beard or pointed ears cut from oaktag and then taped onto the plate (Figure 10-2b). Horns, antennae, bulging eyes and lips can be made by crumbling newspapers into the desired shapes and taping them into position upon the plate. Perhaps your creation will have only *one* eye. Remember, be daring and let your imagination really fly! You can work directly upon your plates, or if you wish, take a moment or two to make some preliminary sketches on scrap paper.

2. When the design of your mask is complete, begin to cover all of the front surface (eyes, mouth, ears, etc.) with the gauze. First, cut strips approximately 4″ in length. Then, dip each piece into water and remove excess liquid by squeezing the gauze between your fingers. Do one strip at a time, and immediately smooth each over the mask.

3. Cover the entire mask by overlapping the wet strips of gauze and smoothing them out with your hands as you go along. One layer of gauze is usually sufficient, but reinforce all parts that have been added, such as ears, noses, etc. with several extra layers of wet gauze. Do *not* cover the back of the plate.

4. After the mask is completely covered with plaster gauze, it can be painted, even though still wet. Use strange colors—bright and different. Perhaps a green man, or a purple elephant. Do *not* try to add details such as stripes or polka dots at this time, however. Wait until the next session, when everything will be completely dry.

5. When the mask has been painted, carry it carefully to the designated area to dry for at least twenty-four hours.

Session II: *Decorating and Adding Details to the Mask*

1. A variety of trims such as rickrack, sequins, felt, feathers, buttons, etc. should be placed in bins where they are readily available.

2. Paints and small brushes should be ready for those who wish to add painted designs.

3. Scissors and white glue should be available at all work areas, along with felt markers.

4. All work areas should be covered with newspapers for easy cleanup.

Procedure

1. Using paint only, you may wish to complete your mask by adding strange teeth, stripes, and bright colors to ears and eyes, etc. However, some of you may wish to add further decorations from the materials we have been collecting. Perhaps some yarn along the forehead of that strange fellow, or macaroni on the cheeks of that one. Feathers, sequins, felt cut-outs, ears are just a few of the ways you can add decorations to your mask.

2. Place the completed masks in the designated area to dry, until ready for a "Fantastic Futuristic Display."

Look Around You

The world of the future may certainly be a strange place, judging by our "futuristic faces." How has the world changed since pre-historic times? That is really quite a question! Think about the appearance of the land, the dinosaurs that once roamed the earth, and how climates have changed. Think about the changes in clothing, buildings, and ways of transportation. What else? How have masks been used throughout time? Think about ceremonial masks of tribal people. What about the masked balls of olden times. How do we use masks today? Discuss with your parents and grandparents some of the things *they* did as children that are the same as now, and some of the things that are very different. Who knows what the children of one hundred years into the future will be doing!

Adaptations

1. These marvelous masks can be displayed by poking holes into two sides with a nail or compass-point (this should be done under careful teacher supervision) and pulling some yarn through the openings. Several thumbtacks may be required to secure the yarn to a bulletin board, depending upon the weight of the mask.

2. After exhibiting the masks in your school, arrange to have them displayed in your local library. Let the community see what can be artistically accomplished by youngsters!

3. Papier-mâché may be substituted for plaster-covered gauze (see *Glossary*), but allow the masks to dry thoroughly before applying any paint.

4. Cover balloons, instead of plates, to form these masks.

5. For extra sheen, coat the completed masks with shellac.

6. Instead of painting the masks, try overlapping and pasting torn or cut pieces of bright tissues for an unusual effect.

7. Tissue can also be used for marvelously colorful fringes around the masks.

8. Use these same methods to create Halloween masks.

9. Use found materials to create people, animals, birds, etc. of the future. (See Chapter 4, "We Are Aware of our Ecology," for ideas and procedures.)

Special Bonus Project: Totem Poles

Follow the procedures in this lesson, covering boxes that have one side made into facial or animal features. Stack the gauze-covered boxes on top of one another, after they have been painted and decorated, to form fantastic totem poles.

Through the Eye of the Artist

Masks have been used for thousands of years for religious, ceremonial, and decorative purposes. Along with reproductions of Egyptian, Greek, and Oriental masks, show the class examples of African, Oceanic, and Indian tribal masks. Discuss, too, how modern artists have often used primitive masks as the basis for their designs.

Suggestions

Paintings:

Picasso—"Three Musicians"
Lam—"The Jungle"

Sculpture:

Lipchitz—"Figure"
Modigliani—"Head"
Picasso—"Head of a Woman"

Glossary

Papier-mâché: a mixture of flour and water, stirred to a creamy consistency, into which strips of newspapers or paper toweling may be dipped to be used as a sculpting material

LESSON 10-3

Reginald Robot and Friends

(group project; box construction)

Materials

boxes and cartons—assorted
 sizes
strong, clear glue
masking tape
tempera paints and brushes
chalk

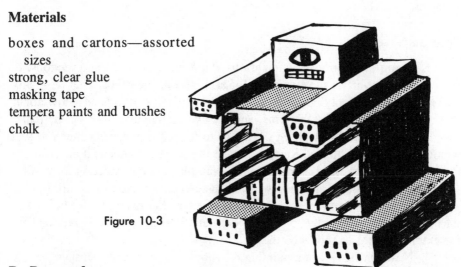

Figure 10-3

Be Prepared

1. Four or five children should work on the construction of one robot. Either assign a group of youngsters to work on one robot, as a special project, or plan on making several robots, so that *everyone* can participate.

2. Collect cartons and boxes, well in advance of the lesson. Elongated boxes, such as those used by florists, or to pack rolls of acetate paper, are particularly suited for the robots' arms. Store the boxes in a designated area until ready for use. Each robot will require at least six different boxes: head, two arms, two feet and torso.

3. The day of the lesson, cover all work areas with newspapers for easy cleanup.

4. Art helpers should distribute all necessary supplies at the start of the lesson. Each group will need six cartons, chalk, a roll of masking tape, and a container of strong glue. Paints can be set up in a central supply area in juice cans. Coffee cans, partially filled with water, will aid in the quick rinsing of brushes.

5. All children should wear smocks.

6. Designate an area for children to place the robots until ready for display.

7. Allow time for cleanup.

Introduction of Lesson to Students

In today's world, machines perform many jobs. Giant computers might even be called "thinking" machines. Do you suppose that the world of the future will be filled with robots, or "mechanical people," who will be able to walk, talk, and work with their "hands"? Let's pretend that we are designers of such robots, as we take our boxes and cartons, and through our art, create Mr. Reginald Robot—or any other named mechanical friends of his that you may think of.

Procedure

1. Examine your boxes and cartons. Turn them in different directions, to see which ones will be most suitable for each part of the robot. That large box will make an excellent body, that square one is perfect for a head. How about those two longer ones for the arms, and the two rectangular ones for the feet?

2. Experiment by stacking the boxes to form a figure, very much as you would with building blocks. Remember, the robot has to balance; if the arms are too heavy, or if the head is too big, for example, the construction may fall.

3. When you are satisfied with the placement of the boxes, apply glue generously to each part that will be joined together. For example, the bottom of the head will be glued to the top of the body, etc. If necessary, add masking tape for extra strength, to reinforce the glue.

4. Now for the real fun: painting the robot. Do you want a strange, wildly colored "machine-man"? Do you want something very dramatic, say all black, white, and silver? Have you decided to make a robot-lady? What about the face of the robot? One eye, two or even *three*? Remember, these are the machines of the future—anything goes.

5. Discuss the plans for painting the robot among yourselves, and when you have decided upon the color, designs, etc., draw details, such as eyes, mouth, etc. with chalk, on the boxes. Apply paint until the robot is completed.

6. Carefully push or slide the robots to the designated area to dry.

Look Around You

What an amazing sight! These robots look as though they are about to march around the room! Ladies, men, even children have been designed. Although they are all very different in the details that have been painted (their faces, patterns on the bodies, etc.), each robot is similar in shape. That's right; squares and rectangles. How many things surround you each day that are similar to these shapes? Look around the room. Windows, paper, boxes of crayons, books. What else? At home, play a game with your family to see who can list the most things in the house that are rectangular or square. Think about stoves, dishwashers, furniture, pictures . . . the list is going to amaze you. Look around as

you walk outdoors. Do you see buildings and houses that are rectangular? How about sidewalks, steps, signs, and doors? Do machines come in other shapes? Do you think it would be good if everything were done for us by machines? Why?

Adaptations

1. Arrange the group of robots in a corner of the room, or along the hall wall for a startling display.

2. Have a class contest for naming the individual robots.

3. Make small versions of this project by using boxes such as shoe cartons.

4. Vary the shapes by introducing cylinders (e.g., inner cardboard tubes) and circles (e.g., paper plates).

5. Experiment with box sculptures. Stack and paint the boxes all one color for a dramatic abstract, or use more realistic subjects. (See Lesson 4-4, "New Life for Old Boxes," for suggestions on animals and other ideas.)

6. Add collage materials, such as yarns, egg cartons, old flash bulbs, sequins, glitter, etc. for extra dimension and sparkle.

7. Create bag puppets of animals and people of the future. (See Lesson 4-3, "Bag It," for methods.)

Through the Eye of the Artist

This is an excellent time to introduce children to "Cubism." (See Glossary.) Reproductions of such art should be shown to the class, with an emphasis on a discussion of form and shape in the art. The influence of African masks and sculpture upon this movement should also be stressed.

Suggestions

Paintings:

> Picasso—"Woman with a Guitar," "Three Musicians"
> Gris—"Guitar and Flowers"
> Villon—"The Dinner Table"
> Braque—"Man with a Guitar"

Sculpture:

> Rodchenko—"Construction of Distance"
> Nele—"The Couple"
> Lipchitz—"Man with a Guitar"
> African tribal masks and sculpture

Glossary

Cubism: an art movement developed in the early 1900's, by which objects

are reduced to geometrical forms and planes, often overlapping, or portrayed as if viewed in several directions at one time

Plane: a flat surface

LESSON 10-4

Sliding Through Space

(projector slides; mixed media)

Materials

clear or frosted filmstrips—35 mm.
a variety of art media: e.g., felt markers, pencils, inks, crayons, temperas, etc.
white paper—9 " x 12"
rulers
35mm (2") slide mounts
scissors
small brushes, swabs and/or pens
rubber cement—optional
masking tape

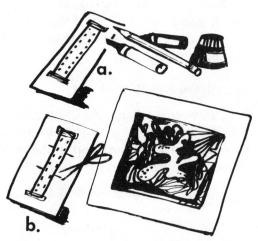

Figure 10-4

Be Prepared

1. Clear or frosted film strips and slide mounts, are usually available from your audio-visual department, or may be purchased from film supply stores. These materials are relatively inexpensive and can also be obtained in kits. Specify film that is *unmarked* by frame lines. If pencils are desired, the special ones for overhead projectors and films should be used.

2. Clear film strips provide brighter colors and can be used with colored cellophanes and tissues: frosted film strips can be used with crayons and *regular* lead pencils. If possible, have a supply of both kinds, so that boys and girls can experiment and see the differing results.

3. To facilitate the lesson, pre-cut the film strips into six-inch lengths. This will provide a workable size, and can be cut later into three slides, each two inches in height.

4. Art helpers should distribute the necessary supplies at the start of the lesson. Each child will need a length of film strip and a piece of white paper. A variety of art media (inks, markers, etc.) should be at each work area, and can be shared. Tissues and clear cellophane can also be incorporated into the slides, but if these are used, rubber cement should also be available. Scissors, rulers, and tape should be at each work area and can be shared. Paints can be distributed in egg cartons or juice cans, or a central supply station can be set up in a corner of the room. Coffee cans, partially filled with water, will aid in the quick rinsing of brushes.

5. Slide mounts should be available at a central place as needed.

6. Designate an area for children to place their finished slides until ready to be shown.

7. Have a slide projector ready for the "preview showing" of the slides.

8. All children should wear smocks.

9. Allow time for cleanup.

Introduction of Lesson to Students

If we were to take a trip into outer space to visit another planet, who knows what kind of wonderful sights we would see along the way; perhaps meteors colliding, or stars streaking—maybe colorful dust blowing in different directions! Let's pretend we are on such a space adventure, and through the magic of our art, we'll capture some of these strange and colorful "space happenings." We'll actually be making our own slides, and when we're finished we'll have a preview on our projector. We're in for quite a surprise . . . so let's get started.

Procedure

1. Place your length of film strip over a sheet of white paper, and carefully tape each end, so that the strip will not slide about (Figure 10-4a). Only a small amount of tape is necessary. If you are working with clear film strip, you may work on either side. However, if your film strip is frosted, be sure to work on the *dull* side, because crayons and pencils will not adhere to the shiny side.

2. With a ruler, and using a felt marker, mark off a line at two-inch intervals along the edges of your film strip (Figure 10-4b). This will show you where to cut your slides later.

3. Now is the time to let your imagination go to work. Experiment with making designs on the film strips with felt markers, inks, paints—anything that is available that you wish to use. Try wetting your strips with small drops of water, and then touching inks to them; let colors overlap and flow. Try lines with markers or our special pencils. Remember, we are working on very small surfaces, so keep the shapes interesting and varied, but not too large. Try applying light colors first, and add darker colors last.

4. How about adding colored tissue or cellophane to the *other* side of your film strips. These will show up as backgrounds to your slides. Experiment with thumbprints (apply a dab of paint or ink on a corner of the white paper and press your finger into it, then make several finger prints on the film strip). Want to try a hole or two? Go right ahead. We're being very adventurous today. After all, we're exploring outer space, remember?

5. When the film strip is completed, carefully cut it at the two-inch markings. You will then have three slides, which can easily be put into the slide mounts. Be sure to write your name on the edge of the mounts, so that we will be able to identify each artist. Remember, we cannot tell now what will be projected on the screen. That's part of the fun!

6. Place the finished slides in the designated area until we are ready for our slide showing.

Look Around You

Now that we have seen our slides, what do you think of our art work? Were you surprised at how different the colors, shapes, and patterns looked after they were enlarged and shown on the projector? Were new colors formed when they were overlapped? Were there differences between the slides made on clear film strip and those made on frosted strips? Were some artistic results accidental? Do you think these "accidents" made the designs more interesting? Often, when painting or drawing, we can change an accidental dripping or smudge into something different and important to our pictures, if we use our imaginations and give it thought. Look around you for accidental happenings that create patterns: dropping a pebble into water, watch the ripples, and what happens to the reflection in the water; look for oil on puddles along the road; watch the moving shadows of trees on a breezy day; what happens when frost appears on a window? There are many beautiful sights to see in *this* world of today; perhaps every bit as beautiful as those that will be in the world of the future. We have to learn really to *see* them.

Adaptations

1. Invite other classes to see your "outer space slide show." Accompany the slides with a musical record.

2. Encourage the children to give interesting titles to their compositions ("Exploding Planets," "Star Happening," "Moon Slivers," etc.).

3. Create these slides with a current theme, using more realistic drawings.

4. Experiment with inks on wet paper and other abstract drawings. (See Lesson 2-1, "Day Dreams," (adaptations) for specific procedures).

5. Project these slides onto the stage of the school auditorium as part of the backdrop for original skits about the world of the future. (See Lesson 2-6, "The Play's The Thing," for procedures related to simple costumes.)

Through the Eye of the Artist

This is an opportune time to explore non-objective art with boys and girls. Reproductions of such paintings should be shown to the class along with a discussion of colors, shapes, media used, and the titles given to the works by the artists.

Suggestions

Hofmann—"Fantasia in Blue"
Brooks—"Cullodon"
Pollock—"Full Fathom Five"
de Kooning—"Composition"
Rothko—"Earth and Green"

Glossary

Non-objective art: art that does not represent forms in nature

LESSON 10-5

Toothpicks of Tomorrow!

(construction; toothpicks)

Materials

toothpicks
cardboard or styrofoam
non-hardening clay

Figure 10-5

Be Prepared

1. The base of these toothpick constructions can be of cardboard, such as scraps of corrugated board or styrofoam. Three-inch balls of styrofoam, cut in half in advance of the lesson, are particularly suitable and attractive.

2. Toothpicks can be round or flat, in colors or natural. Wooden toothpicks are less expensive than plastic ones, and are not as hard to the touch.

3. Art helpers should distribute all necessary supplies at the start of the lesson. Each work area should have a supply of non-hardening clay (approximately ¼ lb. to four or five children) and a box of toothpicks. More should be available, if needed. Each child should have either a half ball of styrofoam (Figure 10-5b) or a piece of cardboard approximately 2″ x 3″ or slightly larger.

4. Designate an area for children to place their completed art work until ready for display. Caution children to carry their constructions very carefully to avoid breakage.

5. A receptacle, such as a plastic bag, should be available for left-over clay.

6. All unused toothpicks should be saved for future projects, such as collages.

Introduction of Lesson to Students

Everyone likes something different and new. Architects and engineers are always experimenting with new shapes for the buildings that they design and build. Today's modern buildings can have different shapes, from curves and sharp angles to the spectacular geodesic dome, which resembles a series of triangles built into a huge dome shape. (*Note:* if possible, have a series of architectural pictures to show the class. See "Through the Eye of the Artist" for suggestions.) The buildings of the twentieth century are certainly very different from those built in the days of ancient Greece and Rome. Who can tell what will be constructed in the future? Perhaps mixtures of odd shapes, or all open spaces, or strange angles and levels. Take your pick—because we are going to use toothpicks today to build some "constructions of tomorrow!" And when we do, we will also be creating "volume," that is, space within or surrounded by a form. Let's see how!

Procedure

1. Roll several small balls of clay between your fingers, and place them at different places on the cardboard (Figure 10-5a). If styrofoam is used, simply poke some toothpicks into it at different places (Figure 10-5b).

2. Join the toothpicks together across the top with more balls of clay (Figure 10-5b). The toothpicks can be leaned in varying directions. Add more balls of clay, and more toothpicks to the base, as the design progresses. This is

one time, that very little advance planning is necessary. The toothpick construction will grow as you go along.

3. Add another level of toothpicks if you wish (Figure 10-5c) but do not build too high, or the construction will collapse. If an accident does occur, however, simply add more clay or toothpicks, wherever they are needed.

4. Continue to create and build, experimenting with changing angles. The more varied the shapes, the more interesting your construction will become. Be daring! Remember, these are constructions of the *future*, so let your imagination really go to work.

5. Carefully carry the completed toothpick constructions to the designated area.

Look Around

Our constructions are three-dimensional, that is they have height, width, and depth. They are also extremely interesting. Look at the shapes formed within the different connections of toothpicks. These spaces are called "volume." Notice, too, how angles are achieved, often by chance. Do you think buildings, bridges, etc. are designed by accident? Great care, training, thought, and preparation must go into each construction. Have you seen open-work, as we have in our constructions, in real buildings? What about the framework of new houses, or the steel girders on a newly rising building? What about bridges, oil towers, and the famous Eiffel Tower in Paris? Surely we have all seen pictures of such constructions. Where in nature have you seen buildings that include open spaces, or volume. Think about a spider's web, or a bee's honeycomb. Be on the lookout for new buildings. Stop to watch as they are being constructed. Look carefully at the design of buildings that you may be very familiar with. Do you think buildings should always be torn down to make way for new ones? Why?

Adaptations

1. Display these constructions on a table or in a showcase for an unusual display.

2. Have the children title their works, and hold a contest for the most unusual design and original title.

3. The constructions can be spray-painted in black, silver, or gold for unusual effects.

4. Draw or paint pictures of "Cities of the Future." (See Lesson 10-6, "Cities of the Future," for suggestions on building such a model city.)

5. Toothpick constructions can be made by gluing the picks together with clear liquid glue, but this is a more difficult procedure.

6. Paste toothpicks in random patterns on cardboard, brush with paint and the print with them. (See Lesson 4-5, "Rollaways," for procedures and ideas.)

Through the Eye of the Artist

This is an excellent opportunity to introduce children to some of the many spectacular modern architectural advances in design. Compare pictures of such new construction with famous buildings of yesteryear, and discuss the change in styles as well as the changes in materials and purposes for the buildings. Reproductions of modern linear sculpture will also enhance the lesson.

Suggestions

Fuller—(the inventor of the geodesic dome)—United States Pavillion, Expo '67, Montreal

Wright—Guggenheim Museum, N.Y.; Taliesin West, Phoenix, Arizona

Buildings in Brasilia, Brazil; Eiffel Tower, Paris, France

Greek, Roman, Byzantine, and Medieval architecture

Sculpture:

Lassaw—"Sculpture"

Picasso—"Construction in Wire"

Giacometti—"The Palace at 4 a.m."

Glossary

Three-dimensional: having height, width, and depth

Volume: space within, or surrounded by, a form

LESSON 10-6

Cities of the Future

(group project: three-dimensional construction)

Materials

corrugated papers—assorted colors

oaktag or bristol board—assorted colors

clear plastic disposable glasses

cellophane tape

scissors

non-hardening clay

toothpicks, pipe cleaners, tissues, cellophanes—optional

mural paper; tempera paints and brushes for background—optional

a. b.

Figure 10-6

Be Prepared

1. This project lends itself extremely well to group participation. Each group of children at a work area can create one city. However, children can each create one city individually, if desired.

2. Collect clean, clear, *plastic* glasses in advance of the lesson.

3. To facilitate the lesson, pre-cut strips of corrugated papers into lengths of approximately 12″ x 6″ and 12″ x 3″. Lengths of oaktag or bristol board can be pre-cut approximately 18″ x 9″ and 18″ x 5″.

4. It will be easier to move these projects if children work on a portable surface. If possible, cover each work area with a large piece of cardboard. (For children who are working singly, individual cardboards, approximately 16″ x 22″ will suffice.)

5. Art helpers should distribute the necessary supplies at the start of the lesson. Each work area should have a selection of various sizes of corrugated papers and oaktag or bristol boards. More papers should be available at a central supply area if needed. Scissors, tape, plastic glasses, and a small amount of clay should also be at each work area. Tissues, cellophanes, pipe cleaners, and toothpicks are optional, but if utilized, should be placed at a central supply area until ready for use. All materials can be shared.

6. Designate an area, such as a large table, where the completed cities can be placed until ready for a final display.

7. Allow time for cleanup. Have receptacles available for children to place all usable scraps of paper, to be utilized in future projects.

8. If possible, have photographs of cities to be shown to the class at the start of the lesson. (See "Through the Eye of the Artist" for suggestions).

Introduction of Lesson to Students

When we think about our cities of today, what comes to mind? Tall skyscrapers, crowded streets, factories. What else? Most of the buildings, as we know them, resemble rectangular shapes. Suppose we try creating cities of the future . . . cities in which the buildings are mostly *curved* or rounded. That will be quite different! These cities will be new and serve needs different from the cities of today. Will there be landing areas for rockets? Will restaurants serve different kinds of foods? Will there be different stores, parks, statues, and decorations? Be thinking about all these things as you start to build some marvelous curved "cities of the future."

Procedure

1. Almost all our materials are flexible, that is, they can be curved. The corrugated papers and oaktag can be made to stand simply by bringing together two ends and taping them together to form a cylinder (Figure 10-6a). What if you want a smaller cylinder? Simply cut off extra paper and start with a smaller size. Our clay can certainly be molded, or changed in shape, to form people, statues, rockets, or even rocks (see Figure 10-6). Our paper cups are not easily changed in shape, but how about turning them upside down and using them as buildings themselves (Figure 10-6) or taping one of them on top of another to resemble glass domes? Let your imaginations work—you are architects and engineers who are building something completely new!

2. Continue to cut and curve the various papers into cylinders, making sure that not all are of the same height and width. We want variety and interest. Connect some shapes together, with tape, if you wish (Figure 10-6b). Try adding interesting curved walls. Put small clay people under the domes.

3. Perhaps you want to add a toothpick construction as part of the interest, (See Lesson 10,5 "Toothpicks of Tomorrow," for procedures).

4. If pipe cleaners, tissues, etc. are to be used, these too, can be curved or folded and added as flags, decorations, etc. Interesting shapes can be cut from cellophane and taped onto the plastic glasses to give the effect of stained glass.

5. Keep experimenting and working until your project is complete, then carry the city carefully to the designated table, where we can arrange our final display.

6. Place all usable scraps in boxes.

7. If a background is desired, paint rocket ships, planets, etc. on mural paper and tack to a bulletin board. Place the table with the city, in front of the painting (see Figure 10-6).

Look Around You

We have tried to create some curved cities of the future and we have really succeeded! We have already talked about the differences in the shapes of our buildings from most of the buildings we know today. Are there curved buildings now? Think about pictures of actual buildings you have seen. Are farm silos, for example, curved? What about the past? Think about castles, the Roman Colosseum, the Leaning Tower of Pisa. What else? What we do in the future will depend very much on what has been learned from the past as well as from the present. Of course, there will probably be new materials with which to build, as well as new needs, such as different kinds of roads for different kinds of transportation, etc. Do you think our cities of today could have been improved by more careful planning? Should we have more parks? Should we have less billboard advertising? What are some other suggestions? Discuss this with your families and see what ideas they have. Ask them how cities have changed since they were children.

Adaptations

1. When time allows, arrange the cities into an interesting table-top display.

2. Have the children name their cities of the future.

3. Work on one city as a class project, and assign various sections to several groups. For example, a park area, a school area, stores, housing, etc.

4. Draw or paint pictures of transportation of the future.

5. Paint a mural of a city of the future.

6. Build a model home of the future from scrap materials.

7. Build an *underwater* city or farm of the future. (See Lesson 5-4, "Something Fishy," for procedures.)

Extra Bonus Project: Corrugated Creatures from Outer Space

Use the left-over corrugated papers and scraps to make collages of strange animals or people from other planets. Yarn or steel wool hair, metallic paper eyes, toothpick antennae, pipe cleaner tails, etc. can all be used to fashion creative and unusual creatures.

Special Bonus Project: Travel Posters of Tomorrow

Paint unusual posters, advertising travel to these cities of the future, or to other planets. For example, "Lunar Lodge—Enjoy Weightless Nights and

Star-Filled Days" or "Saturn Awaits You—Ride the Rings Daily." Children
will delight in the fantasy of it all, and it is an opportune time in which to
introduce simple, bold poster design.

Through the Eye of the Artist

This lesson is greatly enriched and made much more meaningful through
the use of illustrations showing cities and buildings of the past and present. Place
particular stress on cylindrical designs, and discuss the materials used, as well as
the function of the buildings.

Suggestions

Ancient civilizations—Roman Colosseum, arches, and columns
Egyptian—stress the pyramid shape
Byzantine domes
Middle Ages—cathedrals and castles
Modern—Wright—Guggenheim Museum, N.Y.C.
Fuller—U.S. Pavillion, Expo '67, Montreal
de Costa (city planner)—Brasilia, Brazil

Glossary

Model: to work and to mold in a soft material such as clay
Architecture: the art and science of building

AN EFFECTIVE ART PROGRAM

REFLECTS THE CHILD'S WORLD

CHAPTER 11

Display It!

Children's art, with its spontaneity and splashing colors, can, and should, lend sparkle to the school environment. In this vital part of the child's world, such art work can serve as an ever-changing decor that will delight both youngsters and adults. When children see their artistic efforts displayed attractively, they not only gain a greater sense of self-worth, but their understanding and appreciation of the creativity of others are enriched.

Bulletin Board Perk-Ups

Art work can be displayed in many ways and in many places. The staid, symmetrical bulletin board filled with traced patterns is a thing of the past. Try arranging an exhibit that includes various media and themes (Figure 11-1). Hang paintings and drawings in an asymmetrical arrangement, upon a colorful backing. Bright mural paper is relatively inexpensive, and can serve as "instant wall color." After a while, should the color begin to fade, the paper can be reversed.

Every work of art is made more attractive by a mounting. This need only be a sheet of white paper that will act as a border when art is stapled to it. When taping or tacking the pictures to a bulletin board, hall or onto mural paper, however, remember to space the works so that the effect is not overcrowded.

Wake Up the Halls

Look for areas in your school that may never have been enhanced by art before. Does the school entrance have glass doors that might be painted periodically (Figure 11-1a)? Tempera on glass washes off easily and is a delightful art experience for youngsters. Paintings on mural paper or construction paper can also be taped to the glass for still another effective display. (Figures 11-1a and b). The library, auditorium, cafeteria, etc. are also rooms in which art work can be

exhibited dramatically and effectively. By all means, include three-dimensional work, along the walls, table tops, and display cases.

Classroom windows take on new brightness when art is added to them. Transparent and opaque papers such as tissues and cellophanes are particularly attractive. Boys and girls will not only delight in the colors added to the room, but will gain new insight into the changing spectrum created by natural light. (See Chapters 1—''Emotions,'' 2—''Dreams,'' 5—''Nature,'' and 6—''Weather,'' for specific activities.)

Figure 11-1a

Figure 11-1b

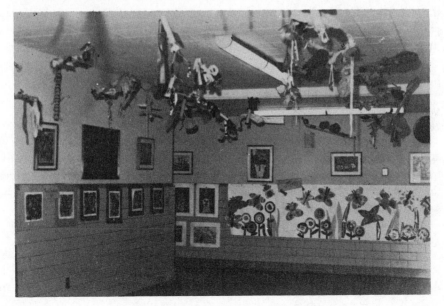

Figure 11-1

Children are particularly fascinated by mobiles. The constant sway and movement of such work can create a new artistic dimension in halls and classrooms. Attach nylon fishing line (almost invisible) to three-dimensional insects (See Lesson 5-6, "Insect Wizardry"), painted fish (See Lesson: 5-4, "Something Fishy"), butterflies, snowflakes, etc. and hang them from the ceilings with masking tape (Figure 11-1). No marks are left when the tape is removed, and such comments from children as, "It looks like a fairyland," will make the effort well worthwhile.

The Art Fair

Community interest in children's art is constantly growing. Your gymnasium or cafeteria, as well as the school halls, can serve as a gallery for a display of the youngsters' creativity. An annual, or semi-annual, art fair not only is a unique opportunity for children to view their own and their friends' works, but should be open to the community as well. Children will be amazed at how much has been accomplished, and how they have progressed in their skills and ability to express ideas creatively. Adults will gain a better understanding of how effective and vital an art program can be.

Often your community library or local department store or bank will agree to display children's art work. Invite other schools in your district to participate in a community children's art show.

Frame It

Why not arrange to start a *permanent* art exhibit in your school? Perhaps the P.T.A. will contribute several frames each year for art work, or a talented parent may volunteer to make them. Adults and children will not only feel that they have contributed to a mutual activity, but the pride of seeing art work actually framed spurs interest in continuing the practice at home. Murals, too, can be permanently displayed in frameworks of dowels or two-by-fours.

Why Art?

Art is a reflection of the life and times of the artists who create it. So too, the art of a child should give evidence of his world: his interests, ideas, skills, inter-relationship with others and his total environment. Through art activities, the child not only enhances his total understanding of the world around him, but will in time, enrich his world as an adult.

A Note About Reproductions

Almost all the suggested reproductions in the "Through the Eye of the Artists" segments of this book can be found in the publications listed in the

following *Bibliography*. Bear in mind, however, that other fine-arts reproductions can be effectively substituted. Museums have many reproductions available at nominal cost, in addition to slides and films that can be rented. Local book stores, libraries, and galleries are also excellent sources for such material. Many publishing houses specialize in art reproductions for use in schools, and are listed in educational periodicals and art supply catalogues.

BIBLIOGRAPHY

Arnason, H. Harvard. *History of Modern Art*. Englewood Cliffs, N.J.: Prentice-Hall, Inc., and N.Y.: Harry N. Abrams, Inc., 1968

Brock, Ray (ed.). *The Permabook of Art Masterpieces*. New York: Permabooks, Garden City Publishing Co., Inc., 1949

Chase, Alice Elizabeth. *Famous Artists of the Past*. New York: Platt and Munk, 1964

Davidson, Marshall B. (ed.). *Art Treasures of the Metropolitan*. New York: Harry N. Abrams, Inc., 1952

Eliot, Alexander. *Three Hundred Years of American Painting*. New York: Time Incorporated, 1957

Faulkner, Ray and Ziegfeld, *Art Today*. New York: Holt, Rinehart and Winston, Inc., 1969

Feldman, Edmond Burke. *Art As Image and Idea*. Englewood Cliffs, N.J.: Prentice-Hall, Inc., 1967

Gallery of Modern Art, Including the Huntington Hartford Collection. Salvador Dali 1910-1965. New York: The Foundation for Modern Art, 1965

Genaille, Robert. *From Van Eyck to Brueghel*. New York: Universe Books, Inc., 1954

Hunter, Sam and Jacobus, John. *American Art of the 20th Century*. Englewood Cliffs, N.J.: Prentice-Hall, Inc. and N.Y.: Harry N. Abrams, 1974

Hunter, Sam. *Modern American Painting and Sculpture*. New York: Dell Publishing Co., Inc., 1959

Huyghe, René (ed.). *Larousse Encyclopedia of Modern Art*. New York: Prometheus Press, 1961

Janson, H.W. (ed.). *Key Monuments of the History of Art*. Englewood Cliffs, N.J.: Prentice-Hall, Inc. and N.Y.: Harry N. Abrams, Inc., 1959

Janson, H.W. and Dora Jane. *The Story of Painting for Young People*. New York: Harry N. Abrams, Inc., 1952

Lancaster, John. *Introducing Op Art*. New York: Watson-Guptill Publications, 1973

Jaffé, Hans L.C. *Pablo Picasso*. New York: Harry N. Abrams, Inc. 1964

Lippard, Lucy R. *Pop Art*. New York: Praeger Publishers, 1966

Muntz, Ludwig, *Rembrandt*. New York: Harry N. Abrams, Inc., 1954

Polley, Robert L. (ed.). *Great Art Treasures in American Museums*. Waukesha, Wisconsin: Country Beautiful Corporation, 1967

Pool, Phoebe. *Impressionism*. New York: Frederick A. Praeger, 1967

Mathey, Francois. *The Impressionists*. New York: Frederick A. Praeger, 1961

Read, Herbert. *A Concise History of Modern Sculpture*. New York: Frederick A. Praeger, 1964

Roos, Frank J. Jr. *An Illustrated Handbook of Art History*. New York: The Macmillian Company, 1967

Swann, Peter C. *The Art of Japan*. New York: Greystone Press, 1966

Whiteford, Andrew Hunter. *North American Indian Arts*. New York: Western Publishing Company, Inc. 1970

Woldering, Irmgard. *The Art of Egypt*. New York: Greystone Press, 1963

Periodicals

Art and Man. Englewood Cliffs, New Jersey: Scholastic Magazines, Inc. Under the direction of the National Gallery of Art

Art in America, New York: Art in America Co., Inc.

Réalités. New York: Réalités in America, Inc.

INDEX

INDEX